ECONOMICS FOR THE MANY

ECONOMICS FOR THE MANY

Edited with an Introduction by
John McDonnell

VERSO
London • New York

First published by Verso 2018
The collection © Verso 2018
The contributions © The contributors 2018

1 3 5 7 9 10 8 6 4 2

Verso
UK: 6 Meard Street, London W1F 0EG
US: 20 Jay Street, Suite 1010, Brooklyn, NY 11201
versobooks.com

Verso is the imprint of New Left Books

ISBN-13: 978-1-78873-223-9
ISBN-13: 978-1-78873-225-3 (US EBK)
ISBN-13: 978-1-78873-224-6 (UK EBK)

British Library Cataloguing in Publication Data
A catalogue record for this book is available from the British Library

Library of Congress Cataloging-in-Publication Data
A catalog record for this book is available from the Library of Congress

Typeset in Adobe Garamond Pro by Hewer Text UK Ltd, Edinburgh
Printed in the UK by CPI Group (UK) Ltd, Croydon CR0 4YY

Contents

Introduction

John McDonnell

The election of Jeremy Corbyn as Labour leader in September 2015 was the opening act in a period of political change and transformation in Britain. Thousands of campaigners and millions of voters, inspired by his message of hope, delivered the biggest rise in Labour's vote share since 1945 in the general election less than two years later. Ten years after the Great Financial Crisis, the prospect of a Labour government elected on a platform to transform society is now very real and so, too, has been the extraordinary flourishing of new ideas on the economy to replace those that have so obviously failed.

The Chancellor of the Exchequer, Philip Hammond, said in 2016, 'We have a problem — and it's not just a British problem, it's a developed-world problem – in keeping our populations engaged and supportive of our market capitalism, our economic model.' Nobody should be surprised. Real wages in the UK today are still lower than in 2010: an unprecedented period of failure.

The crash of 2008 laid bare the failures of mainstream economic policy, otherwise known as 'neoliberalism'. Neoliberalism is a set of policies and beliefs about the economy that have dominated government thinking in Britain (as across the world) since the crisis of the late 1970s. These rules hold it that markets are the best possible means to organise an economy, that wealth would automatically 'trickle down' from the top, and that impediments to corporate power – like regulation and trade unions – should be reduced to irrelevance, if not actually banned.

But since the Global Financial Crisis of 2007–8, we have been approaching the end of the road for this economic model. Growth in the economy has never fully recovered from the crash, and the growth which there has been has not been shared. The UK in particular is the only advanced economy where wages have fallen when the economy has grown.

Meanwhile, the system of in-work benefits which went some way to compensate for low earnings has been slashed, and austerity has cut to the bone the public services we all rely on.

The human costs of this economic failure are intolerable. As billions of pounds have been handed out in tax giveaways to corporations and the very richest in society, cuts have eroded the basic fabric of our society and the quality of the lives we lead. Our schools, hospitals and social care services have been deprived of the funding they need to adequately support us in our daily lives. Good-quality, secure and affordable housing, which should be a staple of any healthy society, is slipping out of the reach of an entire generation.

While the profits of big business and executive pay continue to soar, the proceeds of that wealth are not being shared by those who create it. Despite working some of the longest hours in Europe, for too many people in this country lower wages in often insecure jobs are preventing them from enjoying the basics in life, be it time spent with the family, an annual holiday away or simply a meal out.

Shamefully, it is the most vulnerable in our society that have paid the heaviest price for the economic vandalism of recent years. According to a UN committee, the UK's austerity programme has led to the 'grave and systematic violations' of disabled people's rights.[1] It demeans our society that, in the sixth richest country on the planet, record numbers of vulnerable children are pushed into care; women's refuges, starved of funding, are forced to turn away victims fleeing domestic violence; and record numbers are sleeping rough on our streets.

Faced with the economic and social decay of neoliberalism, our core economic objective must be to create a prosperous economy that provides the richest quality of life possible for all

our people and is at the same time environmentally sustainable.

The essays collected here represent just one small part of the ferment of ideas, which has flourished since the crash, around which that alternative will be built. These are the ideas into which Corbynism has sunk its intellectual roots. I hope that it will act as a spur to further discussion, debate and experimentation as the social movement that we must become develops its own policies and strategies. Since Jeremy asked me to become shadow chancellor, I've tried to help raise the level of the economic debate in Britain through the New Economics events around the country and the annual State of the Economy conferences.

The truth is that we know the next Labour government will end austerity and begin to repair the damage it has inflicted on our country: from the crumbling NHS to the obscenity of street homelessness. But we can't build the best public services in the world on decrepit foundations, and the truth is that our economy is fundamentally broken. Even before the Tories' botched Brexit fatally undermined business confidence, investment by businesses was already among the lowest in the developed world. Productivity, the motor of growth in incomes, is stagnant.

For decades, successive governments have told us that free markets were always best and private wealth should be left untouched. They 'rolled back the frontiers of the state' and were 'seriously relaxed about people becoming filthy rich'. In theory, this was supposed to create opportunities for all, as wealth trickled down from the top. Yet wealth today piles up in a few hands and insecure work is at record levels. Meanwhile, the environmental damage our economy is inflicting is only too apparent in the rising annual deaths from air pollution.

We have to do better than this, but that means doing more than spending more on our public services – essential as this is. Nobel Prize–winning economist Joseph Stiglitz has elsewhere called for a 'rewriting of the rules' of our economies, changing the framework in which decisions are made.[2] We need to transform our economic institutions, and build new ones where they are needed, to create an economy that works for the many, not the few.

Ending Neoliberalism

A recent article by two academics, Joe Guinan and Martin O'Neill, characterised this as Labour's 'institutional turn', high-lighting the continuing influence of Karl Polanyi and his sweep-ing work of economic history, *The Great Transformation*. Polanyi argued that the creation of modern industrial society required the alienation of economic life from the social fabric. But, he argued, the violence of this process threatened society itself. This resulted in a 'double movement' in which society attempted to reassert itself against the demands of the market.

Polanyi's description could sound like a prophecy of neoliber-alism. By attempting to re-establish market rules and competi-tion on the back of society, neoliberal governments have threat-ened the fabric of that society: from the extraordinary expense and failures of the privatisation of public services to the devastat-ing social murder of Grenfell. Labour's 2017 Manifesto prom-ised to restore funding to services devastated in the last eight years by austerity and to bring public services back under public control. Calls for the nationalisation and public ownership of water, electricity, gas, the Royal Mail and trains were greeted with howls of outrage and derision from the press, but were (and remain) very popular, with enormous public support.

The intellectual traditions of the British left run deep, encom-passing everything from Marxism to G. D. H. Cole and the guild socialists; from feminist economics to radical localism. If we want a movement that can provide a viable alternative, we need to know how to draw those strands together to weave a coherent, popular, democratic new narrative for our economy.

Breaking with Neoliberalism

We are, finally, beginning to shake off the great lie in British politics, pushed by the Conservative leadership since the crash in 2007, that somehow a crisis of global finance was due to the spending priorities of the Labour government in power at the

time. The austerity policies this myth supported were a political choice by government, not an economic necessity. Antonia Jennings's chapter in this volume describes how the general crisis of trust in our economic institutions could be dovetailed into support for an 'austerity narrative', which turned economic history and economic rationality on its head to create public support for the most devastating, inhumane cuts to public provision in generations. Similarly, J. Christopher Proctor's chapter highlights the campaign to reform the teaching of economics in our universities and colleges, opening it up to wider sources than the neoclassical straitjacket enforced by too many curricula.

In order for Labour to be a genuinely transformative government in office, we will need a clear rule for our government's overall macroeconomic stance. In an increasingly unstable economic world, in which major powers threaten trade wars, it will be vital to provide macroeconomic stability and certainty as we set about rebuilding the British economy. Simon Wren-Lewis argues here for a fiscal rule that a progressive government can use to keep the government debt and deficit sustainable. Labour's Fiscal Credibility Rule, drawn up in consultation with Simon and other world-leading economists such as Joseph Stiglitz, provides exactly that robust framework.

Prem Sikka's chapter takes up this point, providing a detailed account of the amounts potentially lost to evasion and avoidance and highlighting the ways in which a tax system with a sense of public purpose, properly staffed and with suitable resources, is essential to ensure our public services are properly funded. Özlem Onaran's chapter builds on this to make a powerful case for government investment, not only in the physical infrastructure of telecommunications, housing or renewable energy, but in what she calls the 'social infrastructure' of spending on health, education and care that is fundamental to building a humane society.

Climate Change and Economic Statistics

As is increasingly recognised, many of our economic statistics do not fit the world we live in – or take proper account of its organisation. Gross domestic product excludes unpaid work, like carework or housework, which means it excludes the work most often undertaken by women, as Özlem suggests. It does not account for the damage our economic activities inflict on the environment.

Perhaps the greatest of all these environmental challenges is climate change – which is happening, and happening as a result of human activity. In Africa and other parts of the world more exposed to its impacts, the results of rising average temperatures are already clear in the loss of farmland, poor harvests and pressure on freshwater supplies. Of the warmest years on record, three were in the last four years. The scientific evidence points towards these changes becoming horrifyingly clear over the next decade or so. One estimate has placed the potential costs of a three-month drought at £35 billion.[3] These are cold, hard, economic risks arising from climate change and wider environmental degradation. Ann Pettifor's chapter here presents the economic case for a 'Green New Deal', a major programme of investment in jobs related to climate change and driving through the change to a zero-carbon economy in a way that protects employment and livelihoods.

International Relations and Trade

Ann's ideas here are already being taken up further afield, with Alexandria Cortez-Ocasio's stunning Democrat primary win in New York building on a platform that included a 'Green New Deal'. Similarly, the next Labour government will need to forge a new and better relationship between this country and our friends and partners in the rest of the world.

In an important speech to the United Nations in Geneva in 2017, Jeremy Corbyn spoke of the fundamental principles of

Labour's new approach to international relations: changing how we treat multinational corporations, so that we will seek to apply the same rules to them that bind individuals and governments to a common standard of behaviour, including in the areas of human rights and international obligations. More recently, Kate Osamor has defined Labour's new approach to international development, stressing that we will be a government that fights for equality – and not just against poverty. In his chapter in this volume, Shadow Trade Secretary Barry Gardiner begins to detail how the next Labour government will work to create a new international trade regime that prioritises rights and standards and removes the gross inequalities of treatment that have otherwise characterised international trade.

It is the vote to leave the European Union that, of course, has shaped political debate over the last two years. Against the Tories' extraordinarily bad handling of the process, torn as they are between Brexit ultras and the (increasingly insistent) demands of business, Labour will seek a deal that can work for the whole country.

However, the forces that helped drive the Leave vote, whatever the final deal, will not simply fade away. Like a by-election, in which in any number of issues can be piled together, the Leave vote contained a great many grievances. For the majority of England outside of London, which voted so clearly to reject membership of the European Union, the sense of having spent too long on the wrong side of an economic deal was palpable, as Tom Hazeldine has forcefully argued.[4] Britain is, by some distance, the most geographically unequal country in Europe. It has the richest single area in Europe – central London – but also nine of the top ten most deprived regions in northern Europe. In their chapter, Grace Blakeley and Luke Raikes present the evidence for a persistent failure of our Westminster institutions to deliver the investment and support that the rest of the country needs to succeed, calling for a real devolution of powers and resources out from the centre.

Short-Termism and Finance

Neoliberal rhetoric usually insists on creating a crude opposition between private (good) and public (bad). This has always been wrong: as the work of Marianna Mazzucato on the 'entrepreneurial state' has conclusively shown, the boundary between the private and public sectors was never that clear, with apparently private sector innovations like Apple's iPhone deeply dependent on original public sector funding for research.[5]

Short-term thinking of this kind has blighted our economy. Too often companies have looked to pay dividends to shareholders before putting their money into the skills and new technologies that will secure future prosperity. While the rest of the world moves into the fourth industrial revolution of AI, automation and robotics, Britain has the lowest usage of robots in manufacturing of any major developed economy.[6]

The recent report *Financing Investment* by GFC Economics and Clearpoint on Britain's financial system drummed home this point: the roots lie deeper, but in the last few decades our financial system has come increasingly to focus on the short-term and unproductive at the expense of longer-term, productive investment.[7] The report describes how, in effect, our financial institutions channel lending from manufacturing into real estate and proposes some critical changes to the functioning of the Bank of England. Johnna Montgomerie's chapter looks at one part of this problem of 'financialisation', in which households are dragged further and further into debt, in some cases to the point where there is no realistic prospect of escape. Costas Lapavitsas's chapter complements this with a detailed account of how our financialised economy promotes inequality and rent-seeking.

New Forms of Ownership

However, some of the worst examples of short-termism have been in our outsourced and privatised public services. Carillion, which had slowly crept into more and more provision of our

public services before its spectacular implosion in early 2018, has paid out higher and higher dividends every year for the last sixteen years.[8] It's one glaring example of how short-term thinking poisons the real economy, and it's why the next Labour government will bring private finance initiative contracts back in-house, ending the privatisation racket.

We need to create new forms of economic organisation instead, drawing on the best traditions of the labour movement. Where assets are moved back into public hands under Labour, they will be placed under democratic public control, instead of replicating the old 'Morrisonian' model. As Ken Loach showed in his brilliant 2013 documentary *The Spirit of '45*, this could too often mean creating distant bureaucratic hierarchies that could seem as out of touch with workers and the public as any private sector monolith.

Moreover, democratic economic management needs to go beyond the public sector. When new firms are established to use new technologies, or older companies are changing hands, they can adapt new models of business organisation, drawing on the rich tradition of the cooperative movement. Taking a cue from Labour's *Alternative Models of Ownership* report, published during the 2017 election campaign, Joe Guinan and Thomas Hanna argue forcefully for a 'democratic ownership revolution' in Britain. By breaking with the idea that the ownership of our economic assets should be left only in private hands and that control over those resources should be exercised only by a small number of people, they argue that we can build the foundations of a new, more democratic and fairer society.

Rob Calvert Jump's chapter presents the business case for a shift in how our firms are organised: from ownership held in just a few hands to ownership that is spread out among the many, including the workers at those firms. Rob presents empirical evidence which demonstrates that not only does worker participation and ownership mean more democracy and transparency, it has clear benefits for productivity and long-term decision making, with those who work for a firm having an immediate concern with its long-term future.

The next Labour government will oversee a flourishing of these alternative models of ownership, from worker-owned businesses to local energy cooperatives. Already Labour councils are not waiting for the next election. Battered by austerity, they are being forced to think creatively to protect their local economies and public services. Preston Council in Lancashire has spearheaded the approach in the UK; its new leader, Matthew Brown, writes here with Ted Howard, Matthew Jackson and Neil McInroy about learning from US city councils that have attempted to return spending to their cities and support the growth of locally owned businesses. The Cleveland Model in the US has inspired the Preston Model in the UK, and Labour's new Community Wealth Building Unit is already helping to support local councils following in their footsteps.

New Forms of Wealth

We also need new, more imaginative ways to put the wealth inherent in the vast pools of data that all of us generate into service for the public good. Nick Srnicek's chapter raises the huge challenges posed to those seeking progressive reform through the rise of 'platform capital': the immense concentrations of power and wealth that have developed on the back of rapid advances in computing power and data processing via the internet. How future progressive governments deal with Big Data will be a central question. Nick has pointers to how we could bring the power of Big Data back under progressive control, including creating new digital rights, supporting open-source software and, as Labour policy is committed to, providing greater backing for 'platform cooperatives'.

Municipal authorities such as Barcelona's are using innovative new ways to bring local data infrastructures under democratic and public control. Francesca Bria is Barcelona's chief technology officer, and her chapter provides an overview of the thinking behind the city's radical approach to building a New Digital Deal for citizens, encompassing the idea of technological sovereignty

with cities and towns at the forefront. As councils are bringing local public services back under local control, so too can localities begin to put the immense new wealth of the digital economy into service for the many. Guy Standing's chapter points towards the challenges of the future, and what he argues should be the next steps for Corbynomics. The debates around the universal basic income that he favours will no doubt continue, as will the related conversations about universal basic services: extending the principle of free universal provision to things like transport, communication and housing.

The Future

The intellectual groundwork for these is critical. Christine Berry of SPERI has written recently about the work that right-wing intellectuals and influencers put in over decades to prepare the ground for the Thatcher–Reagan revolution.[9] They had think tanks, academics, politicians and others scattered across civil society developing their ideas and arguing the case ahead of the 'Thatcher Revolution', providing the fertile intellectual soil in which the weeds of neoliberalism took root.

Unlike them, we don't have decades to prepare the ground: the crises of austerity and the environment, and the emerging digital economy, have together forced a far more rapid pace of change on us. At the time of writing, we don't even know how long this government will remain in power, or how they will deal with Brexit.

Yet the possibilities that are being created are immense, in the new technologies we have and the deepening understanding of the need for change. We have the capacity to solve these huge challenges, and to create not just a country, but to help create a world that works for the many, and not the few. We are seeking nothing less than to build a society that is radically fairer, more democratic and more sustainable, in which the wealth of society is shared by all. The historic name for that society is socialism.

In order to build it, we need to inspire people with an

alternative to both the failing neoliberal establishment and the xenophobic nationalism which some promote as a replacement. There are no guarantees, but – forty years after Eric Hobsbawn wrote of 'the forward march of labour halted' – we have an incredible opportunity to put our economy on a new and better path.

For years we have argued that another world is possible. Today, that better world is in sight. In order to achieve it, we need to win the argument that we can get there and to inspire people with how we can all do so. I hope this book will prove to be an important contribution to that goal.

Democratising Economics in a Post-truth World

Antonia Jennings

The Dominance of Economics in the Political Sphere

Whichever definition of democracy one subscribes to, it is a political exercise that involves input from citizens into the decision-making processes of society. Yet when it comes to the discipline of economics, individuals do not have the necessary means at their disposal to participate effectively in discussion of the subject in the public sphere. As well as making an already non-functioning democracy worse, it has also supported the rise of 'post-truth' narratives to gain popular support and credibility. To help alleviate this problem, we need a more democratic economics – to transform the subject from a barrier to a bridge for people to engage in critical, grounded and informed political debate.

The importance of economics in the political sphere is clear. Elections, for many the high point of the democratic calendar, often feature commitments to help the economy as central facets of party campaigns. Indeed, elections are often won or lost on how the public perceives the state of the economy. In the UK, historically we have tended to see a change in government when the economy seems to be in crisis, and conversely when the economy is thought to be doing well most often the party in government stays for a subsequent term.

During his successful bid to become US president in 1992, Bill Clinton coined the phrase 'it's the economy, stupid', singling

out the economy as an issue of incredible importance to voters. Although one of three phrases James Carville (then Clinton's chief political strategist) had developed to keep the Democrats' campaign on message, 'it's the economy, stupid' is the one that is remembered. The slogan has gone on to become an unofficial mantra for winning elections on both sides of the Atlantic.

The explicit focus on the economy in the political sphere is actually a fairly new phenomenon. 'The economy' as an entity was not mentioned in the winning manifesto of any UK political party before 1950. Of course, facets of the economy were discussed (e.g. wage levels and gross domestic product [GDP]) before this time, but 'the economy' as a concept in itself did not prominently feature in political life. Fast forward to the 2015 UK general election, and 'the economy' was the most discussed issue in the media, after the election itself. The winning Conservative manifesto mentioned it fifty-nine times, Labour's manifesto thirty-three times, and the Liberal Democrats' a staggering sixty-six.

The political world's focus on the economy has led to most policy commitments being justified in terms of their effect on it.[1] In other words, the economy has been given semi-sacrosanct status; all policies must pay homage to it in their rationale for existence. This applies both to policies that we would see as obviously relating to the economy (e.g. quantitative easing) and to those whose success we may not want to see measured in traditional economic indicators (e.g. mental health policy).

Furthermore, at the national level the perceived state of a nation's economy is widely recognised as the primary measure by which to judge a country's success internationally. Most popular of these indicators is GDP, a somewhat arbitrary indicator that is not internationally standardised. The UK, for example, includes prostitution and illegal drugs in its GDP, whereas France does not.

The debate on the limits of heterodox economics is not for this chapter, but what I believe the above demonstrates is the dominance that economics and 'the economy' have within the political

sphere. By extension, therefore, we would hope that economic decisions are made with input from citizens. If we aspire to a functioning democracy, people should be able to contribute to the creation of the economy they would like to inhabit. As Ha-Joon Chang wrote, this is imperative if 'we are not to become victims of someone else's decisions'.[2]

Our Economic Literacy Problem

To take ownership over the economic decisions that affect us all, we should have the ability to voice our opinions on how our economy is structured. As economics and the economy are such critical components of public life, we should have the capability to assess how well the economy is doing and understand the discussion that is taking place. This is far from the case; the way in which economics is presented in the public sphere at present is inaccessible to the majority of our society, leading to the situation of a paradoxically marginalised majority.

Research from Economy, an organisation campaigning for understandable economics, has shown that only 12 per cent of the UK public feel that those in politics and the media talk about economics in a way that they understand.[3] Of the 12 per cent, perception of understanding is even starker in lower-income families. For people in the lowest income bracket (C2DE), only 7 per cent find economics accessible (15 per cent in higher-income brackets – ABC1). If we interpret this as revealing that only 12 per cent of the population understands economic statements on anything from the deficit to our export industry, for 88 per cent of the country such concepts mean little.

Given economics' reputation as a male-dominated subject, Economy's research actually showed there is no significant difference in perception of understanding between the sexes. Interestingly, perceptions of understanding also do not differ according to political allegiance. However, UKIP voters were most likely to state that they felt economics in the media was inaccessible.

When it comes to financial literature, recent YouGov research reveals that young adults are least likely to have a handle on it, with just 8 per cent of UK eighteen- to twenty-four-year-olds admitting to having a 'high understanding', compared to at least 20 per cent of older age groups.[4] To apply this to a specific economic concept, the Organisation for Economic Cooperation and Development (OECD) has recently found that only 38 per cent of the UK public understands what inflation is.[5]

Perhaps unsurprisingly given our understanding levels, there is also a severe lack of trust when the economy is discussed, and there is a widespread belief that economic information is not reliable or trustworthy. Further *Economy* research revealed that only 3 per cent of the UK population felt that discussion and information about the economy around election time was completely honest and trustworthy.[6] This drops to 1 per cent of respondents in the north of England.

This research shows that we have a serious economic literacy problem. In effect, inaccessible economics has been left open only to those with a specialist education, power and privilege. This power imbalance leaves the UK with a very unhealthy relationship between citizens and decision makers, often with the poorest, youngest and minorities suffering the worst consequences of this. Producing better economists is not enough to fix this problem; to build a sustainable, just and democratic society we need a general public that is able to engage with economic discussion, scrutinise economic decision makers and articulate what it needs from the economy.

We can also see that alongside these appallingly low levels of understanding, trust and reliability when it comes to economics, political apathy is at an all-time high. This year the Edelman Trust Barometer found that only 11 per cent of the UK would say the system is working for them.[7] Simultaneously, support for democracy, both nationally and internationally, remains consistently high at over 90 per cent.[8]

As a nation, we have switched from having low political apathy and high trust in institutions, into a state of high distrust and an

opinionated population. In other words, in 2017 people actively support democracy in theory, but detest the reality. If the system continues on this trajectory, how stable can we expect our future to be?

With economics dominating the political landscape, demystifying economic language to educate its audience on how the economy works and where they fit in is a critical step to help mitigate this derision. The subject urgently needs to transform from an alienating omnipresence into a conduit for voices to be heard; a means through which people can be empowered to shape the economy into one that better serves them.

Post-truth Narratives: Austerity and Brexit

Poor economic literacy contributes to a democratic deficit. This means that the degree to which people can understand the forces significantly affecting their lives is severely limited. More than this, it understandably puts people off engaging with the democratic process. Engagement, in any form, requires reason or inspiration. However, perhaps most pertinently, given the 'post-truth' era we now find ourselves in, it leaves space for economic falsehoods to quickly gain popular support. The austerity narrative and the Brexit campaign have both capitalised on this.

The extension of citizens' not understanding the forces that are shaping the economy around them is that they are unlikely to change. If we think about some of the major economic problems facing the UK today, such as growing inequality and falling productivity levels, how likely is the public to call for change if people do not fully understand the matters at hand? The harsh reality of many of these issues is that it is often not in the interests of the political establishment to remedy them. We can only expect change to come from a mass movement which is informed, motivated and armed with a good understanding of the situation.

Being unable to link your individual circumstances to the wider structural forces at play is a major barrier to their

changing. Some polling around the 2017 general election found that over half of voters didn't feel they understood the impact of the economic policies presented.[9] When the impact of policies is not understood, the incentive to engage and change the policies is absent. These findings echoed another YouGov poll conducted at the time of the EU referendum, which found that those who did not vote were three times more likely to state that they have 'zero' understanding of what is being said about the economy in the media.[10]

To allow citizens to input into the creation of the economy they would like to see, we need understanding, trust and by extension reason to engage. We currently have little of any, and live in a climate ripe for post-truth narratives to gain popular support. As people's ability for critical economic analysis is low, the skills needed to verify and fact-check political slogans is missing. Taking the austerity programme and the Brexit campaign as examples, we can see this in action.

THE AUSTERITY STORY

Since 2010, the austerity story has been the dominant political narrative in Britain. It has been used to justify huge public spending cuts, the denationalisation of industries and tax rises. Presented as a rational, sensible programme, the austerity story has been incredibly successful in convincing millions that there is no realistic economic alternative to help the country. Moreover, many voters support austerity in spite of their opinion of the government implementing it; it has been accepted as an economic necessity removed from the political context it is presented in.

The Public Interest Research Centre, the New Economics Foundation (NEF), the New Economy Organisers Network and the Frameworks Institute have done some excellent work on unpacking the austerity story into seven frames that underpin it.[11] Many of the frames, which have persuaded so many, have little economic truth behind them. However, they have capitalised on public ignorance of the economic reality and been delivered powerfully through the media and public communications.

On the latter, undeniably the delivery of the austerity story has been impressive. It has been consistent and simple and tapped into very human values and emotions.

The first two frames that the NEF identified as underpinning the austerity story are:

1. *Dangerous debt*: the most important economic issue the UK faces is the size of public sector debt, caused by excessive public spending.
2. *Britain is broke*: the UK's public finances are like an individual household, which has spent all its money.

Both of these frames are at best not facts but ideological viewpoints, and at worst complete untruths. The 'dangerous debt' frame asserts debt to be inherently dangerous (and not as an intrinsic feature of all Western working economies), and also blames excessive public spending for its existence. It points to the previous Labour government as the sole creators of public finance difficulties, overlooking the global financial crash that affected all major national economies.

The 'Britain is broke' frame again exploits the lack of public understanding of the difference between a household and a national budget. National finances are completely different to a household's – debt is taken on by each in completely different ways, and by extension has different consequences. The financially strapped household cannot issue bonds, raise taxes or print its own money to help alleviate its problems. Moreover, issuing household debt does not have the benefit of providing a national short-term economic stimulus, or improving productivity in the long term.

To defeat the austerity story, the left needs to present a coherent, factual and appealing alternative. In tandem, improved economic literacy will also provide people with the tools to be able to more critically assess the validity of the frames that austerity is presented through. Inaccurate metaphors, for example the national budget being comparable to a household's, will be less

easily accepted as people are better able to scrutinise slogans. More than this, economic literacy gives people the faculties to create an alternative, viable economic story – one that produces a more just, sustainable and fair society.

BREXIT

Both sides of the EU referendum campaign were badly fought. A combination of an incredibly short time to campaign (four months, compared to a year for the Scottish referendum) and a great deal of uncertainty on both sides resulted in two campaigns that had inconsistent, nebulous and bombastic claims as their flagship offering. In both camps there were many visions of what the UK's future, either in or out of the European Union, would be.

One of the most famous pro-Brexit slogans, famously stuck onto a bus and driven up and down the country, was 'We send the EU £350 million a week . . . let's fund our NHS instead'. The message implied that should we leave the EU, £350 million would be diverted directly into the NHS. As the UK did vote to leave the European Union, and this message and the 'Brexit Bus' were given a lot of media coverage, it is clear that millions accepted and approved of the statement.

This is another example of a post-truth economic narrative gaining widespread support. The net contribution the UK gives the EU is a disputed figure (even within the Brexit camp) – for one, the £350 million figure does not include the instant rebate we receive.[12] Regardless of the figure, it required an astounding level of audacity to suggest that the contribution could be seamlessly redirected into the NHS. It was knowingly audacious too – just an hour after the leave vote was confirmed, Nigel Farage admitted that it was a 'mistake' to suggest this money could be redirected to the NHS.

Yet for millions this slogan was to a certain extent lauded and applauded as a credible vision for Brexit Britain. As with austerity, I am not suggesting that the sole reason these narratives have such resonance with the country is down to a lack of economic

literacy. However, with the means to assess spurious economic statements more accurately, we all may be a little slower in accepting them.

Post-truth narratives exist on all sides of the political spectrum. Parties and movements of all descriptions are keen to garner support for their ideas, often by using whichever methods they believe will have the most traction. In a fraught political landscape, with much to play for, ideas need be communicated powerfully, loudly and quickly. What is sometimes lost in this is accuracy, highlighting 'the perils of leaving economics to the experts'.[13] Economics, as inextricably linked to politics, needs to become more democratic – so every citizen has an equal stake in deciding what our economy looks like in the future.

Towards a More Democratic Economics

A democratic economics is an economics that is a public dialogue. It is a discipline that people and communities understand, can take ownership of and have input into. For this to happen, economic literacy needs to improve. A generation of 'citizen economists' must be created to hold institutions to account, recognise the ideologies behind the economic ideas presented and contribute to the creation of economic policy. This is no small ask; but I think there is cause for hope. Working people in the UK are angry about the living conditions our economic system has granted them, and there is motivation to change it. The left has a real opportunity now to reclaim economics as a discipline made for and by the people.

The citizen economist needs to resemble something of the public intellectual as described by Edward Said.[14] In his words, the public intellectual's role is 'to raise embarrassing questions, to confront orthodoxy and dogma (rather than to produce them), to be someone who cannot easily be co-opted by governments or corporations, and . . . to represent all those people and issues that are routinely forgotten or swept under the rug'.

To put this into practice, I believe there are five transformations that economics needs to go through. First, we must look at how understanding is acquired: education. The availability and quality of economics education in our society is pitiful – at school, in university and in the wider world. At schools, it currently sits within personal, social, health and economic (PSHE) education, an already sidelined subject. Within PSHE, economics is sidelined further still. One small step to improving this would be statutory PSHE, which the PSHE Association is campaigning for.

At the university level too, economics is not fit for purpose. The teaching of it is overwhelmingly heterodox, inapplicable to the real world and missing any training on how to communicate economic ideas. It is too often presented as a science, from which correct answers can be drawn about how to distribute resources in society. Rethinking Economics is an international network of students, academics and professionals working to change this, campaigning for a more pluralist, critical curriculum in universities that leaves students with a broad understanding of the many approaches to solving societal problems. However, more than just within the school or university setting, we need publicly available resources for anyone who wants to improve their understanding.

Second, economics needs to improve its communication. While there are some academic concepts that are necessary in order to explain economic issues, much reporting on economic news is filled with jargon and alienating to the reader. Akin to the Science Communication movement, Economy (ecnmy.org) is an organisation campaigning for better economics communication from all who contribute to public opinion on it – including the media, government and finance sectors.

Third, a transparency revolution needs to take place. Economics presented to the people needs to be far clearer about the values, facts and assumptions that lie behind it. The subject needs to present itself not as a science, but as a social science, in which the philosophies behind propositions made can be publicly scrutinised. The austerity story is just one example of the opposite in

action, as an idea that was widely accepted as a scientific inevitability if, as a country, we wanted to 'balance the books'.

Fourth, we need to make economics more diverse and representative of the society it serves. Only one woman has ever been given the Nobel Prize in Economics (out of the seventy-five that have been awarded), and only two recipients have not been white. Women make up only around a quarter of economics students, and it is roughly the same ratio for academics teaching the subject. There is little hope for identification with the subject if it is dominated by older white men, who often have a poor idea of the needs of the diverse communities within Britain. A new generation of economic commentators, educators and communicators must be created, who can inspire others to get involved.

Lastly, but supplementing all the transformations described above, economics must change into a discipline that relates directly to people's lived experiences. In our time-poor society, we cannot expect people to engage with a subject that is presented as detached from our immediate surroundings. The tangible effects of economic decisions need to be outlined, and not abstracted into high-level jargon. In many senses, post-truth narratives have realised this, and contorted self-serving politics into a story that falsely claims to benefit the individual. To overcome this, the left must deliver a compelling truthful alternative that people can interpret and apply to the world they see around them.

Economics affects society in so many ways. It dominates public discourse, while simultaneously being seen as an abstract force over which people have little control. Undemocratic economics has fed into the rise of the post-truth world, as self-serving elites exploit people's lack of understanding of the subject. Democratising economics will be a huge step towards allowing people to input into the conversation, and create policy that is more in the interests of the general public. The economy should be something we can all feel a part of, have confidence in and take ownership of.

Labour's Fiscal Credibility Rule in Context

Simon Wren-Lewis

Introduction

Although the Labour Party's Economic Advisory Council only met a few times, it did help produce one important result: Labour's fiscal credibility rule (FCR). (The Council discussed rather than created policy, and the rule was devised by the Shadow Chancellor's office after a discussion with the Council in consultation with some of the Council's members.) In this chapter I want to place the rule in the context of both mainstream theory, and also a more modern school of thought called modern monetary theory, or MMT for short. I also want to talk about how the media almost unanimously failed to understand what made the new rule unique and radically different from earlier fiscal rules. To understand all this it is helpful to start with a bit of history on the macroeconomics of fiscal policy.

Historical Background

When I first studied economics as an undergraduate in the early 1970s, there was a huge debate going on between Keynesian and monetarist economists. In an important sense these labels were misleading, because both schools accepted the basic idea that the economy needed to be regulated to moderate booms and recessions. Monetarists accepted broadly the same intellectual framework as Keynesians in understanding how the economy worked:

the framework developed from that outlined in Keynes's *General Theory* published in 1936.

The key difference between the two schools was over which instrument was better at regulating the economy: monetary or fiscal policy. In this sense it is more accurate to describe the two schools as monetarists and fiscalists. Monetarists had an additional belief, which was that policy was best conducted by setting targets for the money supply. If this was done, they argued, the economy would largely regulate itself.

Monetarists both won and lost this battle. They won in the sense that macroeconomists began to believe that changing interest rates was a better way to regulate the economy than changing taxes or government spending. One of the reasons this happened was the collapse of the Bretton Woods system of fixed exchange rates in 1971. With the freely floating exchange rates that the UK now has, monetary policy can exert a strong and immediate influence on the economy through its impact on exchange rates. Monetarists lost, however, in the sense that money supply targets were tried in both the UK and the US in the early 1980s, and in both cases these experiments failed dramatically.

From the mid-1980s until the Global Financial Crisis (GFC), a new international consensus emerged about how to regulate the macroeconomy. I've called it a 'Consensus Assignment' because it assigns each instrument of policy to a specific task.[1] Independent central banks should control inflation and aggregate demand by varying short-term interest rates. Governments were charged with using fiscal policy to manage the amount of government debt. It was believed that central banks were better at monetary policy than politicians because politicians would be tempted to change interest rates for political as well as economic advantage.

This Consensus Assignment endured for so long because, on the monetary policy side, it appeared to be very successful. The inflation rate, which had reached double figures in the 1970s, now stabilised at the target set by most central banks of 2 per cent. The business cycle, booms and recessions, also seemed to

become more moderate. The fiscal part of the consensus fared less well, however. In many countries (not all, and in particular not the UK) government debt rose steadily over time. Governments seemed less good at controlling their own debt than independent central banks were at controlling the macro-economy. This problem became known as 'deficit bias'.

It might seem intuitive that steadily rising government debt as a proportion of GDP is a problem, but in many cases this intu-ition is based on an erroneous belief that a government is like a household. One obvious difference is that governments 'live forever', so there is not the same necessity to run down debts at some point as there is with households. Another difference is that the government's debt, if it is domestically owned, is money the country owes itself. If government debt increases, someone (or some institution like a pension fund) that holds this debt has an asset that is part of their wealth.

Nevertheless, mainstream economists have identified three main problems with ever-rising government debt. First, it could represent the current generation taking income from later gener-ations. Second, to the extent that governments had to raise long-term interest rates to sell this extra debt, this could crowd out private capital and reduce the supply of output. Finally, higher debt requires higher taxes to service it, and these taxes would discourage labour supply, and therefore also reduce output. (It could, in extreme circumstances, encourage a government to default.) A key point to note is that all these problems are long-term, influencing future generations and supply rather than short-term output and demand.

The response of governments to deficit bias was twofold. First, fiscal rules were set up to try and avoid ever-increasing govern-ment debt to GDP. Second and rather later, fiscal councils (inde-pendent fiscal institutions) like the Office for Budget Responsibility (OBR) were established to provide an independ-ent check on what the government was doing. Together rules and institutions were designed to eliminate deficit bias.

The Global Financial Crisis

You will often hear people say that the GFC was a consequence of this Consensus Assignment. I do not buy this story. In my view the GFC was the result of excessive exuberance in the financial sector, which in the US and the UK lent more and more relative to the capital in the sector. As this capital was the buffer for banks when things went wrong, it made the whole sector vulnerable to any shocks. The GFC was the result of inadequate regulation, not successful macroeconomic policy. It is true that the relatively calm period before the GFC may have encouraged excessive risk taking, but we should not have to suffer a volatile economy for the sake of inhibiting the banking sector.

However, the GFC did expose what turned out to be the Achilles heel in the Consensus Assignment. If the economy was hit by a large negative shock like a financial crisis, nominal interest rates hit what is sometimes called the zero lower bound (ZLB): a level that central banks think is as low as they can go. Any lower and people would start having to pay to hold money in a bank, and they might react by holding cash instead rather than spending more. The ZLB problem is very similar to the 'liquidity trap' problem discussed by Keynes.

This blows the Consensus Assignment out of the water. If rates are stuck at the ZLB and the economy is in recession, monetary policy can do little to encourage a quick recovery. Governments in the US, the UK and even Germany realised what this meant in 2009. Fiscal policy had to take monetary policy's place in stabilising the economy. We had fiscal stimulus in all three countries, and this stimulus was also backed by the IMF.

However, this use of fiscal stimulus was opposed by two important groups. The first, which included the then governor of the Bank of England, Mervyn King, wanted to cling to the Consensus Assignment. They argued that new instruments of monetary policy, like quantitative easing (QE), could stand in for lower short-term interest rates. This was patently absurd once we recognise that reliability of impact is a key feature of a good

instrument. QE was completely untested, and therefore not reliable at all. The Bank of England had little idea what impact it would have.

The second group were politicians from the right. In both the UK and the US they opposed fiscal stimulus in 2009, and when they came to power in 2010 (in the US in terms of dominating Congress, in the UK as the main party in a coalition) they started imposing the opposite policy: austerity. I have talked about their motives for doing this, and the considerable harm they caused in pursuing an austerity policy, elsewhere.[2] I also talk there about how the Eurozone crisis was something that would always be limited to that area: we could never 'become like Greece', and the arguments that the markets forced austerity on us are a complete myth. (More discussion of this below.)

The result was that from 2010 onwards, policy reverted to the Consensus Assignment. In particular the media quickly adopted old habits, believing that the goal of fiscal policy was to do nothing more than reduce the government's budget deficit. It seems likely that a majority of academic economists always opposed austerity, and that this majority increased over time, but they were rarely heard in the media.[3] I coined the term 'mediamacro' for, among other things, the persuasive belief that the government was just like a household and should tighten its belt in a recession. Mediamacro is the opposite of what both first-year textbooks and state-of-the-art macroeconomics tell governments to do.

Fiscal Rules

Before the GFC, fiscal rules had been crafted to conform to the Consensus Assignment, and so were about how to adjust spending or taxes depending on the size of the government's deficit. The ZLB problem that we experienced after the GFC, and which in the UK we continue to experience after the Brexit shock, means that fiscal rules have to adapt so that fiscal stimulus can be used when we are at the ZLB. This is what Labour's FCR does,

and as far as I am aware this is the first fiscal rule to take into account the Achilles heel in the Consensus Assignment.

The FCR is based on a target for the deficit, but it contains a crucial 'knockout'. If interest rates hit their lower bound, or if the central bank says this is likely to happen, the goal of fiscal policy changes from meeting a deficit target to stimulating the economy. The aim of fiscal policy when interest rates are at their ZLB is to help the economy recover as rapidly as possible, which in effect means providing enough stimulus so that interest rates can rise above the ZLB.

This knockout will, of course, mean that the deficit increases substantially, but this is never a problem in a recession. If a country has its own currency and central bank, the markets can never force it to default by not buying its debt because the central bank can buy that debt (as has happened in large quantities as part of the QE programme). The priority in a recession is to achieve a recovery as soon as possible. If that leads to an increase in government debt which is judged too high, then that can be dealt with once the recovery has been achieved. As I noted earlier, high government debt is a problem in the long term, so dealing with it can and should wait until the economy has recovered.

This dichotomy – of dealing with the recession in the short term and debt in the longer term – is what basic macroeconomic theory suggests you should do. The key mistake the Labour government made in its last year in power and in opposition before 2015 was to suggest that policy should somehow aim to help the recovery and tackle the deficit at the same time. (Remember, 'too far, too fast'.) The mistake should be obvious: dealing with the deficit stops you helping the recovery, and indeed can make a recession worse.

If the FCR had been in operation in 2010, we would have seen further stimulus in this and perhaps subsequent years, leading to a much quicker recovery from the GFC. Instead, under austerity we had the slowest recovery for at least a century. If the FCR had been in place this would have meant a higher deficit, but it is less clear that the debt-to-GDP ratio would have

increased relative to what actually happened, because GDP growth would have been much stronger. However, it does not matter whether the debt-to-GDP ratio increases or not in the short term: the increase in debt can be dealt with once interest rates move above their ZLB.

Once the recovery is assured and interest rates begin to rise, the knockout for the FCR ends and we go back to a deficit target. That target may need to be modified in the light of the increase in debt, but even if this means a tight, contractionary fiscal policy, it will not mean an increase in unemployment because interest rates can be cut to offset its impact. This is the key reason why austerity (fiscal consolidation at the ZLB) is such a foolish thing to do: you are taking demand out of the economy at the exact time that monetary policy cannot offset the impact on output.

There are other laudable features of the FCR, but the ZLB knockout is what makes it unique, and brings it up to date with current macroeconomic thinking. Yet for those who are stuck with a Consensus Assignment view, it seems unimportant: I heard one journalist describe the knockout as a 'loophole'. That is a strange way to describe a mechanism that would have ensured a rapid recovery from the GFC, but I fear it is typical of mediamacro.

Modern Monetary Theory

MMT is a new macroeconomic school of thought. It is quite rich in its scope, so I cannot do justice to it here. Instead I want to give my own interpretation of how its views on fiscal policy relate to mainstream macroeconomic thought, and in particular to the Consensus Assignment.

One of the merits of MMT is that it stresses that, for an economy like the UK with its own currency and central bank (and where the government borrows in its own currency), a government can always fund its spending by creating its own currency. It does not need to borrow from the markets, so the markets

cannot exert some kind of veto power on the size of the government's deficit.

The euro crisis happened because individual member countries did not have their own currency or central bank, and in addition the European Central Bank (ECB) initially refused to fill the gap when markets failed to lend more to Greece and other periphery countries. The crisis ended in September 2012 when the ECB changed its policy through its OMT programme. In this vital sense, the UK could never become like Greece.

So what stops a government increasing its spending by creating more money? MMT acknowledges that there is a constraint, which is inflation. If you create too much money during a recession, demand will exceed supply and prices will rise. But that will not happen when supply is greater than demand, as it is in a recession. In that situation there is no need to worry about printing too much money.[4]

My first problem with MMT is that these ideas are not new. They have, in fact, been a basic part of mainstream theory since Keynes. It is why no economics textbook will tell you to embark on austerity when the economy needs to recover from a recession. In particular, Keynes talked about why an expansionary fiscal policy was necessary in what he called a liquidity trap, which is very similar to being at the ZLB. I have already argued that the majority of mainstream academic economists were against austerity, and this is one reason why.

I suspect the real reason MMT gained so much popularity is that the majority opinion of academic economists was rarely heard in the media. Instead the media often looked to economists in the City, who tend to be more politically oriented and had a vested interest in talking up any threat from the markets. Unfortunately, this often included governors of central banks. In addition, too many political commentators with no economics background assumed that governments were just like a household, and could, in Cameron's words, 'max out their credit cards'. Mediamacro was crucial in reinforcing the need for austerity in the popular imagination.

There is, however, an important difference between MMT and mainstream macro, and that concerns the Consensus Assignment. MMT does not advocate using interest rates to control demand and inflation, stating that fiscal policy should be used instead. In that sense it is a throwback to the 1950s and 1960s, and the Keynesians who used to battle the monetarists.[5]

If governments were using fiscal policy rather than monetary policy to regulate demand, there would be no need for fiscal rules related to the deficit, and no deficit bias. Fiscal policy would be whatever it needed to be to regulate demand and ensure inflation reached its target. To say that MMT opposes fiscal rules is rather to miss the point. MMT opposes the whole Consensus Assignment even when interest rates are nowhere near the ZLB, which includes opposing independent central banks varying interest rates to manage demand. Fiscal rules are just one part of the Consensus Assignment that they oppose.

For better or worse, Labour and the Shadow Chancellor John McDonnell have chosen to work within the Consensus Assignment framework. What they have done is deal with its Achilles heel by bringing fiscal rules up to date.

Mediamacro and the FCR

Labour's 2017 election manifesto involved a balanced budget increase in current government spending, which means that all its non-investment spending increases were matched by tax increases. (Investment spending is not part of the main FCR target, and substantial increases in public investment were also part of the manifesto.) At the time of the election, the UK had returned to interest rates being at their ZLB as a result of the Brexit vote. That meant that, according to the FCR, in theory Labour's spending increases did not need to be matched by tax increases, as the priority should be a fiscal stimulus to get interest rates above the ZLB.

That the Labour team chose not to present a manifesto that increased the current deficit was a sensible choice, even though

they could have done otherwise and stayed within their FCR. As I have already noted, the media generally has a blind spot on this issue, and a few weeks was not time for a serious re-education programme. On a more practical level, interest rates could easily rise above the ZLB in the five years after 2017, and covering this would have been too much for the media to handle.

Nevertheless the Labour manifesto was strongly criticised, based on Institute for Fiscal Studies (IFS) analysis which said that their calculations did not add up. The political impact of this criticism was completely blunted, however, by the fact that the Conservative manifesto was completely uncosted. However, the overall reaction still reflected what I have called mediamacro: a focus on the role of fiscal policy in terms of the impact on the deficit, even though this would have been (initially at least) completely inappropriate because interest rates are at their lower bound.

Let us suppose the IFS was correct, and the tax measures outlined by Labour were insufficient to match their proposed spending increases. There were two possibilities. First, and the most likely given the Brexit slowdown, interest rates would have remained at their lower bound. In that case the FCR would have said that the resulting fiscal stimulus was entirely appropriate and welcome. The fact that the numbers 'did not add up' would have been a welcome feature of Labour's manifesto, because it would add to the fiscal stimulus. Second, if despite everything the economy suddenly recovered strongly, the deficit would fall as a result and Labour may well have been able to fund all the spending increases and still stay within the FCR. As a result, the fact that the numbers might not have added up was largely irrelevant, and yet it was a central theme for mediamacro.

At some point in the next five years there will be a general election which Labour have an excellent chance of winning. Their fiscal decisions will be guided by a fiscal rule that would not have given us 2010 austerity, and represents state-of-the-art macroeconomic thinking. But if Brexit goes ahead and we leave the single market, the UK is likely to remain a depressed economy

with low interest rates, and highly vulnerable to negative shocks. As if that were not bad enough, Labour will also face a media that seems incapable of thinking of fiscal policy as anything more than just good housekeeping, and which has not understood how large a mistake austerity was.

Rising to the Challenge of Tax Avoidance

Prem Sikka

Tax revenues are the lifeblood of all democracies. Without these, no state can alleviate poverty or provide healthcare, education, security, transport, pensions and public goods that are necessary for all civilised societies. Tax revenues provide the resources enabling the state to rescue distressed banks and other businesses, and to subsidise business activities. Yet tax revenues are under relentless attack from wealthy elites and large and small corporations. They are supported by a tax avoidance industry dominated by financial experts and accountancy and law firms. The tax avoidance industry employs thousands of individuals for the sole purpose of undermining tax laws, which does not create any social value but enables corporations and wealthy elites to dodge corporate tax, capital gains tax, income tax, inhcritance tax, National Insurance contributions, value added tax (VAT) and anything else that might enable governments to improve the quality of life.

The visible hand of tax avoidance is highlighted by the Panama Papers, leaks from Luxembourg (LuxLeaks) and information provided by whistleblowers about the practices of HSBC's Swiss operations.[1] People may elect governments to make investment in social infrastructure and enhance social rights, but the tax avoidance industry is able to veto such choices by ensuring that governments will not have the necessary resources to fulfil democratic choices. The neoliberal belief that reducing headline tax rates will somehow eliminate tax avoidance impulses has been

shown to be false. The corporation tax rate has been reduced from 52 per cent in 1973 to 19 per cent in 2017, and the top marginal rate of income tax has declined from 83 per cent in 1974/5 to 45 per cent in 2017, but this has not checked the appetite for tax avoidance and evasion.

Tackling tax avoidance and evasion is one of the major social and political issues of our times. A fuller analysis of numerous tax avoidance strategies and possible regulatory responses would require several books and an army of analysts. This chapter's modest aim is to draw attention to some key policy issues which can enable governments to begin the vital task of shackling organised tax avoidance. What follows is organised in three sections. The first section draws attention to some estimates of the leakage of tax revenues, as the losses pose challenges to the ability of any elected government to meet its democratically agreed mandate. The second section sketches out some of the policies that can be used to address the challenges arising from tax avoidance and evasion and safeguard tax revenues. These include an effective, robust and well-resourced Her Majesty's Revenue and Customs (HMRC), reform of the current system of corporate taxation, measures to shackle the tax avoidance industry, abolition of tax relief on interest payments, the intro- duction of a withholding tax, reform of capital gains tax and an investigation of tax reliefs given for selected expenditures. The third section concludes the chapter with a summary and discussion.

Leakage of Tax Revenues

The exact amounts of taxes avoided/evaded are hard to know as those engaged in such practices do not voluntarily provide infor- mation. HMRC estimates that around £36 billion in tax revenues a year remain uncollected due to avoidance, evasion and other reasons.[2] Inevitably, there are difficulties in estimating such numbers. For example, there is a considerable amount of fraudu- lent or perhaps misinformed behaviour on collection of VAT,

especially by online sellers. The full extent of VAT loss depends on data and assumptions embedded in economic models, but the National Audit Office estimates that the UK is losing around £1.5 billion of VAT on online sales. In September 2017, the UK House of Commons Public Accounts Committee accused Amazon and eBay of profiting from VAT evasion at the expense of taxpayers and UK businesses.[3] The extent of the cash-in-hand or shadow economy is hard to estimate and also complicates the calculations. Some small and medium-sized businesses engage in tax avoidance/evasion too, especially when much of their turn-over is in cash. HMRC states that there is a tendency to under-state turnover and overstate expenses, and many companies don't put all of their staff members through the Pay as You Earn system.[4]

In short, there are methodological problems in estimating leakage of tax revenues. Non-HMRC studies have estimated tax revenue losses at between £58.6 billion and £122 billion a year.[5] Even these estimates are likely to understate the leakage of tax revenues as they do not take account of the profits shifted by corporations from the UK to low/no-tax jurisdictions through complex corporate structures and artificial transactions relating to interest payments on intragroup loans, royalty payments, management fees and other dubious practices. It is estimated that between 2013 and 2015, EU states lost around €5.4 billion of corporate tax revenues due to profit shifting by just two global corporations – Google and Facebook – routing their transactions through Ireland and Luxembourg.[6] Such practices have been highlighted in reports by the UK House of Commons Public Accounts Committee,[7] but have drawn little effective response from the government.

Rising to the Challenges

Tackling tax avoidance requires effective institutions, resources, laws and vigilance. There are no magic bullets and a multi-pronged approach focusing on a number of different areas is

needed. This section sketches out a number of key reforms that have the potential to tackle organised tax avoidance and evasion.

AN EFFECTIVE AND WELL-RESOURCED HMRC

HMRC is facing some of the world's biggest corporations and a rampant tax avoidance industry. Tax avoidance is a lucrative part of their business models. At accountancy and law firms, staff are frequently trained and incentivised to develop and market novel schemes to reduce tax obligations of their clients. Complex corporate structures and secrecy provided by low/no-tax jurisdictions add extra layers of complexity and opacity to obstruct the pursuit of tax avoiders. The large amounts at stake demand that HMRC responds by mounting speedy investigations and test cases. The test cases, if successful, can destroy avoidance schemes and safeguard tax revenues. In the event that test cases are unsuccessful, parliament can enact new laws to address deficiencies.

Tax enforcement requires effective organisational structures, technology and human resources. In April 2005, HMRC had 104,670 members of staff and offices in most major towns and cities to enable it to interact with local businesses and traders, not only to provide assistance but also to build a picture of local economies and unusual practices. By April 2017, the staff numbers declined to 61,800 and most local tax offices have been replaced by regional hubs and call centres, far removed from local economies. For the same period, despite inflation, the HMRC financial budget declined from £4.4 billion to £3.8 billion, a huge real-terms reduction. The consequences are evident in HMRC's capacities. In February 2016, HMRC had eighty-two specialists to investigate the transfer-pricing practices of all companies, and an average investigation took about 28.8 months.[8] An investigation into just one major company (e.g. Google or Goldman Sachs) can tie down between ten and thirty specialists for twenty-two months on average, leaving little time for other things. In contrast, the big four accounting firms alone had four times as many transfer-pricing specialists.[9] HMRC executives told the Public Accounts Committee that only about

thirty-five wealthy individuals are investigated for tax evasion each year.[10]

HMRC has been colonised by individuals closely connected with corporations. Despite the hearings by the Public Accounts Committee and voluminous disclosures in the media, HMRC mounted only eleven prosecutions for offshore tax evasion between 2010 and 2015,[11] and none of these related to any large corporation or accountants/lawyers advising them. Due to secrecy around the affairs of large companies the Public Accounts Committee has been unable to investigate the alleged sweetheart deals between HMRC and large corporations.

The next Labour government will need to provide additional resources and improve the operations and accountability of HMRC. It will have to change the structure of HMRC by creating a supervisory board so that stakeholders can scrutinise its policies and practices.[12]

REFORM OF CORPORATE TAXATION

The current system of taxing corporations is dysfunctional and it is too easy for many to avoid taxes. The current system is the residue of numerous international treaties, court cases and protocols, some more than a century old.[13] It needs to be replaced. A way forward is offered by the Common Consolidated Corporate Tax Base (CCCTB) system advocated by the European Union.[14]

Three aspects of the current system stand out. First, at a time when Western nations ruled vast tracts of the globe, it was agreed that corporate profits would be taxed at the place of corporate residence rather than where the economic activity took place. At that time, major companies were headquartered mostly in the Western world and the residence basis enabled Western countries to deprive colonised countries of tax revenues. This is now highly problematical as corporations have economic activity in the UK but are nominally controlled from elsewhere, often a low/no-tax jurisdiction, and avoid paying taxes in the UK.

Second, under various treaties – even though companies may be under common ownership, control and strategic direction

– they were to be taxed as separate entities. Thus a company with one hundred subsidiaries can be treated as one hundred separate entities for tax purposes. This gives companies enormous scope to shift profits and reduce their tax obligations. They play one country off against another and large proportions of corporate profits escape taxes altogether.

Third, the authority of any nation state is confined to its defined geographical boundary, but corporations roam the world in search of profits and their operations are often integrated. Their subsidiaries in far-flung places are part of an integrated supply chain, or perform finance, purchasing and marketing functions. The big question concerns the proportion of corporate profits that can be attributed to each country so that they can then tax the companies to raise revenues. The solution, in the early twentieth century, was to agree on what is known as transfer pricing. All intragroup transactions were to be valued at what the Organisation for Economic Cooperation and Development (OECD) calls the 'arm's length' principle, or free-market market prices, to estimate profit made in each country. This system is now broken, as arm's length transfer prices are hard to find in the era of monopoly capitalism.[15] For example, just ten corporations control 55 per cent of the global trade in pharmaceuticals, 67 per cent of the trade in seeds and fertilisers and 66 per cent of the global biotechnology industry. Companies play creative games to dodge taxes, and resolving transfer-pricing disputes is costly for both companies and tax authorities.

The EU proposals for a CCCTB go some way towards addressing the fault lines outlined above.[16] Under this, a group of companies (say Apple, Google or Microsoft) would be treated as a single integrated entity regardless of the number of subsidiaries, as they have a common business strategy, board, control, shareholders, etc. A CCCTB would focus on a company's global consolidated profit, which essentially arises from transactions with the outside world. This means that most intragroup transactions would be ignored for tax purposes because they add little or no value. The global profit of the company would be allocated to each country by using an apportionment formula based on

key drivers of profit generation. These may be the number of employees and payroll costs in each country, and assets and sales activity. Each country can then tax its share of profits in accordance with its laws.

This is not a magic solution to the deep-seated problems of capitalism, but has a number of strong points. Corporate taxation would still be based on profits. As intragroup transfers are eliminated in the calculation of consolidated profits, all profits shifted to tax havens are ignored. Thus, profits cannot easily escape taxation. CCCTB does not impair the mobility of capital. For example, if a company wishes to seek economic advantage by exploiting factors of production in an emerging economy, it can do so. There would be no point in tax arbitrage through tax havens because those activities would not have any material effect on its global profits. CCCTB and its variants could be applied with global or regional (EU) agreements. It could also be applied by nation states unilaterally, which could insist on negating the effects of intragroup transactions. A future Labour government should support CCCTB.

TACKLE THE TAX AVOIDANCE INDUSTRY

The UK is home to a global tax avoidance industry led by big firms of accountants, lawyers and financial experts. In 2013, the big four accounting firms (PricewaterhouseCoopers (PwC), Deloitte and Touche, KPMG and Ernst & Young) became the subject of a hearing into their tax avoidance practices by the UK House of Commons Committee of Public Accounts. Just before the hearing the committee received evidence from a former senior PwC employee:

> I have talked to somebody who works in PwC, and what they say is that you will approve a tax product if there is a 24 per cent chance – a one-in-four chance – of it being upheld. That means that you are offering schemes to your clients – knowingly marketing these schemes – where you have judged there is a 75 per cent risk of it then being deemed unlawful.[17]

The other three firms admitted to 'selling schemes that they consider only to have a 50 per cent chance of being upheld in court'.

PwC is credited with developing Ireland as a tax haven and particularly with refining a scheme known as the Double Irish Dutch Sandwich.[18] The scheme uses complex corporate structures to exploit tax treaties, tax rate differentials and global tax systems. The essence of the technique is to shift profits to low/ no-tax jurisdictions through royalty payments for the use of intellectual property, transfer-pricing techniques, intragroup loans and other internal transactions. Variants of the Double Irish have enabled companies such as Apple, Facebook, Google, Intel, LinkedIn and Microsoft to avoid corporate taxes.

The fingerprints of the tax avoidance industry and the big four accountancy firms in particular are all over recent scandals such as the Panama Papers, HSBC Leaks and Luxembourg Leaks. On a number of occasions HMRC has challenged the schemes crafted by leading players in the tax avoidance industry, and the schemes have been declared as unlawful by the courts.[19] Despite the strong court judgments, no accountancy firms have been disciplined, investigated, prosecuted or fined.

In their capacity as auditors, big accounting firms continue to abuse their position. They design and implement tax avoidance schemes for their audit clients, and then claim that they have somehow reported objectively and independently on company financial statements. Here are a couple of examples.

The case *of Iliffe News and Media Ltd & Ors v Revenue & Customs* [2012] UKFTT 696 (TC) (1 November 2012) reported that Ernst & Young devised a tax avoidance scheme for its audit client. The company owned a number of newspaper titles and was advised to treat its mastheads as a new asset. These were all transferred to the parent company for a nominal sum, and then immediately leased back to the subsidiaries for annual royalties. Over a five-year period, the subsidiaries paid royalties of £51.6 million and sought tax relief, which was rejected by the tax tribunal. In the case of *Greene King Plc & Anor v Revenue and Customs*

[2014] UKUT 178 (TCC) (22 April 2014), another Ernst & Young scheme involved intragroup loans and a series of complex transactions to enable one company to secure tax relief on interest payments while another company would avoid tax on the receipt of the same income. The scheme was thrown out by the courts.

There is an inevitable conflict of interests. It is hard to think of even one case where audited financial statements have provided details of any company's tax avoidance schemes. There should be a complete ban on the sale of non-auditing services by auditors to their audit clients. There should be large fines on the firms and individuals responsible for developing, marketing or implementing tax avoidance schemes. Offending firms should also face closure, and those engaged in tax avoidance should be barred from securing any publicly funded contracts. The public filing of the tax returns of large corporations and wealthy individuals, together with the tax avoidance advice received from their advisors, would add transparency and increase the potential for public opprobrium of the tax avoidance industry and its clients.

ABOLISH TAX RELIEF ON INTEREST PAYMENTS

Tax relief on interest payments for corporate debt encourages economic instability and tax avoidance. Since the 1960s, finance theory has promoted the view that the value of a firm and hence returns to shareholders can be maximised by increasing leverage.[20] The key ingredient in this is a public subsidy in the form of a tax relief on interest payments which reduces the effective cost of servicing the debt. This encourages firms to increase leverage, but reduced reliance on equity finance can create financial instability. Prior to the 2007–8 financial crash, major European banks had leverage ratios of over thirty and in some cases close to fifty.[21] Many were unable to service their debts and crashed. For example, in August 2007, Lehman Brothers had a leverage ratio of forty-four, i.e. it had £1 of equity for every £44 of debt.[22] This meant that a negative change of just over 2 per cent in the underlying asset position would make the bank technically insolvent.

Prior to its collapse, Bear Stearns had a leverage ratio of thirty-eight and little retail banking activity.[23]

Regulators now urge banks to have a higher equity base, and at the same time governments offer tax relief on interest payments, i.e. incentivise higher debt in pursuit of higher returns to shareholders. Such a state of affairs is encouraged by Section 172 of the Companies Act 2006, which requires directors to 'promote the success of the company for the benefit of its members as a whole'. Under pressure from the finance industry, bank regulators have diluted demands for a lower leverage ratio, and unsurprisingly some believe that this increases the instability of banks.[24]

Tax relief on interest payments for landlords in the buy-to-let market has pushed up property prices and shattered the dreams of many who wish to own their own home.[25] It creates instability elsewhere too. Multinational corporations such as Apple, Amazon, Dyson, Google, ICAP, Shire, Starbucks and others have used interest payments on intragroup loans to shift profits to low/no-tax jurisdictions. Boots was acquired through a leveraged buyout in 2007 by a hedge fund located in the low-tax jurisdiction of Zug, Switzerland.[26] It operated though entities in the Caymans, Luxembourg, Monaco and Gibraltar. Boots found itself with £9 billion in borrowings, more than twelve times the company's annual earnings, even though it was not entirely used in the UK. For the period 2008–13, the company claimed some £4.2 billion in tax deductions for interest payments, resulting in an estimated reduction of its tax bill of between £1.12 billion and £1.28 billion.

Boots is not an exception. From December 2006 to March 2017, Thames Water was owned by Macquarie Bank representing a consortium of institutional investors from China and Abu Dhabi. For eleven years Thames Water operated through a labyrinth of companies, with some linked to the Caymans.[27] The company has been fined for sewerage spills and for missing leak targets, but returns to Thames Water shareholders averaged 15.5 per cent to 19 per cent a year.[28] During Macquarie's ownership shareholders received £1.2 billion in dividends, but this was not

the only return. Thames Water was loaded with intragroup debt through the Caymans and other entities. Its debt increased from about £2.4 billion to £10 billion and interest payments swelled the charges to customers. For the period 2007–2015, Thames Water paid £3.186 billion in interest to other entities in the group alone. This would have been paid without the deduction of any withholding tax, and entities in the Caymans and other low/no-tax jurisdictions would have received the amounts tax-free. At the same time, Thames Water would have been able to claim a tax deduction for the interest payments. Thames Water paid about £100,000 in corporation tax for the period 2007–2016.[29]

Arqiva controls about 90 per cent of the UK's terrestrial TV transmission networks. It is owned by the Canadian Pension Plan and Macquarie through an opaque network of offshore companies. It is heavily financed by shareholder loan notes bearing an interest rate of 13–14 per cent. The audited accounts of Arqiva Group Limited for the three-year period to 30 June 2016 show sales of £2.567 billion, gross profit of £1.639 billion and operating profits of £794 million. The company made interest payments of £1.516 billion to completely wipe out taxable profit, and is presumably accumulating losses which can be offset against future profits. For the three years, holders of shareholder notes (the ultimate controllers) received £739 million, all without any withholding tax. The company has been technically insolvent for many years. In 2016, it had negative equity of £2.966 billion. In 2013, the company secured a £150 million government contract even though it had not paid any corporation tax for the previous eight years.[30]

Companies are using intragroup loans and related parties, or friendly third parties, to shift profits to low/no-tax countries. This practice has been examined by the Base Erosion Profit Shifting project undertaken by the OECD. The key OECD recommendation (known as Action 4) is a general rule that would restrict the amount of relief a group can claim for its net interest expense to a fixed percentage of the group's taxable earnings

before interest, depreciation and amortisation ('tax EBITDA') in that country.[31] The OECD recommended that countries should set the fixed ratio percentage somewhere between 10 per cent and 30 per cent. The OECD-proposed limits do not apply to interest paid to third-party lenders on loans used to fund PFI projects, subject to conditions.

The 2017 Finance Bill opted for a ceiling of 30 per cent. The rules are complex and occupy 150 pages of legislation and 489 pages of draft guidance notes. Let us see what the effect of the rules would be. The table below is an example taken from the HMRC consultation document.[32]

Fixed ratio (% of EBITDA)	30%	20%	10%
Taxable EBITDA (£m)	£600m	£600m	£600m
Net interest expense (£m)	£200m	£200m	£200m
Net allowable interest (£m	£180m	£120m	£60tm
Interest restricted (£m)	£20m	£80m	£140m

Under the 30 per cent debt cap rule, companies will still be able to secure a large amount of tax relief on interest payments. The legislation does not tackle the problems highlighted by the examples of Arqiva, Thames Water or technology companies, who will still be able to shift profits and avoid taxes.

The only effective solution to the exploitation of tax relief on interest payments is to abolish it. Ordinary individuals cannot claim tax relief on interest payments whether for the purchase of sole residence or anything else. The rationale for this is that tax relief on interest payments distorts markets, creating bubbles, unfairness and financial instability. Yet the same arguments are ignored in relation to tax relief on interest payments by businesses. The 2011 Mirrlees Review supported the call for an 'allowance for equity', which it claims equalises the tax treatment of the return on equity and debt.[33] The key idea is to provide tax relief for the imputed opportunity cost of using shareholders' funds to finance the operations of the company. Such an approach does not deal with the abuses outlined above and is also mistaken.

Tax relief for numerous costs (purchases, rent, rates, wages, plant and machinery) is given to companies for the production of goods and services, but payment of dividends and interests are distributions of profits rather than costs of producing goods or services. The state should not guarantee corporate returns.

Whether assets are financed by debt or equity is a matter of managerial risk preferences and how the returns are to be shared by various providers of finance, and for a considerable time legislation did not allow tax relief on interest payments. An early test case related to *Anglo-Continental Guano Works v Bell (Surveyor of Taxes)* (1894) 3 TC 239 and a judge stated:

> It seems to me . . . that the gains of the trade are quite independent of the question of how the capital money is found, that the gains of the trade are those which are made by legitimate trading after paying the necessary expenses which you have necessarily to incur in order to get the profits; and that you cannot for that purpose take into consideration the fact that the firm or trader has to borrow some portion of the money which is employed in the business. If you did that it would land you in very extraordinary results.

The above logic was increasingly problematised by the expansion of the banking sector, which paid interest on savings. In the case of *Farmer (Surveyor of Taxes) v Scottish North American Trust Ltd* (1912), AC 118, the judges referred to the Anglo-Continental case and said: 'It does not appear to me that the reasoning on which this decision is based can apply to a bank whose business is the borrowing and lending of money.'

Thereafter, under the influence of corporate lobbying, governments have subsidised corporate debt by granting tax relief on interest payments. There is plenty of evidence to show that corporations have abused tax relief on interest payments to dodge taxes and create instability. The relief should be ended. The only exception to this rule should be retail banking, where interest payments are the normal cost of doing business. To prevent abuse

and misuse, there should be a legally binding separation of retail and investment banking, thus ensuring that only retail banks can use the relief.

INTRODUCE A WITHHOLDING TAX

Companies and wealthy individuals have excelled at finding ways to avoid taxes. Arrangements with related parties (who are not necessarily part of the same group of companies) can be made to pay dividends, interest and ordinary business expenses to avoid taxes and enrich elites. A good example is provided by a parliamentary report on the affairs of BHS, a major UK retailer that collapsed in 2016.[34] BHS was managed by Sir Philip Green and its main shareholder was Lady Green. BHS had a number of transactions with entities that were not formally part of the BHS Group or its parent company, but were under the control of its major shareholder.

In 2005 the Arcadia Group (connected with BHS), managed by Sir Philip Green, paid a dividend of £1.3 billion. Around £1.2 billion was paid, without any withholding tax, to its main shareholder Lady Green, who is resident in Monaco. Monaco does not levy income tax. Lady Green did not pay any income tax on her dividend even though the UK infrastructure had been used to generate it. If she had been resident in the UK she would have paid around £300 million in income tax.

In 2001, BHS sold a number of its properties for £106 million to Carmen Properties Limited – a Jersey-based company controlled by Lady Green – and then immediately leased them back. Over the lifetime of the sale and leaseback agreement (2002–15), BHS paid £153 million in rents to Carmen. These rents were a tax-deductible expense in the UK and reduced the tax liabilities of BHS. In 2015, the properties were sold back to BHS for £70 million. The sale proceeds and rental income of Carmen were not taxable in Jersey and Lady Green effectively received the amounts tax-free.

In 2005, BHS rented a property from Mildenhall Holdings Limited, a company registered in Jersey. Over the years, it paid £2.7 million in rent. The rental payments generated a

tax-deductible expense for BHS, but the rental income sent to Jersey was received tax-free by Lady Green, the main beneficial owner of Mildenhall.

In 2001, BHS raised a 'subordinate bond' for £19.5 million with an 8 per cent coupon rate from Tacomer Limited, a Jersey-registered company controlled by Lady Green. In 2006, the bond was redeemed with a payment of £28.975 million. This related-party transaction gave BHS a tax deduction of £9.475 million for interest payments and a tax-free income for the same amount to Lady Green.

In July 2009, BHS engaged in an internal reorganisation. Lady Green's shareholding in BHS was sold to Taveta Investments (No. 2) Limited, a subsidiary of Taveta Limited, for £200 million. Lady Green was the ultimate owner of all of the companies in the chain and was in effect transacting with herself. The acquisition was financed with a £200 million, ten-year Eurobond with an 8 per cent coupon rate. The Eurobond was issued at the Channel Islands Stock Exchange and funded by companies controlled by Lady Green. The general rule is that UK companies making payments of interest are required to deduct a withholding tax of 20 per cent and pass it on to HMRC, but there are a number of exemptions. One of these relates to securities issued through the Channel Island Stock Exchange. It is a recognised stock exchange under Section 841 of the UK Income and Corporation Taxes Act 1988 and securities listed there enjoy exemptions from withholding tax even though they may be held by opaque companies. In a nutshell, the Channel Islands Eurobond enabled the borrower (Taveta Investments [No. 2] Limited) to make payments of interest without the withholding tax. For the period to 2015, £76,355,444 was paid in interest, which provided BHS and its parent companies with tax-deductible expenses. Lady Green received the amounts tax-free.

The above examples show that related party transactions enabled BHS to generate huge tax-deductible expenses, and at the same time its main shareholder did not pay any income tax on the receipts. Of course, it is not alone in exploiting the use of

transactions with related parties. Transactions with parties closely related to companies (e.g. directors, major shareholders, major creditors, subsidiaries, affiliates, parent companies) facilitate tax avoidance and need to be subjected to rigorous tests. They must be arm's-length transactions, and must demonstrate strong commercial substance and exchange of economic value. All interest and dividend payments to individuals and companies resident outside the UK should be subjected to a withholding tax at least equal to the basic rate of income tax. The listings on the Channel Island Stock Exchange are not subjected to rigorous related party transaction checks and its recognition should be withdrawn.

REFORM TAXATION OF CAPITAL GAINS

Currently, incomes and capital gains are taxed at different rates and that has created a wealth of opportunities for some to avoid taxes. For the tax year 2017–18, the first £11,850 of annual income for taxpayers in England, Wales and Northern Ireland is not taxed. Income between £11,851 and £46,350 is taxed at the basic rate of 20 per cent; the higher rate of 40 per cent is levied on income between £46,351 and £150,000; and the additional rate of 45 per cent is applied to income above £150,000. Scotland has its separate income tax bands in the range of 19 to 46 per cent.

The rates of capital gains tax are not synchronised with the income tax rates. Since 2016, the UK has had two separate bands for taxing capital gains and the rate depends on whether the taxable gain is from property and/or non-property assets, and whether the taxpayer pays income tax at the basic rate or at higher and additional rates. In general, gains from property (e.g. second homes, buy-to-let investments) are taxed at 18 per cent for basic-rate taxpayers and at 28 per cent for higher- and additional-rate taxpayers. Gains from non-property assets are taxed at 10 per cent for basic-rate taxpayers and at 20 per cent for higher- and additional-rate taxpayers.

Note how the rates for taxing capital gains differ from the rates applicable to income. The differentials have created opportunities

for accountants and lawyers to use their energies to convert income to capital gains, and even vice versa if the circumstances are considered to be advantageous. If wealthy individuals succeed they can pay tax at 28 per cent rather than at the marginal rate of 45 per cent.

The above opportunity for tax avoidance can be curtailed by abolishing the distinction between capital gains and income. Capital gains are windfall gains and increase the purchasing power and potential consumption of the individual. There is no qualitative difference between the two. Capital gains should be added to the individual's total income for the year and taxed at the appropriate marginal rates to reduce opportunities for avoidance.

INVESTIGATE TAX RELIEFS

Successive governments have given a large number of tax reliefs, allowances and exemptions to reduce the tax liabilities of selected businesses and individuals. Some have arisen as a result of international treaties and agreements and seek to avoid double taxation. Some exist as a matter of public policy, e.g. exempting capital gains on main residence from taxation, inheritance tax exemptions and tax relief on contributions to approved pension schemes. Some of the reliefs have arisen because of the government's desire to promote specific industry sectors and particular economic objectives. Thus, there are special regimes for farmers, creative artists, woodlands, the film industry, the oil and gas industry, non-doms and numerous others. Inevitably, some reliefs have been exploited and may even fail to achieve the assumed economic objectives. Therefore, constant scrutiny is needed.

A March 2001 study by the Office for Tax Simplification found 1,042 reliefs, allowances and exemptions.[35] It reviewed 155 and recommended that forty-seven should be abolished because they had expired, there was no longer a policy rationale, the value was negligible or the administrative burden outweighed the benefit. The National Audit Office (NAO) reported that by 2014, forty-eight reliefs had been abolished and another 134

new reliefs had been introduced.[36] By December 2013 the total number of reliefs had increased to 1,128. The reliefs have an estimated tax value of more than £117 billion.[37] The cost of tax reliefs appears to be growing at a time when public spending has declined and this alone poses a challenge with regard to the management of public finances.

The NAO noted that criminals have targeted some reliefs and that others can be abused. It provided examples of some known tax avoidance schemes that seek to circumvent parliament's intention (see pages 28–33 of the NAO's 2014 report).[38] The Public Accounts Committee noted that 'the costs of R&D tax relief increased from around £100 million in 2001 to over £1 billion in 2011–12, while the actual amount of business expenditure on R&D stayed more or less the same.'[39] The committee has also been critical of HMRC (and the government) and its evaluations of HMRC's 2015–16 performance stated that:

> Despite our repeated recommendations, HMRC still does not make tax reliefs sufficiently visible to support parliamentary scrutiny and public debate about areas where the UK chooses not to collect tax . . . While HMRC publishes cost data for 180 tax reliefs, more than many other countries, this only accounts for some 15 per cent of existing UK tax reliefs . . . it is not clear how it decides which reliefs to collect data on from taxpayers through their tax returns. HMRC still does not provide sufficient information to explain the impact that tax reliefs are having on behaviour.[40]

The failures are also echoed by the NAO, which reported that:

> Entrepreneurs' relief has risen by over 500 per cent since it was introduced in 2008–09. Costs have continually exceeded forecasts. Its estimated cost of £2.9 billion in 2013–14 is three times greater than published forecasts predicted . . . HMRC has not quantified these changes robustly or reviewed the accuracy of its forecasts.[41]

Some tax relief numbers seem to be pulled out of thin air. For example, the UK operates a retail export scheme which refunds VAT to UK visitors from outside the EU. A 2013 HMRC consultation paper slapped a figure of £300 million on this.[42] In October 2017, a Treasury minister told parliament that 'Retailers do not separately identify retail exports on their VAT returns so HMRC does not hold any record of the actual VAT refunds made', i.e. there are no meaningful data.[43]

Without good data there is no way of knowing whether tax reliefs are being abused and have become a vehicle for tax evasion, or are delivering the assumed economic benefits. The ultimate responsibility for reviewing the effectiveness of tax reliefs rests with the government, but its response has been inadequate. The government has provided some estimates but has been unable to provide a reliable estimate of the cost or even the economic benefits of a large number of tax reliefs.[44] A key task for the next Labour government should be to develop an analysis of the tax reliefs, their claimants, amounts and economic benefits.

Summary and Discussion

This chapter has sought to draw attention to the persistence of tax avoidance and evasion. It has indicated the possible size of the lost revenues, though the exact amounts are not known, and also sketched out some policies which can begin to shackle tax avoidance. These proposals are not a magic solution to the deep-seated problems of capitalism, where corporations and wealthy individuals play cat-and-mouse games with tax authorities. Therefore governments need to be extremely vigilant and robust.

Tackling tax avoidance requires a sea change in entrepreneurial culture because 'bending the rules' to make profits at almost any cost has become deeply embedded in business models. Some consider it a competitive necessity as they seek to appease markets by reporting ever-rising profits, maximise returns to shareholders and secure performance-related bonuses. Markets rarely ask

questions about the sustainability of profits generated through tax avoidance or the social consequences of such practices.

Too many corporations and wealthy individuals are addicted to tax avoidance, and those engaging in it are willing and able to pay vast sums to accountants and lawyers to develop new strategies. Indeed, the UK has become the home of a highly organised avoidance industry which faces little retribution. Even worse, the cost of hiring accountants and lawyers for such antisocial practices attracts tax relief, i.e. it is treated as a tax-deductible expense. Representatives of the tax avoidance industry have also colonised HMRC and are even permitted to write tax laws. Therefore, the next Labour government needs to develop effective institutional structures and tackle that organised tax avoidance and evasion which forces many citizens to either forgo their hard-won social rights or pay more for crumbling social infrastructure while tax avoiders get a comparatively free ride. Labour needs to win this battle because the alternative is social instability, loss of welfare rights and loss of confidence in democracy.

To Secure a Future, Britain Needs a Green New Deal

Ann Pettifor

The era of procrastination, of half measures, of soothing and baffling expedients, of delays, is coming to its close.
In its place, we are entering a period of consequences.
Winston Churchill, 12 November 1936

As this book goes to press, a range of financial bubbles plague both the British but also the global economy. These include the auto loans bubble, the student loan bubble, stock and bond market bubbles, house price bubbles and the Chinese credit bubble. But the biggest bubble of all is the carbon bubble – and when that bursts the catastrophic impact on the world will eclipse the impact of the 2007–9 financial crisis.

It may just be that the carbon bubble is already bursting, and that Hurricane Harvey is the harbinger.

In July 2017, in a doom-laden article, David Wallace-Wells reprised warnings issued by a widening range of scientific opinion – that climate change threatens the very existence of humanity in the near term:

It is, I promise, worse than you think . . . absent a significant adjustment to how billions of humans conduct their lives, parts of the Earth will likely become close to uninhabitable, and other parts horrifically inhospitable, as soon as the end of this century.[1]

On 2 August 2017, environmentalists marked Earth Overshoot Day – by which time we had used more from nature than our planet can renew in the whole year. In other words, human activities had breached the ecosystem's resource limits and boundaries. We were reminded once again that the world faces limits to the ability of the atmosphere to absorb toxic emissions generated by fossil fuels. Breaching these limits has consequences: extreme weather, floods, droughts, extreme heat and cold. Today's refugee crisis on the shores of the Mediterranean is but a precursor to the 'tens of millions of climate refugees [who will be] unleashed upon an unprepared world' by extreme weather events.[2] Couple this with humanity's careless disregard for the species on which we depend and their need for safe habitats, and we face major extinction events.

By contrast, Silicon Valley billionaires confidently assert that we can look forward to an automated future. This promise is based on the availability of limitless supplies of the 'conflict minerals' known as 'rare earth' materials that power our smartphones, cameras and GPS devices. The truth is that supplies of titanium, boron, selenium, lithium, zirconium, etc. – like all the Earth's assets – are finite.

Conflict minerals are not the only assets likely to become obsolete and periodically disrupted by war and conflict. In a remarkable speech at Lloyd's of London on 29 September 2015, the governor of the Bank of England, Mark Carney, warned the oil industry that a carbon budget consistent with a 2°C target

> would render the vast majority of reserves '*stranded*' – oil, gas and coal that will be literally unburnable without expensive carbon capture technology, which itself alters fossil fuel economics . . . a wholesale reassessment of prospects, especially if it were to occur suddenly, could potentially destabilise markets, [and] spark a pro-cyclical crystallisation of losses and a persistent tightening of financial conditions. [My emphasis]

The governor's speech was a shot across the bows of hundreds of asset managers responsible for more than US$87 trillion in

assets. The bulk of these funds is funnelled into their companies by pension funds and life insurance companies. Fund managers were warned by the governor of the Bank of England that exposure to climate change targets is a potentially huge threat to savers and investors: '19 per cent of FTSE 100 companies', the governor explained, 'are in natural resource and extraction sectors; and a further 11 per cent by value are in power utilities, chemicals, construction and industrial goods sectors. Globally, these two tiers of companies between them account for around one third of equity and fixed income assets.'

In an earlier sign of changing times and attitudes, the oil company British Petroleum changed its name to BP as it 'set its sights on newer assets and established an alternative and low carbon energy business'.

Does Britain's Finance Sector Care?

These are straws in the wind. But they are straws that are still ignored by the City of London's authorities. With a blatant disregard for Britain's climate change policy, City regulators spent August 2017 'rolling out a red carpet' for Saudi Arabia's biggest oil company, ARAMCO.[3] To accommodate Saudi's absolute monarchy they watered down stock exchange governance rules, and removed protections for investors. The reason for such spineless deregulation? To ensure ARAMCO lists its initial US$1 trillion public offering in London, rather than New York. 'Prestige, relevance, trading volumes and fees beckon,' wrote the *Financial Times*, 'if the world's largest extractor of crude oil becomes a public company late next year as planned . . . Politicians, exchange executives, lawyers and bankers all see benefits from helping the national oil champion sell stock.'[4]

So, while scientists warn the costs of continued fossil fuel extraction will be an 'uninhabitable Earth', and the Bank of England governor warns of the threat of 'stranded assets', 'politicians, exchange executives, lawyers and bankers' seek to

encourage, finance and embed Big Oil within Britain's financial and economic system.

But as reality dawns, and investment in and demand for clean energy *outpaces* investment in and demand for oil, oil companies (like ARAMCO) may soon be 'stranded' and become as extinct as the behemoths of the Old Testament. The City's investors – including those representing thousands of pensioners – will be the victims.

That is one reason among many that Britain's climate security as well as its financial security needs to be improved, and as such it is vital that a Labour government removes Britain's finance sector from its role as *master* of the British economy, and instead ensures that it is made *servant* to the transformation of the economy away from dependence on fossil fuels and financial speculation. For, as Labour's National Executive argued in a document on Full Employment and Financial Policy in 1944: 'Finance must be the servant, *and the intelligent servant* of the community and productive industry; not their stupid master' (my emphasis).

The Flawed Economic Theory and Language of Endless 'Growth'

Within nature, plants, animals and humans are seeded, or born. They mature, and then they die. Not so for an economic concept that grips the economic profession: 'growth'. Behind the concept lies an implicit assumption: that the expansion of economic activity can be, and is, limitless; that it will move relentlessly in an upward trajectory. It is a concept that drives capitalism's globalisation ambitions: the need to continually expand and disrupt new markets, lower labour costs and make capital gains – for the few – from rent-seeking and speculation.

The concept of 'growth' was adopted relatively recently by the economics profession. Its adoption served in part to dismantle the Bretton Woods economic order (a system that had led to a 'golden age' in economics) in 1971, and to facilitate the globalisation and financialisation of economies.

In an essay, 'The National Accounts, GDP and the "Growthmen"',[5] Geoff Tily, the TUC's chief economist, explains that the concept evolved as recently as 1961. OECD technocrats were encouraged by economists, like *Financial Times* columnist Samuel Brittan, to promote policies that would turbocharge the economy. At the time, Britain was in the happy position of providing full employment to her people. Macmillan's 1957 comment that Britons 'had never had it so good' still rang true. The 'growthmen', as they called themselves, were nevertheless discouraged by these high, sustainable levels of employment and economic activity. It is my view that they were frustrated because profits made in the 'real' economy were not as high as the *capital gains* that could be made through financial speculation. The question was: how to turbocharge profits? The answer: accelerate 'growth'.

Samuel Brittan's *The Treasury under the Tories, 1951–1964* reads like a manifesto for the 'growthmen'.[6] He records that the Organisation for European Economic Cooperation became the OECD on 30 September 1961; on 17 November, the OECD agreed a 50 per cent growth target for 1960–70 – a rate of change of a continuous function. This target was to be applied to Britain.

At about the same time, on 12 September 1961 the Council of the OECD adopted their Code for Liberalisation of Capital Movements, presumably intended to fuel the ambition of rapid and relentless 'growth', regardless of the extent of capacity in the labour market. The result? High rates of inflation (often blamed on trades unions), but also, and in the broadest sense, intensified exploitation of the Earth's finite assets in order to achieve 'growth' targets. The consequence was 'globalisation' – the financialisation of the global economy. This in turn led to rises in global production and consumption – and in toxic greenhouse gas emissions.

The Good News

Big business is waking up to the threat posed by climate change to future economic security. Clean energy investment (excluding

nuclear and hydro) rose from about US$60 billion per annum in 2004 to hit a record of US$349 billion in 2015. At the same time, clean-energy prices plummeted around the world. Although investment in clean energy fell in 2016, the number of renewable energy installations rose by 9 per cent.

China is now leading the world and the Asian region by expanding investment in clean energy. Thanks largely to Chinese production, solar PV modules costs have fallen – by 99 per cent since 1976. Wind energy costs are down by 50 per cent since 2009. Nuclear energy now costs about US$140 per kilowatt hour as opposed to wind energy costs of just US$34 per kilowatt hour, according to Bloomberg's Michael Liebreich, and the costs of maintaining clean energy installations are much lower than those of dirty fuels.[7] The efficiency of cars has improved substantially over the last eight years, and will improve further as electric cars gain a foothold in the market. A car is no longer the status symbol it once was. If more is done by way of city planning to facilitate walking, biking, carpooling, trains and buses, then reliance on cars will diminish further. The growth of energy efficiency in lighting has also been dramatic. LED lighting uses 90 per cent less energy than traditional incandescent bulbs and has the potential to transform lighting systems around the world.

As a result of these developments, the global energy sector is at a tipping point – potentially an 'accelerating non-linear transition'.[8] This is occurring as public opinion moves towards a greater understanding of the climate change threat. Despite much disinformation, including from President Trump, a Gallup poll shows that 68 per cent of the American public now believe that climate change is down to human activity.[9] In Britain 64 per cent believe that this is the case.[10] China's leaders have declared a 'war against pollution' in big cities, because pollution poses a grave threat to social and political stability. Two-thirds of China's new energy capacity in 2015 was in renewable energy. In India solar power is now cheaper than coal. In an extraordinary campaign to rid the country of nuclear

power, Germans have saturated rooftops with solar power, while expanding thermal power.[11]

While Britain will benefit from the move towards alternative and more efficient energy sources, there is one area in which progress has not been made: in space heating. One of the biggest challenges a Labour government will face stems from the poor thermal performance of Britain's old housing stock.

There are about 27 million households in the UK with a wide range of properties, most dating back to the Victorian era. This has led to a legacy of some of the least thermally efficient housing in Europe. The UK ranked eleventh out of fifteen European countries in terms of housing energy performance; and the UK had the highest proportion of households in fuel poverty of all the fifteen countries assessed. Fuel poverty levels are rising, partly because of pressures on household incomes, but also because of rising energy prices.[12] The level of fuel poverty is highest in the private rented sector (21.3 per cent of households) compared to those in owner-occupied properties (7.4 per cent).[13]

Mobilising a 'Carbon Army'

However, while the state of the housing stock will make it a challenge to meet carbon reduction targets, it is also a great opportunity. To address this challenge will require the devolution of energy, as argued in Labour's manifesto: 'Protecting Our Planet'.[14] We argue that Labour should go further, and ensure that *every one* of Britain's 27 million households becomes a power station, so that energy efficiency is maximised.

To achieve this goal will not only require sound scientific advances and data, but also appropriate materials and equipment – much of which is available or can be constructed in Britain. Above all, retrofitting Britain's housing stock and making it energy secure will require the recruitment and training of a 'Carbon Army' – an army of highly qualified, skilled and unskilled workers to undertake a vast environmental

reconstruction programme: because a 'just transition' to a decarbonised economy will be a labour-intensive transition.[15]

The training and recruitment of a high-skilled, well-paid 'Carbon Army' must be part of a wider shift from an economy narrowly focused on financial services, and on low-productivity, low-paid, insecure jobs, to one that expands productive activity and is an engine of environmental transformation.

Furthermore, the establishment of such a 'Carbon Army' via both public and private investment would, in effect, pay for itself, as I argue below. A report by Cambridge Econometrics and Verco concludes that the economic case for making the energy efficiency of the UK housing stock a national infrastructure priority is strong.[16] In addition to making all low-income households highly energy efficient, and reducing the level of fuel poverty, their modelling has established that this energy efficiency programme would deliver:

- £3.20 returned through increased GDP per £1 invested by government;
- 0.6 per cent relative GDP improvement by 2030, increasing annual GDP in that year by £13.9 billion;
- £1.27 in tax revenues per £1 of government investment, through increased economic activity, such that the scheme pays for itself by 2024, and generates net revenue for government thereafter;
- 2.27:1 cost–benefit ratio (value for money), which would classify this as a high-value-for-money infrastructure programme;
- Increased employment by up to 108,000 net jobs per annum over the period 2020–30, mostly in the service and construction sectors. These jobs would be spread across every region and constituency of the UK.

That is the strong economic case for mobilising a 'Carbon Army' to achieve both climate security and poverty reduction.

How Can Labour Finance the Transformation of the Economy?

To kick-start investment in the Green New Deal will require the next Labour government – in cooperation with the monetary authorities, the Bank of England, the Treasury and the Debt Management Office (DMO) – to sell valuable assets in the government's possession. Thanks to the founding of the Bank of England in 1694, and ever since then, British governments have not had to resort to taxation to finance investment and spending. Instead finance has been raised by the sale of public assets backed by Britain's 31 million taxpayers. These are known as government gilts or bonds. These government assets are in great demand because governments like Britain with sound tax-collection systems and strong institutions are regarded as the safest destination for investors – both individual investors, and big institutional investors such as insurance companies and those that manage pension funds.

The sale of gilts has served as the time-honoured way in which governments have financed wars, infrastructure, spending and, recently, private bank bailouts. Given the security threat that climate change threatens, financing the Green New Deal should be undertaken in the same way, and with the same urgency as the financing of a war to defend the nation's security.

If the finance so raised is used to invest in productive activity that leads to skilled, well-paid employment in both infrastructure and services, then the 'multiplier' will kick in. Employees will pay taxes – for all the years of employment. Years of tax-paying employment will mean that returns to the Treasury (via HMRC) will ensure the investment will pay for itself. Once employed, and by spending on housing, food and clothing, employees will increase government tax revenues (e.g. VAT) from firms and other sources. Profitable firms will pay higher corporation tax, and so on. In other words, the investment in full employment will not only generate tax revenues from the employed, but will also 'multiply' tax revenues from other

sources. These higher tax revenues can then be used to pay down the public debt associated with the gilts or bonds issued to finance the Green New Deal.

Indeed, only full employment can balance the government's budget. 'Look after employment', the great John Maynard Keynes once said, 'and the budget will look after itself'.

What Will the Green New Deal Cost?

Estimates suggests that to implement the Green New Deal would cost, at the minimum, about £40 billion a year, for many years. This level of investment would help finance the transformation to sustainable energy sources and transport, to retrofit the housing stock and for flood protection. In 2016/17 public investment was approximately £73 billion gross (about 4 per cent of GDP). If this was raised by £40 billion – to £115 billion a year gross (or about 6 per cent of GDP) – this would be comparable to the mid-Thatcher years (1984–5) when gross investment was 6 per cent of GDP. Raising public investment to this level would place Britain in line with Germany and the US, where current levels of public investment are at 6 per cent of GDP.

In other words, governments have invested at this rate before, and can do it again.

Is There No Money?

'But . . . but', says the reader, 'I'm afraid there's no money.' So wrote Liam Byrne MP, in a note for his successor on leaving the Treasury on 6 April 2010. Byrne was doing no more than echoing Mrs Thatcher, who in a speech to Conservative Party Conference in October 1983 said:

> The state has no source of money, other than the money people earn themselves. If the state wishes to spend more it can only do so by borrowing your savings, or by taxing you more. And

it's no good thinking that someone else will pay. That someone else is you . . .

There is no such thing as public money.

There is only taxpayers' money.

Her flawed understanding of the public finances was subsequently echoed by David Cameron on the campaign trail, on 6 April 2015: 'We know that there is no such thing as public money – there is only taxpayers' money'.

The belief that all spending is financed from taxation, that the government has no other source of financing, and that like a household, it has, under all circumstances, to 'balance its books' between expenditure and tax income, is flawed economic theory. Governments are not like households, and have other sources of finance. The Treasury, working closely with the monetary authorities, could finance the Green New Deal without having recourse to tax revenues. In fact, tax revenues (from, for example, increased employment) would be a *consequence*, not a *source*, of government investment.

Mrs Thatcher's flawed economic ideas are tacitly supported by professional and academic economists, including those at the Treasury, the Office for Budget Responsibility and the Institute for Fiscal Studies. The theory was adopted wholesale by politicians from across the spectrum; those who worry endlessly about 'fiscal rules' and other ways of 'cutting the debt'. It is a flawed theory that has had disastrous consequences, as witnessed by 'austerity' in Britain and Europe. It is an economic theory that has delivered a severely weakened British economy, while at the same time leading to a rise in public and private debt.

The 'fiscal black hole' that Conservatives (and the Institute for Fiscal Studies) complain of exists as a *consequence* of George Osborne's failed 'fiscal rules'. It cannot be 'fixed' without fixing the defective economic strategy based on austerity. Cutting public spending in a slump has not worked, and will not balance the budget. Instead it has weakened the already weak, post-financial crisis economy. Government policy should not be

about the *design* of fiscal rules. Instead we should ask: what fiscal policies are compatible with an economic strategy aimed at boosting national income? What fiscal policies would increase both public and private investment, employment, wages and tax revenues?

That has not been the approach since 2010. As a result, Britain has high, and still rising, levels of public and private debt. And *because of* 'austerity' the government's 'books' are not balanced. The country is excessively reliant on one leg of the economy: consumption. Britain's trade terms are dangerously out of balance with the rest of the world. The UK has one of the lowest levels of private and public investment in the OECD, and has suffered the slowest ongoing economic recovery in history. High levels of low-paid, insecure employment in low-productivity work are further weakening the economy.

As a result of these imbalances and of economic weakness, Britain has suffered social and political unrest. This was most clearly manifest in the referendum vote for Brexit.

Labour Needs a Green New Deal to Build a Sustainable, Stable Economy

If we are to secure a sustainable, stable and liveable future for the people of Britain, then implementation of the Green New Deal will be vital. Not just for the sake of the ecosystem, but also for the sake of rebuilding a stable, sustainable economy. A sustainable economy will be one dominated by a 'Carbon Army' of skilled, well-paid workers. Workers that will help substitute labour for carbon, and that through employment will generate income – income needed by households for paying down debts and buying homes; income needed by wind farmers and other environmentally innovative firms, both for profits and for investment; and tax income needed by government and local governments, to reduce public debt and finance public services.

Only implementation of the Green New Deal can ensure a more stable, more sustainable economy – one that will generate

the finance and income needed to transform the economy away from fossil fuels.

What we can do, as Keynes once argued – within the limits of our imagination, intelligence and muscle, and within the limits of both the economy and the ecosystem – we can afford.

Fair, Open and Progressive: The Roots and Reasons behind Labour's Global Trade Policy

Barry Gardiner

The UK stands at a defining moment in the history of its commercial relations with the rest of the world. The 2016 referendum decision to leave the European Union means that the UK will once again be responsible for defining its own trading relationship with other countries, including the remaining twenty-seven EU member states. As the Conservative government threatens to turn the UK into a deregulated offshore tax haven for the benefit of the few, Labour is committed to reinforcing its historical identity as a party dedicated to open markets and a fair, rules-based international trading system that delivers prosperity for the many.

Historical Roots

Labour has a long tradition of promoting an open multilateral trading system, even when this was not the dominant orthodoxy that it is today. In the early years of the twentieth century, the fledgling Labour Party rejected the arguments of Joseph Chamberlain and the Tariff Reform League that protectionism would strengthen domestic industry and result in higher wages. Instead, tariffs were dismissed as being more likely to increase the price of essential goods (especially food) and lead to the

immiseration of the already impoverished worker. The Labour Party and trade unions together confirmed this shared conviction with a series of public awareness campaigns against tariff reform across the country from September 1903.

At the same time, Labour rejected the Liberal Party's unilateral market liberalisation as an equally ineffective means of meeting the needs of working families. The historical tendency towards higher unemployment and lower wages in the later nineteenth century had undermined the strength of free trade's classic appeal to consumer interest through cheaper prices, and Labour leaders regularly condemned the undercutting of domestic labour through 'sweated' imports as yet another failure of unregulated trade. As Keir Hardie, one of the most eloquent opponents of tariff reform, told a Manchester audience in February 1909:

> The idea of the Free Trade Party to leave things to take their natural course has resulted in the production of a submerged tenth which cannot be equalled in any other country in Europe. Our people have been driven from the land to herd in the great cities, robbed of the opportunity of working for their own livelihood till they could find a market. The harrying wind of Free Trade Radicalism has swept over the nation and destroyed all that is most beautiful in our nature.[1]

This rejection of laissez-faire capitalism was a common theme across the left, even if opinions might differ as to what should replace it. Highlighting the overproduction and international antagonism inherent in free trade, Labour theorists called for a new policy of open but regulated commerce that could build peace between nations rather than further exacerbating their rivalries. As the leading historian of the Edwardian tariff reform debate describes it, 'The left's re-evaluation of Free Trade represented a watershed in the history of political economy, where progressive politics began to turn from unregulated trade to new collectivist schemes of regulation.'[2]

This commitment to regulated trade liberalisation was developed during the 1920s and 1930s, just as the Conservative Party was embracing protectionism. Labour's radical 1934 programme, *For Socialism and Peace*, pledged that the party 'would attack the disastrous economic nationalism of the present age by working for an all-round lowering of tariffs, and their substitution by a system of planned international exchange'. The drive for international planning in economic and financial affairs was presented as the corollary of planning at the national level, even if there would necessarily be tension between the two.[3]

In fact it was the postwar Labour government that was to affirm the party's belief in a rules-based international trading system with the most far-reaching impact. As well as eliminating half of all the tariff lines it inherited after the ending of hostilities, the Attlee administration persuaded the US of the benefits of a multilateral settlement to govern global trade alongside the international financial institutions already established at the 1944 Bretton Woods conference. Driven through to its conclusion by the skills and perseverance of Labour's lead negotiator, Sir Stafford Cripps, the resulting General Agreement on Tariffs and Trade would serve as the forum for multilateral trade talks until the birth of the World Trade Organisation (WTO) in 1995.[4] The Labour Party's solution to the twin dangers of protectionism and unregulated trade is rooted in the 'institutional internationalism' that created the framework for liberalisation on a reciprocal basis.

Minimising Barriers, Maximising Trade

The rationale behind Labour's support for international commerce stems from the economic benefit that trade offers working people. In an open economy such as the UK, overseas trade represents a critical source of employment: currently, exports of goods and services account for around 30 per cent of GDP, and millions of jobs depend on continued access to overseas markets. Equally, inward investment to the UK has sustained

hundreds of thousands of jobs over many decades, and remains a critical element in the country's economic success. The positive links between inward investment, innovation and productivity are well attested, as is the trade dividend: over half of all foreign-owned companies in Britain are exporters, compared with 10 per cent of UK-owned firms.[5]

Recognition of the economic benefits to be gained from trade liberalisation informed the Labour Party's 2017 manifesto commitment to minimise tariff and non-tariff barriers in all future UK trade agreements.[6] The first and most important of these agreements will be with the EU itself – an agreement unlike any other, in that it starts from the unique situation of two trading partners that have shared full harmonisation of regulations and standards within a single market and are moving to a situation of lesser rather than greater integration. Labour's demand is the same as that of all major businesses, trade unions and industry federations, namely that the UK must retain access to the single market under terms as close as possible to those we enjoyed while a member state of the EU. Leaving with no deal in place for the future is the worst option.

Upholding and enhancing our social and environmental standards will be a crucial element in the future relationship between the UK and EU. In some cases, 'new generation' free trade agreements have identified such standards as 'barriers' to trade, and negotiations have targeted them for removal or downgrading. Yet high social and environmental standards are not only important in their own right, they are essential if our businesses are to retain access to the EU market. UK exports will be denied access to the EU if they fail to meet the standards that the UK currently shares with the EU – hence the fear of regulatory divergence in the years following Brexit if no mutual recognition frameworks are put in place.

Beyond our commitment to enhancing market access for British goods and service exporters, Labour will actively promote British exports in overseas markets, including the extension of export finance and other support measures (export credits,

insurance and promotion) to actual and potential exporters. In order to ensure that the benefits of trade are shared across the country, Labour has committed to setting up a network of regional champions to promote the export and investment interests of businesses throughout the UK, and to include regional representatives on international trade missions so they can have direct access to new markets around the world.

A progressive trade and investment policy is essential for any effective industrial strategy, and vice versa. Only by having mutually beneficial relations with trading partners can we develop the modern industrial base needed to deliver decent jobs and a secure future for working people. By the same token, it is only by sustaining the necessary levels of investment in people, skills and productivity that we will be able to compete successfully on international markets. Labour will prioritise trade support to those high-productivity sectors of the economy identified for development in the industrial strategy, creating a coherent and mutually supportive relationship between the two.

In the UK context, 60 per cent of all private sector jobs are created by small and medium-sized enterprises (SMEs), and Labour has pledged to put small businesses at the heart of its economic strategy. While only 9 per cent of British SMEs are themselves engaged in exporting overseas, a further 15 per cent are integrated into the supply chains of other businesses active in export trade – meaning that one in four British SMEs are involved either directly or indirectly in exporting overseas.[7] In addition, there are many SMEs that fall into the category of potential exporters, where strategic government support could enhance their ability to break into overseas markets. Labour is committed to developing a bespoke incentive scheme to help SMEs develop their export potential, as well as requiring trading partners to include market-access opportunities for British SMEs in any new trade agreements.

More generally, once the UK has regained the competence to set its own international trade policy, we must use that competence to negotiate trade and investment agreements that will

bring genuine benefits to workers and businesses in the UK. Twenty-first-century trade agreements are about much more than the removal of tariffs on goods and the opening of markets for finished products from one country to be exported and sold in another. In today's interconnected global environment, value chains that account for some 80 per cent of international trade see raw materials and component parts cross borders numerous times to be incorporated into finished products for consumers across the world.[8] This globalisation of supply chains creates opportunities for British businesses to access global markets and for many more SMEs to participate in international trade as component or service suppliers. If managed properly, this can be a powerful engine for growth and prosperity.

The UK is primarily a services economy, with 80 per cent of all jobs now distributed across the various service sectors. In terms of the UK's balance of payments, our surplus in services trade is an essential counterweight to the large deficit in goods trade – yet trade in services still represents less than half of total UK trade by value.[9] Services have represented an essential element in trade agreements for many decades now, with a focus on removing unnecessary barriers to international participation across all modes of supply. Labour is committed to building on the liberalisation of trade in services that has already been achieved in multilateral and bilateral agreements, and to maxim-ising the opportunities that exist in emerging markets in particu-lar: the value of UK services exports to Asia saw an increase of 8.9 per cent in 2015 alone, the largest percentage growth from any continent.[10]

Labour is equally committed to ensuring that UK businesses can take full advantage of opportunities for exports of environ-mental goods, where liberalisation of trade could greatly increase the availability of green technologies such as solar panels, wind turbines, recycling machinery and other waste management tools. The environmental goods and services sector contributed an estimated £29 billion to the UK economy in terms of value added during 2014, and supported over 370,000 jobs.[11] Labour's

2017 manifesto included the commitment to back negotiations towards an Environmental Goods Agreement at the WTO, creating the potential for further expansion of UK exports at the same time as encouraging the global transition towards a low-carbon future.

Labour will also safeguard the interests of Britain's high-quality agricultural producers in future trade agreements. Uniquely among major EU member states, the Conservative government failed to promote the interests of British producers in the negotiations towards the Comprehensive Economic and Trade Agreement between the EU and Canada, which offered protection on the Canadian market for national products with geographical indications, at a comparable level to that offered in the EU. While other EU member states listed their national products for protection, the UK government failed to register a single one of the dozens of British products that qualify for protected geographical status. Labour will seek proper recognition in future trade agreements for quality products such as Scotch beef, Scotch lamb, Scottish salmon, Welsh beef, Welsh lamb and the many British cheeses, pies, pasties and other specialities designated as having protected status.

The Need for Regulation

While the potential gains from increased trade and investment are self-evident, the dangers of unregulated liberalisation must also be clear. The financial crisis of 2008 exploded once and for all the resurgent myth of the self-regulating market, and brought with it catastrophic impacts far beyond the centre of the banking collapse. Global trade experienced its steepest and deepest contraction since the Great Depression, and this became the vector which turned the financial crisis into an economic crisis through loss of industrial production in all major trading nations of the world.[12]

Regulation is not only necessary to prevent the recurrence of crisis. There is now an open consensus that globalisation produces

both winners and losers, with more and more academic studies highlighting the negative impacts of unregulated trade on jobs, wages and workers' rights. Collating the findings of these studies, a recent report from the WTO, International Monetary Fund (IMF) and World Bank acknowledged the 'harsh' consequences for those who lose their jobs as a result of import competition. The report recognises that the negative impacts of these permanent policy changes cannot be dismissed as minor transitional adjustments, as they have been in the past, given that they lead to 'long-lasting displacements as well as large earnings losses' in the sectors most affected.

The report further notes that the costs tend to fall especially hard on women and an older and less skilled workers, who can often find it more difficult to find alternative work, and that they have intergenerational impacts: 'Such long spells of unemployment also lead to worse health outcomes, higher mortality, lower achievements by children of affected workers, and other adverse consequences.'[13]

Studies of specific instances of trade liberalisation underline the social costs. As a result of the 1994 North American Free Trade Agreement, 2 million agricultural jobs were lost in Mexico and hundreds of thousands of high-paid manufacturing jobs were displaced from the US.[14] Official projections for the proposed Transatlantic Trade and Investment Partnership (TTIP) between the EU and the US suggested that at least 1 million people would lose their jobs in the resulting economic dislocation, and the European Commission acknowledged there were 'legitimate concerns' that many of those people would not find alternative sources of employment.[15] Where displaced workers do manage to find new jobs, these can often be at lower skill or wage levels: studies of US workers forced out of manufacturing into service sector jobs as a result of trade liberalisation have found that they typically experience a decline in wages of 6 per cent to 22 per cent.[16]

Those now arguing for post-Brexit Britain to regress to unilateral trade liberalisation are aware of the social and economic

devastation such a policy will cause. Professor Patrick Minford of Economists for Free Trade has acknowledged that the adoption of his preferred free trade approach would 'effectively eliminate manufacturing' in the UK, wiping out not only the 2.7 million jobs currently provided in direct industrial employment, but also many more in associated service industries.[17] Similarly, unilateral liberalisation of agricultural tariffs would expose British farmers to unequal competition from producers in other countries who are not required to meet the same high quality and animal welfare standards as pertain in the UK, with devastating consequences.[18] Agriculture currently provides direct employment to 466,000 people in the UK, and many more in the upstream and downstream supply chains.[19]

There needs to be a recognition beyond political rhetoric of the commercial and economic realities facing Britain as it leaves the EU. The main 'losers' on the world stage from the past three decades of rising inequality are known to be the lower-income families of affluent countries, whose experience of globalisation has been one of wage and income stagnation, just as the winners are the middle classes of certain Asian economies and the 'global plutocrats' who have seen their vast wealth grow even greater.[20] In the UK, the divergence has been even more acute than elsewhere, in that working people have seen their share of national income collapse still further in the years since the financial crisis. Average wages fell in the UK by a full 7 per cent in the decade up to 2015, at the same time as average wages in competitor countries such as France, Germany, Canada, Australia and the US all rose.[21] With a further downturn in real wages during 2017 obliterating any recovery seen in the past two years, official statistics reveal that the British workforce is now living through the worst period for pay since the Second World War, and that the average worker will still be earning less in 2021 than in 2008.[22]

Rather than dismissing the genuine reasons for popular resistance to globalisation, there needs to be an open recognition that the free trade programme of the past four decades has brought with it challenges as well as opportunities, although evidently

not to the same social groups. Governments need to acknowledge the deep disaffection that has resulted from the divergence in people's life chances, and the danger of allowing racist and extreme right-wing groups to capitalise on that disaffection, as witnessed across Europe over recent years. In our economic policy – and particularly in our trade and investment strategy – Labour must seek to redress the imbalances that have developed and to forge instead a model of inclusive, sustainable growth.

Policy Space

First and foremost, any progressive trade and investment strategy needs to safeguard the policy space for governments to act in the public interest. Labour has committed to ensuring that trade and investment agreements cannot undermine future governments' ability to regulate on social or environmental grounds, and we will seek to promote the highest possible levels of regulation in trade negotiations, not the downgrading of standards and decrying them as 'barriers' to trade. On leaving the EU, Labour is committed to rejoining the Government Procurement Agreement in the WTO, but we will insist on safeguarding the capacity of public bodies to make their own procurement decisions in keeping with public policy objectives. Despite repeated assurances from Conservative ministers that public services are safe from free trade agreements, even the EU's own trade lawyers have confirmed that progressive moves by future governments to reverse public service privatisations could fall foul of liberalisation commitments under international trade rules.[23]

Upholding the right to regulate in the public interest requires a fair and balanced legal framework within which to adjudicate any disputes with overseas investors. Many 'new generation' trade agreements such as TTIP include sweeping powers for foreign investors to challenge host governments in specialised parallel judicial systems if they can argue they have been denied 'fair and equitable treatment' through having to abide by social or environmental regulations. In keeping with more and more

governments around the world, Labour rejects the model of investor–state dispute settlement that grants foreign investors such treaty rights. The UK ranked higher than any other European country in the 2017 index measuring quality of judicial process in the enforcement of contracts, so foreign investors can have full confidence that they will be able to secure justice in the same way as domestic British businesses, in the same courts.[24]

An open trading environment requires controls to ensure that there can be no abuse of the system by producers that have been granted an unfair advantage by government subsidies or other means. Successive UK governments have blocked the EU from imposing higher anti-dumping duties on countries such as China, requiring the European Commission to stick to the 'lesser duty' rule that limits the level of response available. Working together with business and trade union representatives, Labour will develop the full range of trade remedies necessary to support those sectors of the UK economy affected by unfair trading practices, and the capacity to use those remedies effectively.

Enhancing Rights

Trade can be an important source of economic benefit for working people in all countries. While comprehensive statistics are hard to come by, EU exports to the rest of the world are said to support an estimated 31 million jobs.[25] The impact of trade on women workers has been especially significant in those countries where women have not previously enjoyed other economic opportunities. In Bangladesh, for instance, formal employment in the export-oriented garment industry has provided millions of women workers with a regular source of independent income, which has in turn allowed them to enhance their social status and political participation.[26]

While integration into the global economy can be a source of social and economic empowerment, many working people have found themselves trapped in situations of extreme exploitation as a result of poverty wages and dangerous working conditions.

This is a particular threat to workers at the bottom of global value chains, producing goods for distant retailers that control the terms and conditions under which their suppliers operate. While recognising that trade and investment can make a significant contribution to decent jobs and social empowerment, the International Labour Organisation (ILO) notes that trade via global supply chains 'tends to generate economic benefits for firms (in terms of higher productivity) but not necessarily for workers (in terms of wages)'.[27]

The '10 Pledges to Transform Britain' unveiled at the 2016 Labour Party conference included a commitment to 'build human rights and social justice into trade policy', and the same conference pledged its support for a progressive trade and investment policy that 'protects and promotes skilled jobs, human rights and workers' rights based on internationally recognised labour standards'. Labour further pledged in the 2017 manifesto to ensure that trade agreements cannot undermine human rights and labour standards. Yet the traditional mechanism of including non-binding social clauses and sustainable-development chapters in EU free trade agreements has not been effective in achieving such an aim. Labour will ensure that all new treaties are subject to rigorous impact assessment early in their negotiation, and a Labour government will seek ways to implement social clauses in future UK trade and investment agreements. The ILO has found that including labour provisions in trade agreements increases the value of trade by 28 per cent on average, compared to 26 per cent for treaties without such provisions.[28]

Even binding clauses in future trade agreements may not be the most effective vehicle for upholding (let alone enhancing) labour standards and human rights. Unequal power relations within global value chains mean that UK-based companies exercise significant control over the practices of their suppliers and subsidiaries around the world. As a result, even the most progressive employers at the bottom of the value chain can find themselves severely constrained if UK buyers will not guarantee their ongoing support for improved conditions and the extra costs they can entail.

Labour will explore ways to hold businesses to account for human rights and labour standards throughout their spheres of influence. The absence of binding rules on corporate behaviour has long been recognised as a major failing of global economic governance, with successive attempts to address the issue at the international level coming to nought. Professor John Ruggie, the UN secretary general's former special representative on business and human rights, concluded that it is precisely the 'permissive environment' created by relying on corporate social responsibility and other voluntary mechanisms over the past four decades that has allowed global corporations to commit human rights abuses with impunity.[29]

The UN Human Rights Council adopted Ruggie's 'Protect, Respect and Remedy' Framework for Business and Human Rights in June 2011. The framework rests on three pillars: (1) the duty of states to *protect* against human rights abuse by third parties, including business; (2) the responsibility of business to *respect* human rights; and (3) the provision of effective *remedy*, both judicial and non-judicial, for victims of human rights violations. Crucially, however, the UN framework failed to introduce any mechanism of accountability, and left it instead to individual governments to develop their own national action plans to enforce its provisions.

The UK was the first country to publish a National Action Plan on Business and Human Rights, but even its most recent update contains no binding mechanism for corporate accountability.[30] Labour's 2017 manifesto included a commitment to work with business to tighten the rules governing corporate accountability for abuses in global supply chains, and a Labour government will actively support the working group on human rights and business set up by the UN Human Rights Council in 2014, whose mandate is 'to elaborate an international legally binding instrument to regulate, in international human rights law, the activities of transnational corporations and other business enterprises'.

Non-reciprocal Preferences

Labour is committed to addressing the historical development needs of the world's most vulnerable countries and communities in its trade and investment policy. This means guaranteeing the countries of the Global South access to the UK market under at least the same terms they have enjoyed while the UK has been part of the EU. Foremost among these is the need to maintain duty-free and quota-free access for exports from the world's least developed countries (LDCs), as specified in the Sustainable Development Goals adopted by the international community in 2015. Labour included this pledge in its 2017 manifesto, and the new Conservative government announced shortly after the election that it would be adopting Labour's policy.[31]

The UK must maintain and develop our relationships with trading partners beyond the LDCs, especially at a time when we seek to re-establish our presence on the world stage and to maintain our sphere of influence. Our trade agenda must recognise the historic failings of established global trade models and ensure that we do not repeat the mistakes of the past. Much damage was done to the economies of Africa and Latin America in the 1980s and 1990s as a result of being compelled to open up their markets under the structural adjustment programmes of the World Bank and IMF. The policies imposed led to such widespread deindustrialisation, unemployment and increased poverty that even the IMF itself would later admit that it had got it wrong on trade.[32] Labour has affirmed that it will never use aid conditionality to force countries to open their markets, a pledge made in the 2005 general election manifesto and repeated regularly since.

Likewise, it is a mistake to think that the poorest countries can simply 'trade their way out of poverty'. The World Bank's former research director, Paul Collier, has warned of the perils of export orientation, concluding that reliance on trade is 'more likely to lock yet more of the bottom-billion countries into the natural resource trap than to save them through export diversification'.[33] The pursuit of export markets at all costs has also been

responsible for significant human rights abuse, as in Cambodia, where preferences granted to LDCs under the EU's Everything but Arms scheme have encouraged the expansion of industrial sugar plantations and the forced displacement of hundreds of thousands of peasant farmers from their land.[34]

These are caveats to the fundamental principle that well-managed trade and investment can form an important part of a country's development strategy, leading to poverty reduction and social empowerment. On the microeconomic level, fair trade has shown how access to markets on equitable terms can transform the lives of local producers and their communities. Labour will use UK 'aid for trade' to support the development of local markets and regional trading opportunities as the most sustainable building blocks of economic growth, as well as strengthening fair trade schemes for wider export.

On the macroeconomic level, Labour will look to build on the EU's existing Generalised System of Preferences for low-income and lower-middle-income countries.[35] Many other industrialised nations already operate such non-reciprocal preference schemes for vulnerable countries, which are permitted under the WTO's Enabling Clause as long as they are based on objective criteria. In addition, some countries run targeted schemes (such as the US's African Growth and Opportunity Act) via renewable WTO waivers. The UK has long provided preferential access under the EU's schemes, and should continue to do so after it leaves the EU.

Reciprocal UK trade agreements with other trading partners must also take into account the needs of more vulnerable countries and communities if they are not to harm their long-term interests. Even trade agreements between OECD states can have negative impacts on third countries through trade diversion, where less powerful producers risk losing market share as they are brought into direct competition with the world's largest multinationals. Equally, blanket liberalisation of tariff regimes can lead to unintended losses for those countries that see their preferences eroded; Commonwealth exporters, for instance, currently

benefit from their preferential access to the UK market by as much as £600 million per year.[36]

Positive investment environments are equally important in ensuring that countries can benefit from globalised capital flows. Too many of the poorest countries have been denied their just share of the proceeds from the extraction of their natural resources by multinational companies, while tax dodging – which can include transfer pricing in intra-corporate trade – still costs the countries of the Global South around US$200 billion every year in much-needed government revenue.[37] Most of the UK's investment treaties with these countries date back to the 1980s and 1990s, and are in urgent need of revision.[38] Labour's 2017 manifesto included the commitment to review the UK's historic investment treaties and ensure they are fit for purpose for the twenty-first century, rebalancing the rights and responsibilities of investors to ensure that host communities benefit from the opportunities that foreign investment provides.

Labour's vision of positive trade and investment is an internationalist vision that seeks to promote mutual benefit through our commercial relations with peoples across the world. We uphold the conviction of the early Labour Party pioneers that global trade can and should be a win–win proposition, building shared prosperity and fostering peaceful relations between nations. For this to be a reality, we need to sustain a trading environment that maximises the opportunities of global markets, not a self-defeating race to the bottom. The task for an incoming Labour government is to articulate this progressive vision of an open, rules-based international trading system that meets the challenges of the twenty-first century and delivers for the many, not the few.

'De-financialising' the UK Economy: The Importance of Public Banks

Costas Lapavitsas

The performance of the UK economy during the decade since the outbreak of the great crisis of 2007–9 has been mediocre in terms of growth, income and employment. Working people have borne the brunt in terms of wages, welfare services, housing, education and so on.[1] The crisis, in which private banks played a major role, resulted from the transformation of the UK economy in recent decades that has lent extraordinary prominence to finance. The UK economy has become 'financialised', with rising volumes of private debt and extensive penetration of finance in economic and social life.

Since the crisis, however, UK finance has lacked the expansionary drive of the previous period, and private debt has not grown with nearly the same vigour as in the previous decade. At the same time, public debt has risen substantially as the government has intervened to support the financial sector, and especially to protect the private banks. Financialisation has acquired a public aspect due to government policies which have also shaped the poor performance of the economy.

The UK needs a significant change in economic policy to benefit working people by gradually transforming the economy in the direction of higher incomes and better employment. 'De-financialisation' would be necessary to create an economy serving and empowering working people. A vital step in this regard would be to create public banks that could serve the investment and consumption needs of the UK.

A Crisis of Financialisation in 2007–9

The global crisis of 2007–9 sprang out of the US financial system, subsequently engulfing the UK economy and its financial system. The crisis had its roots in the financial expansion of the previous years when a housing bubble took place in the US, but also in the UK. It was fed by extraordinary growth in household debt and was sustained by complex financial operations, including securitisation of mortgages and other assets.[2]

The main culprits in the US were commercial banks but also 'shadow banks', that is, enterprises that do not take deposits but instead borrow in open markets in order to make loans. The 'shadow banking' sector in the UK is much smaller, and the main culprits of the bubble were commercial banks, including the old building societies which had become banks in the 1980s and 1990s.

The bubble was pricked in the US in the summer of 2006, when many of those who had obtained mortgages proved unable to keep up payments. They typically belonged to the poorest sections of the US working class, and often were black or Latino. Since they could no longer make regular mortgage repayments, the securitised assets based on their mortgages could no longer deliver the contracted payments to their holders. The assets had become 'toxic'.

From that moment onwards events unfolded catastrophically for banks and 'shadow banks'. Since securitised assets had become problematic – indeed they were getting worse and worse – financial institutions could no longer borrow by using these as security. Given that they could not borrow, it followed that they had no liquid funds to lend, and so the financial markets gradually went into an extraordinary contraction as liquid funds became increasingly scarce.[3]

The liquidity shortage eventually reached panic dimensions and people began to withdraw their deposits, while owners of liquid money capital also began to withdraw it from banks. For the first time in decades the UK witnessed a traditional bank run

when, in the autumn of 2007, depositors queued outside branches of Northern Rock, a building society that had become heavily exposed to the bubble. Even worse for the banking system, however, was the 'silent bank run' of withdrawals by large owners of money capital. At the same time, the solvency of banks was put in doubt as they began taking losses on mortgage-related assets.

The combination of liquidity and solvency pressures brought the crisis to a peak in the summer of 2008, marked by spectacular collapses of giant banks in the US. Huge UK banks also faced tremendous pressure, none more than the Royal Bank of Scotland, which had played a pivotal role in the excesses of the preceding bubble. There had not been a financial crisis of this type and magnitude since the great collapse of finance in the early 1930s.

The intervention of the government in both the US and the UK was, however, dramatically different from the interwar years. In its absence the disaster that had befallen the financial system would have reached inconceivable dimensions. Thus, central banks began freely to provide liquidity to assuage the extreme shortage of liquid funds; Treasury departments began to supply banks with capital to lessen the risk of insolvency; bank deposits were guaranteed. In the UK, banks were placed under government ownership, most prominently the Royal Bank of Scotland (RBS) but also Lloyds Bank. Even in the US, bank nationalisation was seriously considered in 2009, though it did not come to pass. Eventually state intervention stabilised the financial system.

The great crisis of 2007–9 represents a systemic failure of contemporary private banking and finance. It is a failure that has had dramatic effects on the UK and other mature economies in the years that followed, marked by deep recession, weak recovery, tremendous loss of income and sustained austerity that has damaged health, education and welfare provision generally. The failure of private finance, moreover, has demonstrated its profound dependence on the state. This is a fundamental point in considering policy towards the financial system today.

An even more important point is that the crisis of 2007–9 reflects the deep structural weaknesses of contemporary capitalism as finance has grown relentlessly. Since the late 1970s the economy of the UK can be aptly described as having steadily 'financialised', a term that is now widely deployed in social sciences. The financial sector has become extraordinarily important in a variety of ways, some of which are discussed below.[4]

The turmoil of 2007–9 was a crisis of financialised capitalism in terms of both its origins and its subsequent impact on the economy and society of the UK. The years that have followed have witnessed the stabilisation of the economy through the intervention of the state, but they have not brought a reversal of financialisation. Rather, financialisation in the UK – and the US – has come to depend more heavily on government. This is the standpoint from which policy relative to the financial system ought to be considered.

Ten Years On: Financialisation Relies Heavily on the State

The UK has one of the largest financial systems in the world; the UK system is also very international, and the City of London is a major global centre for financial transactions.[5] London is the true financial centre of Europe, with strong participation by international banks and other financial institutions. The prominence of finance in the UK has increased greatly as the economy has become financialised during the last four decades. Consider briefly some evidence regarding both the evolution and the current state of UK financialisation.

One indicator of the relative size of finance is given by the total assets of UK banks relative to GDP, including both domestic and foreign banks resident in the UK, as is shown in Figure 6.1.[6] Even though this indicator leaves much of the financial system out – for instance the assets of hedge funds, pension funds and insurance companies – it is still informative since the banks are by far the most important element of the financial system.

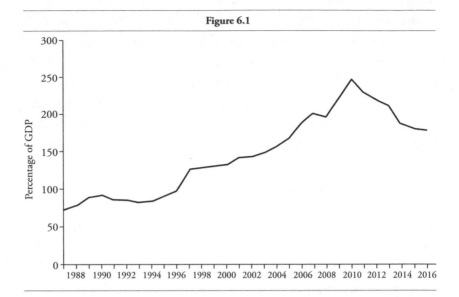

Figure 6.1

It is clear that banking has grown remarkably during the last four decades, with rapid growth commencing in the early 1980s and peaking at the time of the crisis in 2007–9. Since the crisis, however, banking has failed to grow with similar dynamism, for reasons discussed below. Its relative decline is an important factor in planning policy towards finance.

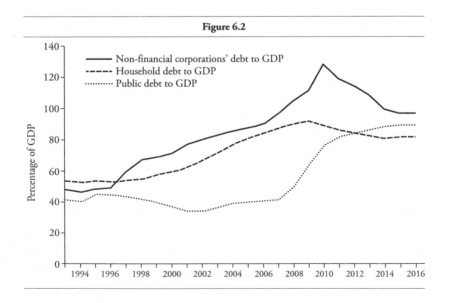

Figure 6.2

The general growth of bank assets, however, implies that debt has been growing in the UK economy, since bank assets are basically loans. Financialisation has brought tremendous growth of debt in the UK, the composition of which is also revealing. To examine the trajectory of debt, it is useful to split total debt into the debt of, respectively, non-financial corporations, households, financial corporations and the government, as is shown in Figure 6.2.

Total debt has grown substantially relative to GDP in the years of financialisation, but note that the growth of private debt has been generally arrested since the crisis of 2007–9. Specifically, although the debt of both the corporate and household sectors has witnessed strong growth historically, it has tended to decline in relative terms for both since 2007–9. In contrast, public debt, which has generally been rather stable or declining, has escalated since the crisis. UK financialisation has begun to acquire a distinctly public aspect.

It is worth considering the corporate and household sectors more closely to obtain a better view of the trajectory and the content of financialisation. Thus, Figure 6.3 shows the total credit provided to the UK corporate sector – productive and commercial enterprises – by the financial system.

Bank credit to non-financial corporations has expanded systematically throughout the period of financialisation, peaking in 1991 and 2002, while reaching an overall peak in 2009. In 1991 and 1992, credit resumed its sustained expansion after a short period of contraction or stagnation. However, since 2009 bank credit to productive enterprises has declined precipitously and has not shown a sustained tendency to rise. Household debt presents an equally striking picture, as shown in Figure 6.4.

Household debt grew substantially in the decades of financialisation, mostly driven by mortgage rather than consumer debt, especially in the 2000s. However, since the crisis mortgage debt has fallen significantly relative to GDP and has shown no signs of rising in a sustained way; consumer debt, on the other hand, has gradually recovered.

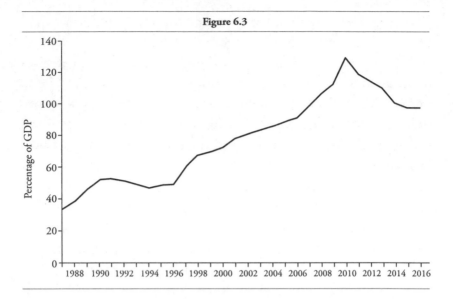

Figure 6.3

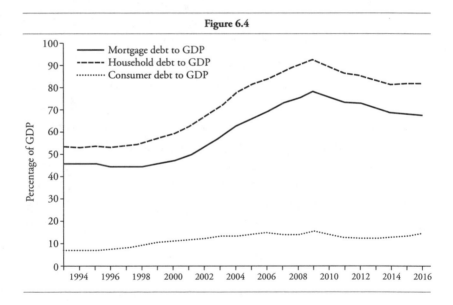

Figure 6.4

Financialisation has been marked by drawing households into the realm of the financial system, even more than by the expansion of credit to the productive sector. Indeed, the large enterprises of Britain and other countries have been awash with money capital in recent years, which they have not been investing but rather deploying in financial operations. Households have been

drawn into the financial system mostly through mortgage provision, but consumer debt has also been significant. It is important to note that financialisation has also affected household assets, i.e. pensions, insurance and so on, which have also been drawn into the private financial system.

The financialisation of households has been a characteristic feature of the last four decades in the UK, with private finance penetrating personal and family life. The needs of households for housing, education, transport and so on have become fields of profit-making for financial institutions. Key to this development has been the restriction or withdrawal of public provision in these fields, together with downward pressure on real incomes.

The intervention of the state in the course of the crisis of 2007–9 can now be understood in greater detail. The main concern of the government was to protect the exposed financial system and to prevent a collapse of the basic structures of financialisation. First, the Bank of England provided abundant liquidity to ease the shortage, thus tremendously expanding its balance sheet, as shown in Figure 6.5. Second, interest rates were driven practically to zero, thus allowing banks to obtain funds cheaply. Third, some of the largest banks were nationalised to prevent collapse, most prominently the Royal Bank of Scotland.

State intervention has rested on issuing large volumes of public debt by the government, above all to finance the generation of liquidity by the Bank of England. Thus, ten years since the outbreak of the crisis, the British state has substantially increased its indebtedness, while the private sectors of the economy have been reducing theirs, as is shown in Figure 6.2. The Bank of England has, meanwhile, come to tower above the financial system and the economy more generally. Needless to say, increased public debt and liquidity have not supported public spending on investment, welfare, wages for civil servants and so on. On the contrary, while supporting the financial system, the British government has applied relentless austerity in the forlorn hope of limiting public debt.

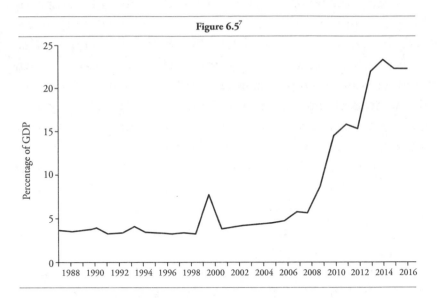

Figure 6.5[7]

The cost of austerity could be gauged by declining quality of welfare provision, especially in health, but also by rising indebtedness for students. Austerity has had the further cost of depressing aggregate demand, thus preventing a strong recovery of the economy; rates of growth for the British economy have averaged around 2 per cent since 2009, the weakest period of growth since the oil crisis of 1973–4. Recessionary pressures have been made worse by the lack of investment by enterprises, matched by declining credit by banks, as is shown in Figure 6.3. The weakness of the economy since the great crisis has also been reflected in poor growth of productivity. Finally, employment has gradually recovered, but the jobs created have generally been poorly paid.

Not surprisingly, the financial system has continued to face difficulties since 2007–9. Depressed demand and weak income growth together with the huge backlog of mortgage debt have led households to reduce their debt in relative terms, as shown in Figure 6.4. Moreover, enterprises have generally not been investing and have thus also reduced their relative exposure to banks. Low interest rates and reduced financial transactions in general have put additional pressure on financial profitability for several years.

In sum, during the decade since the outbreak of the crisis the UK has been drifting. Financialisation has been marking time, while becoming heavily reliant on state support. The performance of the economy in terms of growth, income, productivity and employment has been deeply problematic. At the same time, the tendency of finance to generate bubbles and to create instability has far from disappeared. Low interest rates and abundant liquidity provided by the state have gradually created conditions for speculative growth in the stock market in both the US and the UK, particularly in 2016–17. The financial sector has gained some leeway and boosted its profitability, but the final outcome of stock market growth remains to be seen.

De-financialising the UK

A general change in policy towards the financial system is called for, if things are to improve for the British people. The 'de-financialisation' of the UK economy ought to be placed on the agenda. Moreover, the Brexit vote in 2016 has unexpectedly created opportunities to take steps in that direction.

The implications of the UK leaving the European Union in 2019 are far from clear for the British financial system, and they are not directly relevant to this chapter. However, there is little doubt that banks will be forced to rebalance their domestic and international activities. It is likely that some international financial institutions will move part of their activities elsewhere, although the comparative advantages of the heavy concentration of financial processes and skills in London would be hard to replicate in other European cities. It is also possible that UK banks would face extra costs in operating elsewhere in Europe, which might affect some of the large UK banks, including Barclays and HSBC.[8]

In this context there is the possibility of intervening decisively to rebalance the financial sector, thus setting in train a process of 'de-financialisation'. Vital to it would be transforming the

banking system. To be specific, policy changes that placed the interests of working people at the forefront should seek to create public banks. They should also seek to create special-purpose public financial institutions that could serve the investment and consumption needs of contemporary Britain.

Public ownership of banks and other financial institutions has been far from rare in the decades of financialisation. Public banking, for instance, has remained very significant in Germany throughout the last three decades, including a large long-term investment bank (KfW). During the crisis the UK government took majority stakes in RBS and Northern Rock, plus a minority stake in Lloyds-HBOS. The aim was to rescue these banks, subsequently to return them to full private ownership. This has already been done with Lloyds-HBOS, but the weakness of RBS was so great that the UK government has retained a strong majority stake.

It is unfortunate that the UK government has consistently refused to take over the actual management of the banks it placed under public ownership. They could have been operated in a public spirit aiming to support the performance of the economy as well as facilitating 'de-financialisation'.

For one thing, public banks could become major providers of commercial banking functions to small and medium-sized enterprises (SMEs) as well as to households. Steady provision of commercial credit to SMEs and households could sustain aggregate demand, support employment and boost investment. Without neglecting the monitoring and screening functions over lenders, public banks could in principle regulate the flows of individual (and SME) credit to achieve socially set objectives.

For another, public banks and special-purpose financial institutions could support the provision of long-term development credit. With secure financing backed by the state, public banks would be able to contribute to the long-term rebalancing of the UK economy by reducing the predominance of finance. The rebalancing would include areas of advanced technology and

high productivity growth. It could also include supporting 'green' activities, such as non-fossil fuel forms of energy, less reliance on private cars, raising the energy efficiency of private homes, reducing industrial pollution and so on. Generally speaking, these aims require major public investment, which public banks would be able to finance.

As for households, public banks could provide credit for housing and education as well as for general consumption. Such credit would presuppose regular repayment at publicly determined rates of interest, which would vary according to the objectives of social policy. Public banks could certainly adopt the techniques of information collection for income, employment and personal conditions, while still deploying credit scoring and risk management. Their role in providing such credit, however, would be heavily circumscribed by the revitalisation of public provision in these fields, especially with the construction of large numbers of new homes and the abolition of student fees for universities. These would be crucial steps in 'de-financialising' the life of working people in Britain.

A spirit of public service would be vital to 'de-financialisation'. Finance has been one of the least transparent sectors of contemporary economies, with disastrous results. Establishing public banks would be more than mere nationalisation, and certainly not the simple replacement of failed private managers by state bureaucrats. Their remit would be set socially and collectively, imposing transparency on decision making and full accountability to elected bodies. Public banks could thus become an effective lever for the systemic regulation of finance, facilitating controls over the activities of private banks. Finally, the technological revolution of the last few decades, with the rapid growth of data collection and processing by banks on a massive scale, offers further potential to coordinate banking activities on a public basis. The potential to support the democratic management of the economy has correspondingly increased.

These are some of the policy issues relating to finance that should be discussed in detail in Britain. With sufficient political

will, the UK could make considerable progress in the coming period, potentially opening a path for the rest of Europe.

Better Models of Business Ownership

Rob Calvert Jump

The economic system in the United Kingdom is dominated by private ownership and control of the means of production. This has manifested itself in various ways over the past forty years, with the collapse of council housing and the privatisation of previously nationalised industries being key events. Tables 7.1 and 7.2 give an idea of the distribution of enterprises and employment across legal status. Currently, around 69 per cent of enterprises in the UK are organised as private companies, with the next largest shares being taken by sole proprietors and partnerships. Government and public corporations comprise the smallest share of enterprises, although

Table 7.1: UK enterprises by legal status and employment, percentage figures

Legal status		Employment size band, percentages*						
		0–4	5–9	10 19	20 49	50 99	100–249	250+
	Central government	1.88	0.88	3.13	18.75	22.75	33.63	19.00
	Company	77.05	10.82	6.36	3.53	1.20	0.63	0.40
	Local authority	71.42	6.39	3.66	5.15	4.40	3.04	5.95
	Non-profit or mutual	60.56	17.14	10.87	6.05	2.26	1.70	1.43
	Partnership	70.45	18.03	7.30	3.64	0.46	0.11	0.02
	Public/ nationalised body	17.07	4.88	4.88	9.76	7.32	17.07	39.02
	Sole proprietor	87.40	9.78	2.31	0.46	0.04	0.01	0.00
	Total	77.71	11.44	5.83	3.08	1.00	0.56	0.38

*Note: figures are as a percentage of legal status, e.g. 1.88 per cent of central government enterprises have 0–4 employees.

Table 7.2: UK enterprises by legal status and employment, total figures

		Employment size band*						
		0–4	5–9	10–19	20–49	50–99	100–249	250+
Legal status	Central government	75	35	125	750	910	1,345	760
	Company	1,353,465	190,135	111,765	61,945	21,060	11,045	7,090
	Local authority	5,760	515	295	415	355	245	480
	Non-profit or mutual	51,605	14,610	9,260	5,160	1,925	1,445	1,215
	Partnership	157,715	40,355	16,335	8,155	1,025	240	50
	Public/ nationalised body	35	10	10	20	15	35	80
	Sole proprietor	416,565	46,600	11,025	2,190	195	50	10
	Total	1,985,220	292,260	148,815	78,635	25,485	14,405	9,685

*Note: figures are in total numbers, e.g. there are 75 central government enterprises with 0–4 employees.

these organisations tend to have a large number of employees in comparison with private firms. Finally, around 3 per cent of UK enterprises are organised as cooperatives and mutual associations.[1]

The current extent of private ownership in the UK has been arrived at, in large part, by the wave of privatisation that took place in the 1980s. While a significant part of British Petroleum shares were sold by the Labour government in 1977 to raise money following the 1976 International Monetary Fund loan, privatisation as policy was instigated by the various Conservative governments after 1979. The companies privatised during this period include British Aerospace, Cable and Wireless, British Telecom, British Gas, British Airways, various oil and energy companies and Rolls Royce, among others. Part of the rationale for this wave of privatisation was to increase household share ownership; the result has been a significantly skewed ownership distribution. Finally, the number of private companies has continued to increase at the expense of alternative forms of ownership during the recent coalition and Conservative governments, as illustrated in Figure 7.1.[2]

Figure 7.1

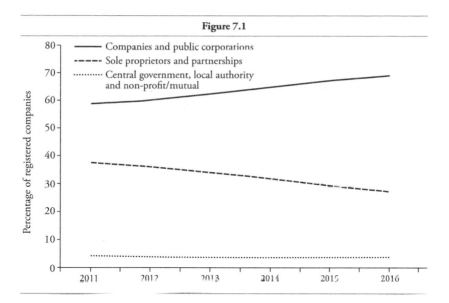

The standard model of business organisation within private companies may loosely be defined as a legal structure in which private capital investors have the collective right to appoint management, as well as ownership rights to any residual income generation. Management, among other things, has the right to dismiss employees with minimal consultation, particularly when the workforce is not unionised. A number of well-documented welfare losses have resulted from the predominance of this form of organisation over the past forty years. The results have included increases in inequality and financial insecurity among working households, short-termism among business managers, and regional disparities in wage levels, employment and investment.[3] A more subtle welfare loss arises from the workes' lack of control over their working lives. This includes, but is not limited to, a lack of control over hours of work and a lack of control over the type and quality of work.

Finally, and perhaps most importantly, a direct macroeconomic effect of the prevalence of private ownership and control of firms is the existence of unemployment as a discipline device. The existence of unemployment facilitates the ability of management to control employees, particularly in regard to productivity and performance, and dampens demands for higher wages. This

follows directly from the various theories of fair wages and efficiency wages that emerged in economics in the 1990s, for which Marx's differentiation between labour and labour power is a common ancestor. There are various ways of driving down the unemployment rate using demand management policy, some of which are considered by Simon Wren-Lewis in Chapter 2 of the present volume. Changes to the dominant model of business ownership and control, which in turn affect the dominant management–worker relation, can be considered as complementary supply-side reforms designed to reduce the underlying requirement for unemployment as a discipline device.

Cooperative Forms of Ownership

Cooperatives stand in stark contrast to the dominant model of business organisation, as they embed democracy at the heart of firm governance. This can be exercised by workers, consumers or other stakeholders. Cooperatives UK, a membership organisation for cooperative enterprise, defines worker cooperatives as those businesses where the members and beneficiaries work for the cooperative and have direct ownership and control, although the UK legal framework is not as prescriptive as in many countries where worker cooperatives have a precise legal definition. As of 2012, Cooperatives UK estimate that there are around 500 worker co-ops, with just under 80,000 workers in the UK being members of worker cooperatives, and a further 78,500 workers employed on a non-member basis by worker cooperatives.[4]

There are a number of benefits to worker cooperatives. Chief among these is the stability of employment. In particular, worker cooperatives appear to adjust labour costs in response to negative demand shocks by decreasing wages and hours, rather than decreasing employment. The Mondragon group, Europe's most famous collection of cooperatives, only dismissed twelve members without compensation during the 2008 economic crisis, out of a total of around 20,000 members, with a further ninety-six members taking early retirement and 350 working fewer hours.[5]

A second benefit is improved productivity. A 1995 paper by Craig et al., considered to be one of the more reliable studies in the literature, found that worker cooperatives in the US plywood industry are more efficient than conventional firms, with some estimates showing a 6–14 per cent productivity advantage. Finally, there are obvious welfare gains to workers resulting from increased control of working life.[6]

Increasing cooperative forms of ownership would therefore tackle the increased insecurity, inequality and lack of control over working life arising from the dominance of privately owned and controlled firms. At the same, there may well be productivity gains in certain sectors resulting from an increase in cooperatives, and one would expect unemployment levels to reduce with the need for a worker discipline device. Unfortunately, worker cooperative members only constitute around 0.27 per cent of total employment in the UK, and employee-owned businesses only constitute around 2 per cent of GDP. Why are worker cooperatives so uncommon, and what policy levers exist to encourage the sector's growth?

There are a number of structural reasons for the relative scarcity of worker cooperatives in wealthy capitalist nations. One of the most important stems from the fundamental inalienability of labour in comparison with capital; one can accumulate an effectively unlimited amount of financial and/or physical capital, but one cannot indefinitely accumulate labour power nor the ability to work. As a result, capitalist firms tend to have fewer controlling parties than worker-owned firms, substantially reducing coordination problems and conflicts of interest. An important practical consequence is the difficulty that worker cooperatives face in raising external finance, as most sources of risk capital entail some level of control operated on a 'one share, one vote' basis. This, clearly, is incompatible with the basic principles of cooperative production.[7]

The difficulties involved with raising finance suggest the need for new financial instruments. At the same time, 'shelter institutions', to use a term coined by Jaroslav Vanek, are almost certainly

indispensable for a flourishing cooperative sector. Proposals for the former include variants on share capital that pay a competitive rate of return, but do not imply a share in the surplus earnings of the cooperative. This type of 'limited return' on capital places the proposed instrument halfway between community shares and standard share capital, and implies the need for a secondary market. Examples of the latter include the Italian national federations, e.g. Legacoop, and the Mondragon group, particularly the Caja Laboral Popular. The Caja Laboral Popular, among other things, provides a long-term source of finance to the Mondragon cooperatives that is ideologically supportive of cooperative production, which reduces the probability that a cooperative firm in financial difficulty either fails or has to resort to non-cooperative forms of financing.[8]

Finally, there are a number of legislative changes that would encourage the expansion of the cooperative sector. Tax asymmetries between cooperative and profit-making companies could be removed, and subsidies could be introduced for setting up cooperatives or engaging in worker buyouts. The principle of disinterested distribution, which stops the accumulated capital of cooperatives being distributed to its members on dissolution of the enterprise, could be introduced in the UK. Importantly, the sector is flourishing despite the relative lack of political support, with new cooperatives being regularly created – Joe Guinan and Thomas M. Hanna discuss this further in Chapter 9 of the present volume. This suggests that the sector may well expand rapidly with the reintroduction of the type of supportive framework embodied in Labour's 1976 Industrial Common Ownership Act, updated for the twenty-first century.

Municipal and Local Forms of Ownership

Municipal ownership is the ownership of an enterprise by the governing body of a town or district. Traditionally this has existed in the UK in areas such as local waste collection, utility provision and public transport. Assuming that local democracy is

functioning, municipal ownership introduces democratic forms into enterprise ownership, but in a different manner to cooperative production. As with public ownership in general, municipal ownership in the UK declined throughout the 1980s and 1990s. To take one example, over half the bus fleets formally under local authority ownership had been sold to the private sector by 1994, at which point around 84 per cent of bus services were run on a commercial basis. While twenty-nine of the newly privatised bus firms were created with employee stock ownership plans, by the early 2000s only two worker-owned bus services remained in existence.[9]

The benefits to municipal ownership stem from the advantages associated with local control of services, including local democracy and accountability. In turn, one would expect this to reduce the welfare losses associated with regional disparities in wage levels, employment and investment that stem from the current dominance of private ownership and control. At a very basic level, the pursuit of profit by privatised companies should increase the price paid by consumers, and uncompetitive behaviour has not been uncommon among privatised utility companies in the UK. This is not particularly surprising, as the majority of municipally owned enterprises in the UK have tended to operate in naturally uncompetitive industries. The key difference is that a municipally owned enterprise has considerably less incentive to take advantage of this.

As well as straightforward ownership of enterprises by local authorities, local ownership might also be encouraged in other ways. Community benefit societies, for example, are set up to serve the broad interests of the local community, and accumulated financial surpluses cannot be distributed to members. In addition, and similar to the proposals for cooperative share capital discussed above, share capital in community benefit societies is subject to a maximum rate of return. Social enterprises might also be considered. There are currently around 70,000 social enterprises operating in the UK, employing nearly 1 million people. These are, naturally, a more light-touch approach to

expanding the organisational diversity of enterprise, but the general umbrella term encompasses a large number of organisations with an obvious social benefit. A significant proportion of social enterprises operate at the level of local authorities and regions, and 31 per cent of social enterprises operate in the UK's 20 per cent most deprived regions.[10]

Given the benefits of municipal and local forms of ownership, their expansion should be encouraged in the same way as the expansion of cooperative ownership. One key way that this can be achieved is via government procurement policy. A useful contemporary example of this in action is the Preston model, discussed in Chapter 10 of the present volume by Matthew Brown et al. Another way, also utilised in the Preston model, is by influencing the expenditure patterns of local 'anchor institutions'. These are large institutions that are either unwilling or unable to relocate from a given area. Examples include hospitals, universities and locally owned businesses with a historical attachment to the area. Encouraging these organisations to focus their procurement and expenditure within the local area can achieve large gains by increasing local expenditure multipliers. Interesting examples of this in action include the various local currencies that have been introduced in the UK over the past decade, although lower-cost mechanisms of raising awareness of local procurement possibilities also exist.

Municipal and local forms of ownership have been historically widespread in the UK, particularly in local utilities and transport. Reintroducing widespread municipal ownership and encouraging other forms of local ownership are arguably both preconditions for tackling regional disparities in wage levels, employment and investment. Fortunately, at least compared to the cooperative sector, encouraging the expansion of municipal and local ownership is relatively straightforward, as the former is directly under government control, and the latter can be targeted by government procurement policy and the expenditure patterns of 'anchor institutions'.

National Forms of Ownership

Nationalised enterprises are owned and controlled by the government or state. They can be wholly or partially owned, and often have politicians or their representatives sitting on the board of directors. Nationalised enterprises are extremely common worldwide, particularly in the financial sector, and were common in a large number of industries in the UK prior to the 1980s. Despite the subsequent wave of privatisation, there remains a number of high-profile state-owned enterprises operating in the UK, including the BBC and various NHS agencies, and various infrastructure agencies including Highways England and Network Rail.

There is an ongoing debate regarding the relative productivity advantages of nationalised versus privatised firms, which depends to a large degree on the industry in which the enterprise operates and its corporate governance structure. Allowing for this, the benefits of nationalisation are straightforward. First, when the industry in question is a natural monopoly, nationalisation can lead to a reduction in price to the consumer. Second, in the presence of financial short-termism, nationalised enterprise can lead to the type of long-term investment required to transform a country's technology and infrastructure, leading to long-term increases in productivity. Third, nationalised enterprises are uniquely placed to allow a reduction in so-called 'postcode lotteries' in service provision, thus improving regional equity. Finally, nationalised enterprises allow for a strategic response to national emergencies, with centrally planned emergency services and healthcare being a prime example of this benefit in action. This may well be useful in tackling climate change, where the disjoint nature of decision making in decentralised markets is not conducive to long-term strategic planning.[11]

The major difficulty with national ownership is the cost associated with nationalisation. This is particularly important when the enterprise in question is owned or part-owned by foreign nationals, in which case the foreign investors are legally entitled to compensation. In most of the bilateral investment treaties that

the UK is party to, this compensation is for the 'market value', 'full value', 'genuine value' or similar of the enterprise being nationalised. This is not a trivial problem in the UK, where 54 per cent of ordinary shares held in UK incorporated companies listed on the London Stock Exchange are known to be held by foreign nationals. These costs make privatisation a particularly pernicious policy, and the effects are compounded when a state-owned enterprise has been sold at less than its market value. The privatisation of Royal Mail is a recent example of this type of policy error. While £1.98 billion was raised by the first sale, leaving the government with a 30 per cent stake in the company, the share price rose 38 per cent on the first day of trading.[12]

As well as being a straightforward redistribution of wealth from the average taxpayer to the average share owner, who by and large are not the same person, the sale of Royal Mail at less than its market value means that if a future government decides to renationalise the company, it will have to spend hundreds of millions of pounds more in compensation to shareholders than the coalition government raised from its sale. Given this, it is worth bearing in mind that in a number of important situations, nationalisation is much more straightforward than the foregoing discussion suggests. Taking train operation back into public ownership is one example, as this operates on the basis of fixed-term franchises. As these franchises run out, they can be taken back into public ownership with very little cost. In addition, even if market value has to be paid for a company, all this implies is that the government sells a given value of bonds in order to purchase the same value of equity – so assets rise by the same amount as liabilities, and interest costs should be covered by dividend revenue.

The foregoing suggests that nationalisation should focus, in the first instance, on industries that offer the greatest public benefit with the lowest cost of compensation. The creation of new state-owned enterprises would also be a straightforward way to proceed, with the proposed national investment bank being one key example. Enterprises that are targeted for nationalisation

due to their monopoly position might be subject to price caps prior to nationalisation. If this results in an adequate welfare gain then nationalisation might not be required; if nationalisation is still required, the price cap will have served to depress the share price of the enterprise in question, thus reducing the costs of nationalisation. Finally, part nationalisation is almost certainly a more cost-effective way of achieving social goals than full nationalisation, as a simple majority of share ownership is sufficient to influence the direction of company policy.

Getting from A to B

The dominant form of business ownership in the UK is private ownership, with the dominant form of enterprise being private companies. A number of well-documented welfare losses have resulted from the predominance of this form of organisation over the past forty years, including increases in inequality and financial insecurity among working households, short-termism among business managers, and regional disparities in wage levels, employment and investment. More subtle welfare losses include the lack of control of workers over their working lives, and the necessary existence of unemployment as a worker discipline device. This chapter has considered some of the alternatives to private ownership that a future Labour government could promote, including cooperative production, municipal and local forms of ownership, and national ownership.

Worker cooperatives tackle the increased insecurity, inequality and lack of control over working life arising from the dominance of privately owned and controlled firms, and may lead to increases in productivity in certain sectors. Municipal and local forms of ownership reduce the welfare losses associated with regional disparities in wage levels, employment and investment that stem from the dominance of private ownership. National forms of ownership can tackle the short-termism associated with private enterprise and finance, and are also in a position to reduce regional disparities. In addition, as earnings distributions in

public sector bodies are generally more compressed than their private sector counterparts, all three alternatives should increase equality and improve financial security among working households. Finally, all three alternatives should reduce the need for unemployment as a worker discipline device. There are difficulties associated with their promotion, however. Worker cooperatives are rare, and have difficulty raising capital. Municipal and local ownership is more straightforward to promote, but this still requires the procurement and expenditure patterns of local government and 'anchor institutions' to be successfully influenced by policymakers. Nationalisation can also be difficult, given the large costs associated with compensating private owners.

How would a future Labour government achieve a transformation in the ownership of UK enterprise? The task is perhaps not as difficult as it first seems. First, the vast majority of privately owned and controlled companies in the UK are small and medium-sized enterprises (SMEs), which generally perform well – albeit in the context of structural problems including a lack of access to finance. Private ownership will continue to dominate this sector for some time. However, the creation of financing options, shelter institutions and tax advantages would certainly encourage more SMEs to convert to cooperative forms of ownership or similar forms including community benefit societies and social enterprises. Influencing the procurement and expenditure strategies of local government and 'anchor institutions' would also encourage the growth of this type of enterprise within local economies. The process would take time, but gradually the ownership structure of SMEs would be transformed.

There are a relatively small number of very large companies operating in the UK. Their size and associated market power make these firms difficult to influence, but their small number provides some hope. Nationalisation of certain key organisations, mainly in transport and utilities, is far from impossible and may be undertaken with relative ease in certain sectors (e.g. train operation). Given this, large firms in the majority of

industries in the UK – particularly systemically important industries such as financial services, insurance, business services and pharmaceuticals – would certainly suffer as a result of full nationalisation. Similarly, their large size and capital intensity make cooperative forms of ownership infeasible. In these cases, therefore, wholesale change of ownership structure is undesirable, although part nationalisation might be appropriate for certain organisations in the financial sector, where a degree of strategic influence is desirable. Although detailed discussion is outside the remit of this chapter, a promising policy option would be legislative changes to corporate governance in large private companies. In this respect, a new Committee of Enquiry into Industrial Democracy, complemented with an updated Industrial Common Ownership Act, would constitute a solution to the welfare losses arising from private ownership and control across all types of firm in the UK.[13]

Beyond the Divide: Why Devolution Is Needed for National Prosperity

Grace Blakeley and Luke Raikes

The UK Has a Problem with Its Regional Economies

The UK has a regional economic problem without parallel in the developed world. London and the South East are responsible for most of the UK's economic output, and London is considerably more productive than the rest of the UK.[1] The UK is now the most regionally unequal country in Europe, and there is emerging evidence that London and its hinterland are starting to 'decouple' from the rest of the UK – that is, not acting as an engine for the country but becoming a separate economy.[2]

These economic issues have also begun to manifest themselves in declining socio-economic outcomes. For example:

- In all the English regions outside of London, average incomes are between 10 and 20 per cent below the UK average.
- The unemployment rate in the UK varies from 3.3 per cent in the South West to 5.1 per cent in the West Midlands.
- Healthy life expectancy at birth is 66.1 years for men and 66.3 years for women in the South East, compared to 59.7 for men and 60.6 for women in the North East.

- The proportion of people with no qualifications averages 10 per cent across the North and the West Midlands, compared to 6 per cent for London, the South East and the South West.

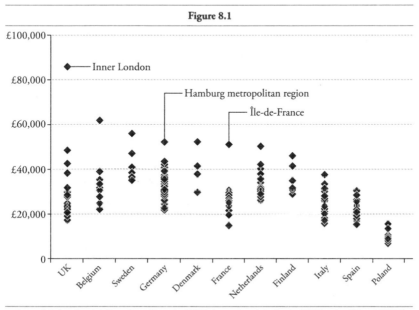

Figure 8.1

Source: Data from Eurostat, 'Gross domestic product (GDP) at current market prices by NUTS 2 regions' (Eurostat 2016)

There are complex reasons for this gap, many of which relate to structural changes in the economy over many decades. Since the Industrial Revolution, the UK has transformed from an economy based on mining and other forms of extraction, through to heavy industry, on to light industry and now to services. These shifts have partly been prompted by the changing face of globalisation and advances in technology, which have led to labour in these industries being outsourced, automated or simply made redundant in the modern world.[3] The long-term transformations and frequent economic shocks associated with globalisation have tested the resilience of different regions: some areas have had the economic diversity or specialism they need to adapt better than others; other places have suffered long-term decline.[4] For the English regions where much of the UK's manufacturing was located, this shift has been particularly painful. Meanwhile, the

continued growth of financial services in London has accelerated its integration into the global economy.

However, the causes of such change cannot simply be reduced to the impersonal 'forces' of globalisation. Globalisation itself has not been a neutral, irresistible change associated with human progress; its shape and direction are determined by a specific set of policy decisions. There is nothing 'natural' about this geographical pattern of economic success. Other countries and regions have responded to changes in the global economy and seen very different results – the UK's regional imbalance may be unique, but the successive challenges the country has faced over the last century are very similar to those faced by overseas nations.[5]

One of the most significant differences between many other countries and the UK – and England in particular – is that other countries have had strong subnational governments delivering regional economic policy and interventionist industrial strategy. In the UK, central government makes almost all of these decisions, and does so under the strong influence of the financial sector in the City of London.

The Central State Has Been a Major Cause of Our Regional Problem

While other countries have reaped the benefits of regional government, the UK has continued to experiment from Whitehall, which has shown little interest in tackling the UK's regional problems. Central government has not only failed to tackle rising regional inequality – its economic policy has actively favoured London. The emergence of a powerful City–Bank–Treasury nexus in the capital has had far-reaching implications, and has led to economic policy in the UK being consistently geared towards boosting our financial sector at the expense of regional exporters.[6]

THE GROWTH OF THE UK'S FINANCE SECTOR HAS LED TO
THE EMERGENCE OF A FINANCIAL DUTCH DISEASE

Since the 1980s, the UK has had a large and persistent current account deficit.[7] The current account deficit reached a peak of 6 per cent of GDP in 2017 – one of the largest of any advanced economy.[8] Macroeconomic theory would suggest that interest and exchange rates in the UK should adjust to bring about a reduction of the current account deficit, but up until the vote to leave the European Union in 2016, sterling remained remarkably strong.

This puzzling pattern is explained by the UK's ability to attract financial flows from overseas due to our large financial sector. Our current account deficit – primarily the result of a trade deficit – is financed through an equally large surplus on our financial account. The attractiveness of UK assets to international investors over the last forty years can be explained by a combination of low global interest rates and asset price inflation in the UK. High levels of lending in the domestic economy, encouraged by financial deregulation in the 1980s, have pushed up the prices of UK assets, particularly housing. Asset price inflation has increased the amount of capital flowing into the UK via the financial account, much of which has been transformed into debt for UK consumers. These capital inflows are what have sustained the high value of sterling, even in the face of a large and growing current account deficit. This model ultimately came to a head in the crisis of 2007, which has had a much greater lasting impact on the UK's regions than on the financial centre in London.

This model amounts to the emergence of a form of financial 'Dutch disease' in which an overvalued currency, induced by the growth of the finance sector, negatively impacts other economic sectors and therefore those regions where finance is less significant.[9] Finance and related business services grew from 16 per cent of economic output in 1970 to 32 per cent in 2008, while manufacturing shrank from 32 per cent to 12 per cent over the same period.[10]

Dutch disease has manifested itself in the UK in two ways. First, with a strong currency boosting purchasing power the UK

economy has become extremely reliant on imports for consumption, while our manufacturing exporters have found it more difficult to compete and retain a domestic market share. This means that devaluation generates significant cost-push inflation, of the kind that the UK has experienced since the Brexit referendum.[11] Second, over time the strong pound has become 'locked in', as manufacturing sectors have developed a reliance on relatively cheap imported inputs. Path dependencies have now developed in UK manufacturing that make it harder for the sector to take advantage of currency depreciation when it does happen.[12]

This reduced capacity to benefit from exchange rate depreciations has been evident in the wake of the financial crisis. Between July 2007 and January 2009, the effective value of sterling declined by over 25 per cent. The pound dropped again when the UK voted to leave the European Union: since the vote, the value of sterling has fallen 25 per cent in effective terms.[13] This precipitous decline has failed to lead to an improvement in the UK's current account. In fact, it has catalysed an acute deterioration in the current account deficit, which peaked at 6 per cent of GDP in 2017. Since its low point, the current account has recovered somewhat, but statistics from the first quarter of 2018 show that the trade balance has started to deteriorate again.[14]

CENTRALISED POLICYMAKING HAS REDUCED
REGIONAL ECONOMIC RESILIENCE

Successive governments have failed to address this issue because policymaking has come to be dominated by a 'City–Bank–Treasury' nexus, in which the interests of finance in London are prioritised over those of manufacturers in the regions. Monetary and fiscal policy have, since the 1980s, exacerbated the problems associated with the UK's Dutch disease rather than ameliorating them:

- The new economic model of the 1980s focused on low inflation, stable exchange rates and low public spending. A steep rise in interest rates crippled British industry at the

very moment it required support and investment. The deregulation of financial markets catalysed the 'Big Bang' in London, which contributed to exacerbating a pre-existing 'Dutch disease' due to the discovery of oil in the North Sea, which saw a strong pound render what remained of Britain's exports even less competitive.[15] During the recession of the 1980s, manufacturing employment fell by 11.2 per cent, while employment in finance and insurance increased by 3.9 per cent.[16]

- The Labour government of 1997 responded to the clear regional problem that had developed by the early 1990s by increasing public sector employment. This helped to improve output and employment, but also increased public sector spending without providing a sustainable basis for long-term employment. As interest rates continued to increase, monetary policy worked in opposition to these measures, with a former governor of the Bank of England stating that 'unemployment in the North East is an acceptable price to pay to curb inflation in the South'. The North and the West Midlands saw their share of output from manufacturing decline from 24 and 27 per cent of regional gross value added (GVA) to 15 and 13 per cent respectively. Financial services output increased at double the rate of GDP growth and the proportion of GVA accounted for by manufacturing halved.

- The recent Conservative-led governments have since constrained public sector employment for the UK's regions, while again protecting it in London. The Conservatives have argued that the public sector is 'bloated' and needs to be cut back, with large parts of the country 'dependent' on public sector spending. Thanks to the structural decline of the previous decades, these areas are generally found in the North and the West Midlands. In the North, public sector employment has fallen by 302,000 (18.7 per cent), while in London it's fallen by only 91,000 (11 per cent) since 2009/10.

- The current Conservative government cites recent labour market statistics to indicate its positive record on job creation – across the UK, unemployment is the lowest it has been in decades. But this headline figure disguises both the regional variation within this figure, and the precarious nature of the employment that has been created. While unemployment in the UK as a whole is at 4.2 per cent, it is 5.1 per cent in the West Midlands, next to 3.3 per cent in the South West. Much of this employment is insecure, low-skill and poorly paid.[17]

During this time there has been some devolution and regional policy: since 2000 Northern Ireland, Scotland and, to a lesser extent, Wales have had economic power devolved to their national assemblies and parliaments. This appears to have borne fruit, with economic affairs spending per head consistently higher than in English regions in recent years, and some economic statistics in these nations are beginning to show relative improvement.[18]

However, within England – home to 55 million of the UK's 65 million population – regional policy has failed to gain a foothold. While the devolved nations were getting some real power and democratic legitimacy, the regions of England have remained under the control of Westminster via the regional development agencies. These were intended to be set up alongside regional assemblies to ensure some democratic accountability, but the government has shown little enthusiasm for this arrangement.[19] Without constitutional or democratic protection, these fragile bureaucracies were wiped out within months of the new government in 2010.

The high levels of political centralisation in the UK (more specifically England), coupled with the policy capture implied by the immense power held by the finance sector in the City of London, have resulted in a distinctive 'British business model', characterised by 'close government–business relations in finance and the economy and political influence of the financial services sector in the UK'.[20] This has meant that the interests of the

financial sector have, for decades, been placed at the heart of Britain's policymaking, and the policy decisions made by successive governments have served to exacerbate the challenges faced by regions outside of London, instead of supporting these regions to thrive in a rapidly changing world.[21]

More Economic and Fiscal Power Should Be Held in the UK's Regions and Nations

Devolution to the UK's regions is the only way to resolve the UK's severe regional problem. The fundamental problem facing UK productivity is the lack of regional autonomy necessary to mobilise the appropriate players, institutions, knowledge and capital in order to respond to global economic shocks and develop effective responses. While by its nature the effect of devolution is difficult to prove definitively, research has shown how regional economic performance – including resilience to shocks and restructures – is closely related to the strength of governance and the presence of regional institutions.

Fiscal devolution is a challenging but extremely important component of devolution. In the UK, local government raises only 5 per cent of total taxation, placing it among the most 'fiscally centralised' countries in the developed world.[22] Contrary to suspicions that fiscal devolution will exacerbate these differences, a wealth of research has shown that it tends to engender a 'race to the top' and greater equality:

- Fiscal devolution can improve GDP per capita, and is strongly correlated with investment in human and physical capital, as well as education outcomes.
- Regional disparities are reduced in countries where more local spending is financed by local taxes, because sub-central governments are more inclined to spend on economic development.
- Fiscal devolution results in higher levels of equality, improved well-being and improved social welfare.[23]

Fiscal devolution may be essential, but it will not be achieved easily and needs a long-term solution in order to work. Because of the many decades of underinvestment, parts of the country simply don't have an economy strong enough to generate the tax revenues required. This means that any fiscal devolution will need to be preceded by a period of 'pump priming' by central government funding streams, before taking on greater responsibility. There will also need to be safeguards in place, and some redistribution between regions will always be necessary. Moreover, any new regional institutions must be sufficiently democratic to ensure that the interests of citizens are placed at the centre of a new regional settlement.[24] The UK does not lack the capacity to move towards such a settlement, merely the political will.

Conclusions

The UK has a serious regional problem: over generations, successive governments have failed to utilise the economic assets that sit outside of London, and with each economic shock or shift governments have simply doubled down on the capital as the supposed 'engine' of the UK economy. This is not simply globalisation running its course: it has been driven by policy decisions.

These decisions have been made almost exclusively by central government. For decades, central government managed and manipulated globalisation in the interests of London and the financial sector. A centralised state has built an economy which has itself become centralised on one city, and far too dependent on one particular sector. With no regional government or industrial strategy, the modernisation of the rest of the country's economy has been a painful uphill battle. It is clear that our national experiment with centralisation has categorically failed.

To deliver national prosperity, Labour must end its love affair with the centralised state and devolve real power to the regions of England. We will only have thriving regions if central government

ends the 'Whitehall knows best' approach to economic policy, which has surely been proven to be a mistake. To act as a real counterweight to London, these regional institutions must be afforded real powers, be properly resourced and, crucially, be made democratically accountable to citizens.

Democratic Ownership in the New Economy

Joe Guinan and Thomas M. Hanna

Britain needs a democratic ownership revolution. Our deepening problems – wage stagnation, underinvestment, low productivity, widening inequalities of wealth and power – are not simply accidental or the result of poor policy choices but the entirely predictable outcomes of the basic organisation of our economy. The institutional arrangements at the heart of today's capitalism – private ownership, credit creation by banks, global capital markets, giant publicly traded corporations – together form the most powerful engine for the extraction of value the world has ever known. It is this set of relationships, this basic institutional design, that drives the outcomes we are seeing in terms of crumbling public infrastructure, social atomisation, uneven development, environmental destruction and a widespread sense of popular disempowerment.

A political economy is a system, and our system is programmed not to meet basic needs but rather to steadily concentrate virtually all the gains to the economy in the hands of a tiny elite. Fifty-two per cent of all wealth in the United Kingdom is now held by the top 10 per cent, with 20 per cent held by the top 1 per cent – and inequality continues to grow. It follows that if we are serious about addressing real economic challenges then we need a different set of institutions and arrangements capable of producing sustainable, lasting and more democratic outcomes – an economy for the many not the few.

The Labour Party is now promising to deliver this fundamental change. Jeremy Corbyn's leadership has opened up space for a broader political conversation on economics than has been possible for many decades. Not since the 1970s and early 1980s – when the party was committed to bringing about what Tony Benn termed 'a fundamental and irreversible shift in the balance of power and wealth in favour of working people and their families' – has Labour put forward as bold a plan for the transformation of Britain as is contained in the 2017 manifesto, *For the Many Not the Few.*

Although widely described as a social democratic programme, the manifesto in fact contains the seeds of a radical transformation beyond social democracy. Policies such as establishing a national investment fund to help 'rebuild communities ripped apart by globalisation', linking public sector procurement to a regionally balanced industrial strategy, creating a national investment bank and a network of new regional public banks, and democratising the economy by supporting public and worker ownership provide the vision of a break with established economic orthodoxies. In combination with a commitment to devolving and decentralising power and decision making to local communities, and forming a Constitutional Convention that 'will look at extending democracy locally, regionally and nationally, considering the option of a more federalised country', the contours of a very different pattern of political economy begin to appear.

The scaffolding of this emerging new approach can be found in John McDonnell's 'new economics'. At the core of this programme is a new set of models, institutions and strategies that, if put in place, would in and of themselves produce vastly improved societal outcomes. In his first conference speech as Shadow Chancellor, McDonnell pledged that Labour would 'promote modern alternative public, cooperative, worker controlled and genuinely mutual forms of ownership'. Instead of the extractive and concentrating forces of corporate capitalism, the new economics would be circulatory and place-based,

decentralising economic power, rebuilding and stabilising regions and local communities, allowing for the possibility of real democracy and participation, and providing the long-run institutional and policy support for a new politics dedicated to achieving genuine social change.

A few days before the June 2017 election Labour released *Alternative Models of Ownership*, a report to McDonnell and Rebecca Long-Bailey, Shadow Secretary of State for Business, Energy and Industrial Strategy, by a group of cutting-edge theorists and practitioners. This report represents the beginnings of the most exciting economic programme to be developed for the Labour Party in forty years. It models the way in which the wider left should now be rolling up its sleeves and getting to work, going beyond rhetoric to detailed institutional design and policy formulation. It starts from the premise that if powerful underlying trends are to be altered it is no longer possible to sidestep fundamental questions of ownership and control, and concludes that, ultimately, a truly impactful alternative left strategy must go after capital itself. The authors of the report call on Labour to 'push issues of economic ownership and control to the front of the political agenda' and 'commence work on a strategy to win support' for such ideas.

None of this is about selling a fantasy. Real-world examples of democratic, participatory economic alternatives already exist (or previously existed) in communities across the globe. Worker ownership, cooperatives, municipal enterprise, land trusts and a host of kindred institutional forms all represent ways in which capital can be held in common by small and large publics. They illuminate how practical new approaches can generate innovative solutions to deep underlying problems. They embody alternative design principles, relying not on regulatory fixes or 'after-the-fact' redistribution but on fundamental structural changes in the economy and the nature of ownership and control over productive wealth that go right to the heart of our current difficulties – and are capable of producing greatly improved distributional and other outcomes as a matter of course. They breathe new life

into old traditions of economic democracy through the democratisation of capital.

There are huge potential benefits to pursuing a massive expansion of democratic ownership. The opportunity presented by the coming 'silver tsunami' of retiring baby boomer business owners, and the succession question this raises for large numbers of small and medium-sized firms, means that the time for such an expansion is now. *For the Many Not the Few* calls for a 'right to own', which would give workers the right of first refusal when their companies are up for sale. *Alternative Models of Ownership* takes this further, urging (among other things) that local public authorities in the UK should be actively supporting and funding the incubation and expansion of worker cooperatives as part of their local economic development strategies, as is now happening in cities across the United States. It also suggests that Labour should investigate the benefits and limitations of employee stock ownership plans, which – again as in the United States – could dramatically increase worker ownership with little risk or cost to workers.

A large worker-owned and cooperative sector could form an important institutional base for a new place-based economics and politics in Britain – one that is capable of overturning simplistic notions of 'pro- or anti-business' and replacing them with new alignments around embedded democratic local and regional economics in opposition to footloose, extractive multinational corporations lacking any real ties to place. In a political landscape fractured and divided by Brexit, decentralised public control of the economy could reconstitute the basis for democratic participation by giving people real decision-making power over the forces that affect their lives – a chance to actually 'take back control'.

The June 2017 election showed genuine popular appetite for Labour's new direction. Theresa May achieved a vote share comparable to Margaret Thatcher's in 1983. That the Conservatives lost rather than increased their majority is due to the 'Corbyn surge', an unprecedented turnaround in public

opinion resulting in Labour's largest vote share increase since 1945. The Labour Party is now a government-in-waiting, poised for the next general election, which could come at any time and could easily carry Corbyn into Downing Street as prime minister.

Embracing the magnitude of this historic opportunity, the British left's task now is to put flesh on the bones of a transformational agenda capable of living up to the hopes and responding to the deep structural challenges of a fluid and rapidly changing political and economic landscape. To consolidate the ambitious project they have initiated, Corbyn and McDonnell must now follow through on the construction of a radical new left political economy. The responsibility is enormous. As McDonnell has said, 'I want us to surpass even the Attlee government for radical reform. The situation demands nothing less.'

Models of Economic Democracy: Spain, Italy, Canada

It's easy to miss just how radical Labour's new economics really is, in the original sense of 'getting at the root of the matter'. When it comes to economic fundamentals, there has been a decades-long deficit of new thinking and ideas on the left. Most social democrats are still splashing around far downstream from where the real action is, seeking a way forward among the muddy puddles of 'tax-and-spend' transfer policies and modest redistribution left behind by the high tide of Keynesianism and the welfare state.

Even Thomas Piketty, in his bestselling book *Capital in the Twenty-First Century* – a masterwork of statistical analysis of capital accumulation over the *longue durée* that demonstrated capitalism's 'fundamental force for divergence' – largely avoided grappling with the deep structural determinants of who owns capital, focusing instead on 'regulating capital' via a global tax on wealth. However, given that returns to capital are increasing at the expense of labour, it's only natural that we should be looking

at broadening and democratising ownership. Nobel laureate Robert Solow commented to this effect during a 2014 panel on Piketty's book in Washington, DC. Among the 'things we can do', he observed, 'democratising the ownership of wealth is perhaps the most obvious'.

Who owns and controls capital – productive wealth – is the most fundamental question of political economy, central to understanding the operations of any economic system. Karl Marx famously viewed human history through the lens of the differing forms of ownership of the means of production. In tribal societies, communal ownership and cooperative labour were widespread. Ancient societies, by contrast, were characterised by patrician ownership, with slave labour serving as the critical source from which the propertied classes extracted their surplus. In the Middle Ages, agricultural production by feudal elites was the primary economic driver, with labour provided by a peasant class tied to the land. Under industrial – and, more recently, financial – capitalism, the means of production has largely been in the hands of capitalists, to whom workers sell their labour for wages.

For socialists, responses to capitalist private ownership of the economy have traditionally been divided along two main lines. In vastly simplified terms, *state socialism* placed ownership and control of capital with the state, whereas *social democracy* left it largely in private hands but sought to redistribute the returns through taxation and transfers via the welfare state. A neglected third tradition, however, largely eclipsed by the left's two great twentieth-century projects, is to be found in the long-running libertarian socialist commitment to *economic democracy*.

The central idea of economic democracy is the notion of extending principles of popular sovereignty from the realm of politics and governance into economics. In *A Preface to Economic Democracy*, the renowned American political scientist Robert Dahl defined economic democracy as 'help[ing] to strengthen political equality and democracy by reducing inequalities originating in the ownership and control of firms'. Approaching the

question from the opposite end, G. D. H. Cole, the British guild socialist theorist and economic democracy advocate, argued that principles of democracy should apply 'not only or mainly to some special sphere of social action known as "politics", but to any and every form of social action, and, in especial, to industrial and economic fully as much as to political offices'.[1]

Labour is no stranger to the economic institutions involved. Many of them have their origins in the struggles of the nineteenth- and twentieth-century European workers' movement. In Britain in particular, economic democracy has a long and impressive lineage going back to the dawn of the Industrial Revolution, from Luddite insurrections to the Owenite movement, the Grand National Consolidated Trades Union, and the syndicalism of Tom Mann. The birth of the modern cooperative movement can be traced back to the Rochdale pioneers – and today it boasts a billion members worldwide. There have also been many overseas experiments, ranging from Algerian 'autogestion' and Yugoslav workers' self-management to Argentine factory reclamations, each providing important design and operational lessons for the future. In Italy and Spain – both on the front lines of recent austerity struggles – and in Canada there are prominent examples that show the power of the institutions of economic democracy when taken to scale in particular geographical locations.

In the Basque region of Spain, the famous 73,000-person Mondragon Cooperative Corporation – one of the largest corporations in the country – has annual revenues of around €12 billion across a network of companies that include retail, manufacturing and financial services. The first cooperatives date from the mid-1950s, and the network has since evolved into a federation of 102 cooperatives, 140 subsidiary companies, eight foundations and a benefit society. Each year it teaches some 10,000 students in its education centres, and has roughly 2,000 researchers working at fifteen research centres, at the University of Mondragon and within its industrial co-ops.

Mondragon has, over time, evolved a participatory decision-making structure, and a far more egalitarian compensation structure than is to be found in similar-scale capitalist enterprises. Mondragon's pay ratio, top to bottom, is a maximum of around nine to one, whereas comparable private companies in the UK often operate with pay ratios between the chief executive and the *average* worker of over a hundred to one. There are also multiple levels of democratic representation and participation at Mondragon, including direct election of managers by workers, general assemblies (both annually, and to deal with specific issues) and representative councils made up of delegates from each co-op in the network.

Mondragon is not without its limitations. As Sharryn Kasmir has pointed out, it has made certain compromises to its cooperative principles over the years in order to compete in global markets, including hiring lower-cost wage labourers in its foreign plants and temporary and short-term contract workers in some of its Spanish businesses.[2] Unlike most traditional large corporations, however, Mondragon acknowledges these practices as deficiencies to be corrected rather than advantages to be exploited. Many observers have also noted its highly egalitarian and cooperative internal culture.

Moreover, Mondragon has served as an important anchor amid recent economic storms. The unemployment rate has remained much lower in the Basque country than in Spain as a whole, and when Mondragon was forced to lay off workers in the wake of the 2008 financial crisis – and again in 2013, with the bankruptcy of Fagor Electrodomésticos, its flagship white goods manufacturer – many were rehired by other companies within the network or provided with support from its social insurance funds.

Another oft-cited, significant-scale modern experiment in economic democracy is to be found in Emilia Romagna in Italy's *zona rossa*. The so-called 'Emilian Model' consists of a grouping of more than 8,000 worker-owned enterprises in the region's cooperative economy, which now accounts for around 40 per

cent of area economic activity. It has helped transform Emilia Romagna from one of the poorest regions in the country in 1970 to one of its most prosperous (and one of the richest in Europe) today. Significantly, the region also boasts Italy's most equal distribution of wealth.

Author and cooperator John Restakis calls Emilia Romagna 'the world's most successful and sophisticated cooperative economy'.[3] It represents one of the primary examples of a networked model of economic organisation. 'Networking', as University of Bologna economic historian Vera Zamagni recently observed, 'is the alternative to full integration, to reap economies of scale and scope. If and when mergers and the building up of a single integrated firm is not acceptable either on technical grounds (need for specialisation) or on cultural ones (no propensity to work in a big business), networks can provide the necessary cuts in transactions costs.'[4]

The development of Emilia Romagna's network model of production was aided in its early stages by the creation, in 1974, of a majority publicly owned economic development agency, ERVET (Ente Regionale per la Valorizzazione Economica de Territorio). ERVET's mandate was to implement a regional industrial strategy, to which end it established a network of specialised subsidiaries to provide local firms with a variety of services and support, ranging from certification and marketing to business development.

The Emilian Model – and Italian cooperatives more generally – also benefited from other forms of state support. In addition to the provisions of Italy's postwar constitution guaranteeing recognition of cooperatives, supportive legislation has included a 1977 tax exemption for co-op profits designated for indivisible reserves, a 1983 provision allowing co-ops to hold shares in and control joint stock companies, and a 1991 law formally recognising social cooperatives. There is also the famous 'Marcora Law' – first passed in 1985, struck down by the European Union as illegal state aid, and then revived in modified form in the early 2000s – which set up funds to invest in

co-ops formed by workers who have been laid off from companies that are closing or downsizing.

A third example is the so-called 'social economy' (or solidarity economy) in Québec, Canada. In a province of around 8 million people, cooperatives and enterprises linked to non-profit organisations account for upwards of 200,000 jobs, CAN$40 billion in assets, and between 8 and 10 per cent of GDP. 'We always say the social economy is simply the formalisation of the commons', Nancy Neamtan, co-founder of Chantier de l'économie sociale, a network of social economy organisations, has stated. 'It's social ownership, the goal of which is a sustainable, democratic economy with a market – instead of a market economy.'[5]

In Québec, solidarity economy enterprises in sectors ranging from agriculture to housing, and from childcare to media to manufacturing, are supported by a diverse array of public and private institutions, including government, philanthropy, trade unions and non-profits. For instance, the Fonds de solidarité is a Can$13 billion capital fund established by the FTQ union (Fédération des travailleurs et travailleuses du Québec) that invests in small and medium-sized businesses across the province under the guiding principle of 'sustainable economic development where people come first'. It also serves as a vehicle for residents to save for retirement by selling shares, which return a dividend and are given favourable tax treatment by the government.

A New Wave of Democratisation: The United States

Mondragon, Emilia Romagna and Québec are only the most prominent longstanding attempts around the world at building a more democratic economy. Recent decades have also seen a more general uptick of interest in economic democracy, and of experimentation with its institutions and approaches – especially with the onset of neoliberal crisis and austerity.

The collapse of the Argentine economy back in 2001 saw unemployment soar to 25 per cent, prompting the emergence of

the *sin patrón* ('without bosses') movement, numbering over 10,000 workers in around 200 recovered workplaces – 'an old idea', as Naomi Klein remarked, 'reclaimed and retrofitted for a brutal new time'.[6] More recently, new waves of factory occupations have followed in the wake of the 2008 financial crisis, especially in Europe (in Spain, Italy, France and Greece) but also in Egypt and the United States.

The shuttering of Republic Windows and Doors in Chicago and its reopening (after two occupations) under cooperative worker ownership as New Era Windows garnered international attention, as did the experiment in economic and ecological self-management at the Vio.Me factory in Thessaloniki, Greece. Such crisis-driven, worker-led transitions of previously capitalist enterprises into collective ventures offer hope for a new future rising out of the ashes. The growing sophistication of older cooperative networks in Spain, Italy and Canada, described above, demonstrates the ongoing viability of such models over time and at scale.

In the United States, deepening structural problems and the inability of traditional politics and policies to address fundamental challenges are now fuelling an extraordinary amount of experimentation along similar lines, much of it unreported by the corporate media. As federal and state transfers dry up, social pain is intensifying in communities that have long suffered high levels of unemployment and poverty. Precisely because large public expenditures for jobs and housing have become increasingly impossible politically, more and more people are turning to economic alternatives in which new wealth is built collectively and from the bottom up.

The Democracy Collaborative has been tracking and promoting the growth of these innovations across the United States for almost two decades, under the rubric of 'community wealth building'. They include cooperatives and municipal enterprises, non-profit community-owned corporations and land trusts that keep housing affordable over the long term, as well as community financial institutions responsible for US$60 billion a year in local investment. Employee ownership now encompasses over

10 million US workers, around 3 million more than are members of unions in the private sector. Fully a third of Americans (over 100 million people) belong to various urban, agricultural and financial cooperatives, including credit unions that have around 111 million members and manage US$1.3 trillion in assets – more than Wall Street giant Goldman Sachs.

Worker co-ops are emerging in every sector of the economy. In New York City, a coalition of grassroots community organisers and cooperative advocates – including the New York City Network of Worker Cooperatives, an affiliate of the United States Federation of Worker Cooperatives, and the Working World (which originated in the Argentine factory reclamations) – secured multi-year funding from the city's budget to support the development of worker-owned businesses in low-income communities. One of the driving forces behind the New York City legislation is Cooperative Home Care Associates, the largest worker co-op in the United States, with 2,000 unionised workers (most of whom are women of colour) who enjoy above-average pay and benefits as a result of their cooperative business model.

Similar advances have been made in other American cities. In Madison, Wisconsin, the city council passed a measure earmarking US$3 million for cooperative development. Supported by Mayor Paul Soglin and backed by a diverse coalition that includes the University of Wisconsin Center for Cooperatives, the South Central Federation of Labor and various other community organisations, unions and economic development groups, half the funds will be used to capitalise a loan fund that will facilitate the conversion of existing businesses to worker cooperatives, help form worker-union cooperatives and provide general start-up capital for all forms of cooperative enterprises, while the other half goes to build technical assistance capacity.

Another variation on the theme has seen a number of trade unions begin to explore new directions involving worker cooperatives and community structures. Some are moving to act in a significant way, notably the United Steelworkers (USW), who signed an agreement with Mondragon in 2009 and are now

actively supporting new worker-union co-ops in Cincinnati, Ohio and other cities. The union co-op model is based in significant part on the Social Council, which functions as a voice for workers at Mondragon.

In the public sector, state and local government economic development programmes now invest in local businesses while municipal enterprises build infrastructure and provide services, raising revenue, creating employment and diversifying the base of locally controlled capital. Publicly owned utilities, together with co-ops, currently provide a quarter of America's electricity – including in Nebraska, an all-public-power state in which every resident and business gets electricity from one of 166 community-owned entities. From California to Alabama, public pension assets are being channelled into job creation and community development. Many states and a growing number of cities (from Santa Fe, New Mexico to Philadelphia, Oakland and Los Angeles) are looking to the creation of public banking systems like North Dakota's, widely credited with ensuring that the state had no bank failures and a low unemployment rate during the financial crisis and Great Recession. Giant public trusts that capitalise on public ownership and management of natural resources are providing revenue streams from capital and directly funding public services in places like Alaska, Texas and Wyoming, recalling the unjustly neglected ideas of the economist James Meade.

The full scale of the possibilities is just beginning to be understood. From parks and blood banks to libraries and the internet, commons management systems can provide an expanding zone of decommodification to buffer against the market. Public trusts can be extended into additional domains, from water and air to the electromagnetic spectrum, underwriting public services or issuing a citizen dividend. Platform co-ops can offer a democratic alternative to the increasingly evident depredations of the 'sharing economy'. Community land trusts can ensure the long-term affordability of housing and prevent disruptive gentrification and speculative real estate bubbles. Participatory budgeting

and planning approaches can establish local democratic control over the allocation and distribution of public funds. It is becoming possible to project and extend a vision of fully democratised local and regional economies, oriented towards local multipliers, as an alternative to neoliberal austerity and corporate extraction.

Examples of such strategies are increasingly thick on the ground and growing in sophistication. The 'Cleveland Model' in Ohio – our own flagship initiative – involves redirecting the massive purchasing power (around US$3 billion a year in goods and services) of large non-profit 'anchors' (hospitals and universities) in support of a growing community-based network of linked green worker co-ops in historically disinvested and predominantly black neighbourhoods. Meanwhile, several jurisdictions have been investigating the possibility of using eminent domain (a form of compulsory purchase) to seize and refinance underwater mortgages in radical new principal-reduction schemes, or have established publicly owned or non-profit land banks to take direct ownership of vacant and foreclosed properties. This builds upon efforts begun in the late 1980s, when the city of Boston granted the Dudley Street Neighborhood Initiative (DSNI), a non-profit community development corporation, eminent domain powers over vacant land in a neglected sixty-acre portion of the city and entered into a partnership agreement with the organisation related to publicly owned vacant land in the area. DSNI has subsequently established a community land trust to ensure permanently affordable housing and developed more than half of the neighbourhood's 1,300 previously vacant lots.

Examples of the power of such strategies can also be found in places where they might least be expected, deep behind enemy lines in Trump's America. Kentuckians for the Commonwealth, for example, organised for participatory economic planning around a post-coal future in Appalachia, fighting for the Clean Power Plan when it was blocked at the state level. Greensburg, Kansas became – in a deep red state, under a Republican mayor

– one of the greenest towns in the country when the government acted as partner and catalyst to rebuild the town after it was levelled by a tornado. Chattanooga, Tennessee has one of the fastest internet connections in America, thanks to a municipal fibre broadband network, whereby public ownership of digital infrastructure is driving local economic revitalisation.

Such approaches point in the direction, ultimately, of rebuilding a power base, in both 'red states' and 'blue cities', for a transformative politics capable of standing on its own feet and managing the economy for the benefit of the many, not the few. They suggest a way forward to a more democratic economy that is rooted in place, one that can deliver local development, jobs, environmental sustainability and new public revenues without requiring drastic cuts to social services or massive burdens on local taxpayers. They indicate the likely future preconditions of genuine regional, national and international cooperation built on mutual benefit and solidarity in a world faced with global challenges such as climate change and war. They embody the social architecture of a new economy – a quiet ownership revolution that is slowly gathering pace, offering a powerfully appealing alternative vision to set against the current downward trajectory of deepening inequality and ongoing crisis and decay.

Bringing Home the Revolution

Twice in the course of the last century, radical reforming governments have brought about fundamental transformations of Britain's political economy on the basis of significant changes in ownership. In the first instance, the nationalisations of the 1945–51 Labour government brought the Bank of England, coal, steel, civil aviation and the major utilities into public hands. This was conducted in the teeth of vehement political opposition, including interventions on behalf of the UK private sector by the United States government. By 1951, Labour had reorganised large chunks of British industry and assembled a public sector workforce of 4 million, 18 per cent of the total. A fifth of the

economy was in public ownership, with the government sector responsible for a third of net fixed capital formation. Despite a great deal of mythology to the contrary, the nationalised industries were quite efficient, outperforming both their US privately owned counterparts and the British economy as a whole in terms of total factor productivity. For all its shortcomings, this remains today the most radical economic programme ever implemented in Britain.

The second occasion saw a counterrevolution. The Conservative governments of Margaret Thatcher and John Major substantially reversed the earlier transformation of ownership. The commanding heights of the economy – electricity, gas, water, steel, civil aviation, telecoms and railways – were all delivered up for auction. Between 1980 and 1996 Britain racked up fully 40 per cent of the total value of all assets privatised across the OECD, an astounding figure. The only remotely comparable experiences occurred in countries – Pinochet's Chile and the disintegrating Soviet Union – that were undergoing exceptional transitions and in which the rule of law was basically inoperative.

Thatcher's privatisations amounted to a massive transfer of wealth from public to private interests. Most small individual investors sold their shares within a relatively short period, reaping quick capital gains from undervaluation but giving the lie to extravagant promises of a shareholder democracy. Privatisation not only allowed for attacks on the trade unions and a restoration of capital's 'right to manage' but was also – together with Big Bang deregulation – instrumental in the expansion of London-based capital markets. The £3.9 billion rollout of shares in British Telecom in 1984, for example, was *six times* larger than any previous stock offering. In this way the serial privatisations of the 1980s and 1990s helped secure the ascendancy of finance capital and the City.

Today, we are within sight of another revolution in ownership. The current Labour leadership is carefully putting together a new twenty-first-century socialist political economy – one with a direct focus on democratised ownership at its core. 'Co-operatives,

shared ownership, and workplace democracy', McDonnell has stated, 'all have a central role to play here' – 'here' being at the heart of what he terms 'the new economics'.[7] Corbyn, for his part, has called for local councils to have more freedom to run utilities and services in order to 'roll back the tide of forced privatisation'.

It's also clear that a Corbyn government would have no intention of simply reverting to the postwar model of public ownership – that of large, top-down, centralised public corporations at arm's length from democratic control. McDonnell has spoken of the limitations of such bureaucracies, stating that 'the old, Morrisonian model of nationalisation centralised too much power in a few hands in Whitehall. It had much in common with the new model of multinational corporations, in which power is centralised in a few hands in Silicon Valley, or the City of London.' The alternative, he argues, is *plural* forms of democratised and decentralised common ownership at a variety of scales: 'Decentralisation and social entrepreneurship are part of the left . . . Democracy and decentralisation are the watchwords of our socialism'. This dual emphasis on democratised ownership and radical political decentralisation is truly remarkable coming from the national leadership of a major political party.

Corbyn and McDonnell have created a hugely important opportunity. The tools and strategies exist to enable the British left to pursue a bold economic programme based on alternative economic institutions and approaches and the centrality of ownership, control, democracy and participation. Given the growing systemic challenges facing our politics and economics – not to mention the impending threat of climate catastrophe – it's imperative that we now begin thinking and planning for the long haul, as well as developing strategies that contain the potential for creating (as neoliberalism was able to do in a different way) a new politics and culture based on a new notion of collective agency and democratic economic citizenship.

In this way we can aim to generate the fundamental transformation Britain so urgently needs – and, in so doing, create a

powerful model for emulation far beyond our borders. As the long dark night of neoliberalism comes to a close, radical economic change appears once again to be within our grasp, making this the most exciting time to be active on the British left in a generation. To borrow from Raymond Williams, ours will doubtless be a Long Revolution but it's under way at last.

A New Urban Economic System: The UK and the US

Matthew Brown, Ted Howard, Matthew Jackson and Neil McInroy

Introduction

The United Kingdom's economic model and approach to economic development are flawed. Economic growth has stagnated and where we do have economic growth it is benefiting the wrong people. The wealthiest are becoming wealthier and we have entrenched issues of inequality and poverty. Inequality is not as simple as a north–south divide – it is evident everywhere. Despite this inequality, the economic approach remains largely unchanged – attract inward investment and the benefits will 'trickle down' to local economies and communities. This thinking is outdated, wrong and lacks supporting evidence.

What we need is reorganisation of the economic approach – where we recognise, understand, build and harness wealth at the local level for the benefits of people and places. This wealth comes in the form of the institutions, assets and people we have at the local level, and our ability to deliver economic development that brings a local economic, social and environmental dividend.

Some places in the UK are beginning to understand the need to adopt a different approach to local economic development. However, the vast majority still build their economic strategy around narrow notions of growth, the knowledge economy and inward investment.

Over the last thirty years, the Centre for Local Economic Strategies (CLES) has been at the forefront of UK-based policy thinking about local wealth building, most recently in our collaborative work in Preston. In the United States, the Democracy Collaborative has developed and promoted a similar approach under the framework of Community Wealth Building. This chapter draws together the learning from CLES's work in the UK in Preston and other places such as Birmingham and Oldham with that from Cleveland, Ohio by the Democracy Collaborative. What we portray below through exploration of the Cleveland and Preston 'models' is a new way of thinking and practice about local economic development, but thinking that should be – and is – becoming the mainstream.

The US and the Cleveland Model

Despite having the largest and most productive economy in the history of the planet, the United States is beset with a systemic crisis in its political economy, one that is deeply destructive of the country's democracy. Today, just 400 Americans own as much wealth as approximately the bottom 185 million, and the trend in wealth inequality is escalating. White median net wealth is thirteen times greater than among African Americans and ten times greater than Latino net wealth.

Twenty-two per cent of American children live in poverty, a percentage that is the same as in the 1960s. The number of people living in concentrated poverty has doubled from 7 to 14 million since 2000; all told, nearly 50 million people in the US live below the government-established poverty line. Health inequality is on the rise, with the life expectancy gap between rich and poor people born in 1950 up significantly over those born in 1920. The labour force participation rate has fallen steadily for two decades – and is projected to decrease still further. America's core urban areas continue to erode and become less stable through disinvestment in an age of capital hyper-mobility.

Traditional economic development, as practised in American cities and states, has proven increasingly incapable of addressing these systemic challenges. The use of more than US$80 billion annually in public subsidies, tax breaks and corporate incentives has resulted in a situation in which every city is at war with every other city, as they try to entice corporations (some would say 'bribe' them) to relocate from one community to another. This zero-sum game produces local economic instability and rewards companies with no real loyalty to the community. The general approach has been to pursue regional economic growth, on the assumption that some of the benefits would 'trickle down' to those most in need of decent work, wages to support families and the fulfilment of basic needs. Demonstrably, though, 'trickle down' is not working.

Fortunately, over the past decade and a half a powerful new approach to equitable and inclusive economic development has gathered momentum in communities across the country. This new paradigm is called 'community wealth building'. Rather than simply a partnership between business and government (with business usually calling the most important shots), community wealth building involves many key local actors – community-based organisations, anchor institutions, philanthropy, locally owned businesses, organised labour and the public sector. Community wealth building is a progressive strategy to democratise the economy by broadening ownership over capital (through, for instance, cooperatives, employee ownership, credit unions and land trusts), preventing financial resources from leaking out of the community (through targeted 'buy local' initiatives, social procurement and public banking), thus achieving a multiplier effect in the local economy, and leveraging the economic power of existing assets (such as large public and non-profit institutions) to benefit the local community. The fundamental goal is to rebuild the basis of a strong local economy, from the ground up, on principles of equity, inclusion, democracy and resilience.

The pre-eminent model for this new system-changing approach in the United States is the Evergreen Cooperatives of

Cleveland, Ohio. Cleveland is a mid-size Midwestern US city –
with about 386,000 residents. In the 1950s, Cleveland was one
of the most successful cities in the country, with a population of
915,000 people, and ranked in the top-five wealthiest communi-
ties in the nation. (Cleveland was home, for instance, to John D.
Rockefeller, and in the late nineteenth century the tax valuation
of properties along the major street, Euclid Avenue, exceeded
that of Fifth Avenue in New York City.) Today, Cleveland is
consistently ranked in the top-five poorest cities, a victim of
deindustrialisation, flight of capital and jobs, and neoliberal
trade deals and federal government policies that have devastated
its once great manufacturing base. Roughly 35 per cent of the
entire city's population lives in poverty.

The Evergreen Cooperatives – now widely known across
the United States as the 'Cleveland Model' – began in 2007.
The Democracy Collaborative, an action-oriented think tank
that has pioneered the concept of community wealth build-
ing for nearly twenty years, was commissioned by the
Cleveland Foundation (the city's largest philanthropy) to
create a new approach to business development and job crea-
tion among unemployed Clevelanders. The model that
evolved into the network of Evergreen businesses was based
on a set of insights and principles that have guided its mission
from inception:

- *A job alone is not enough*: work should not only pay a family-
 supporting living wage but also enable workers to build
 their personal and family assets. A job can lift you out of
 poverty, but it is assets and wealth that keep you out of
 poverty.
- *Employment must be created near where people live*: for people
 without access to good transportation, a job that is ten
 miles from their home may as well be one hundred miles
 away.
- *Jobs must be available to the most disadvantaged residents*:
 people with 'barriers to employment' – such as a criminal

record or low educational attainment – need to be brought into the economy through an inclusive and equitable wealth-building strategy.

• *Local assets must be leveraged to rebuild a local economy*: in Cleveland's case, three of these assets – the Cleveland Clinic, University Hospitals and Case Western Reserve University – annually purchase more than US$3 billion in goods and services. But most of these procurement dollars were leaving the community rather than going to local vendors, thus creating little local economic impact.

• *A community wealth strategy must be closely tied to the broader community*: the goal is not only to build up the assets of individuals and families, but the entire community must benefit. In the case of Cleveland, the target geography has 50,000 residents. Any meaningful economic development strategy must be linked to ways that impact the whole community, creating and anchoring productive capital in local neighbourhoods, and broadening ownership over it to produce the maximum benefit to all.

Based on these insights and principles, the first Evergreen worker cooperative – the Evergreen Cooperative Laundry (ECL) – was launched in October 2009, following a nearly two-year development and incubation period. Today, the co-op has about fifty employees – every member owns a share in the company. Members elect some of the company's board of directors and participate in setting broad company policy, including electing the president of the company and determining how profits should be allocated. After several years of business challenges, the company is now highly profitable and workers are sharing in those profits. Many are also participating in Evergreen's home-buying programme, a company-sponsored asset-building initiative to enable workers to buy their homes so that they can stay in the neighbourhood and help with its revitalisation. The company is now anticipating expanding beyond its current capacity of about 8 million pounds of laundry (mostly towels and sheets for

local hospitals and nursing homes) to perhaps as much as 20 million pounds.

Another Evergreen Cooperative, Evergreen Energy Solutions (E2S), is in the renewable energy and green construction business – including installations of large solar arrays to meet the energy needs of the city's anchor institutions, and LED lighting installation in parking garages and other facilities. Among its achievements is constructing a one-megawatt solar field providing clean energy to a local hospital and university – the largest such array in any core urban area in America.

A third company, Green City Growers (GCG), is a year-round hydroponic greenhouse now producing 3 million heads of leafy greens and several hundred thousand pounds of basil for the local food market. By growing lettuce locally in downtown Cleveland, GCG is keeping millions of dollars from leaving the local economy to purchase lettuce from more than 1,200 miles away in Mexico, California or Arizona. Like ECL and E2S, GCG is owned by its employees.

All of these companies have been supported in various ways (including through the extension of low-cost loans) by the city government. Local philanthropy, particularly the Cleveland Foundation, has been a longstanding supporter. Anchor institutions have committed to using the services of these companies – since universities and hospitals are rooted in place and rarely move, these institutions see it as a sound business proposition to support local community-owned businesses. This growing integrated network of for-profit, worker co-ops (more are in the pipeline and scheduled for 2018) has not only provided employment for hundreds of Clevelanders (most previously unemployed) but has generated millions of dollars in tax revenues for the city's general fund, including the local educational system, which is under severe financial pressure.

All of this activity is coordinated by a non-profit 'holding company' – the Evergreen Cooperative Corporation. Its mission is not only to create employment for Clevelanders, but also to

build assets and wealth for the *entire* community, as well as spread
education about the virtues of cooperative ownership as a busi-
ness model. In service of the community mission of Evergreen,
each of the operating companies agrees to provide a portion of
their profits to the holding company to develop employment
opportunities for others in the community. Thus, to be success-
ful, an Evergreen company must not only turn a profit but also
contribute in concrete ways to revitalising the broader commu-
nity beyond the walls of the business.

Today, the Evergreen model is inspiring similar community
wealth strategies in other American cities. The city of Rochester,
New York has launched the Market-Driven Cooperative
Corporation and Richmond, Virginia has created an Office of
Community Wealth Building in the city government structure.
A growing number of cities have begun to fund the creation of
workers' cooperatives as part of their economic development
strategy. Anchor-institution collaboratives that localise procure-
ment, hiring and investment are growing rapidly. The Democracy
Collaborative has recently launched the Healthcare Anchor
Network, a consortium of thirty of the major hospitals and
health systems in the country, committed to focusing their
procurement, hiring and investment policies to strengthen their
communities. Interest in public banking is also growing rapidly,
with many cities and more than twenty states exploring
approaches to building their own local public banks to free
themselves from the dictates of large commercial financial
institutions.

The Evergreen Cooperative story is still in the early stages of
its unfolding. Certainly, it is no 'silver bullet' to resolve the
problems created by decades of neglect and neoliberal policy.
But as this model of community wealth building takes hold –
and now most recently in the city of Preston, England – a vision
of fundamental, systemic change at the local level is becoming
an idea whose time is coming.

New Local Economies for the UK

Like in the United States, the UK has challenges with its post-industrial economy. Too many places have seen large industry leave without a progressive and focused plan for rejuvenation. In many places, there has been no absence of concern and action backed by public sector 'regeneration' funds, with physical improvements and social regeneration initiatives. However, the impact of such initiatives has had some benefit, but there the underlying issues remain. In this, efforts to create a more consumption-based economy are floundering under low wages, insecure work and the lack of local demand.

Today we have some devolution in our large cities, and some areas are doing well: attracting inward investment, with property-led development and new spaces of consumption. However, this is the exception rather than the rule. Many areas continue to struggle, and indeed in some areas the problems are deepening, made worse by public sector austerity. The promise of a 'trickle down' or 'trickle outwards' of wealth is just that – a mere promise. Inequality and poverty are on the rise, which is unacceptable.

The UK is the sixth largest economy in the world, and has large amounts of both private and public sector wealth. Therefore, the defining issue here is not the absence of wealth, but that it is not being retained or organised for all. The defining questions of our time are who owns the wealth, who influences it, who benefits from it and where does it go?

With these questions, the economic mainstream is being challenged and a new movement is growing. This movement is characterised by a growing range of alternatives and actions, which seek to advance inclusion and reorganise the economy – a reorganisation where wealth is extracted less, and is more broadly held with increasingly local roots. There are, however, two core challenges to be confronted.

First, it is challenged by global financialisation – the act of making money from money. The desire for speedy returns on capital investment means there is a preference for the relatively

low-risk property and land markets (often in the urban centres of our core cities). This skews investment away from other – less investment-ready – locations, and from the relatively employ-ment-rich real economy of manufactured goods and services. Furthermore, investors are now increasingly global, often with little or no attachment, connection or affinity to local places. This means that returns on investment are not readily recircu-lated by local investors into their local economy. Indeed, in an era of opaque and fast-moving global capital, it is increasingly difficult to even identify who investors are, let alone where invest-ment gains go. As such there are limits to any central after-the-fact redistribution. By the time any process for wealth capture is in place, the wealth has already been extracted into the ether of the global economy.

Moving forward, there is the need to reorganise these 'after-the-fact' policies of social democracy. We need policy that works before and during wealth creation. This entails more 'sticky' and 'patient' investment in real local economies, and re-energising the focus of economic development on human and social outcomes, alongside growth gains.

Second, there have been and will continue to be profound shifts in the economy, in technology and in employment prac-tices. Automation is speeding up a longstanding process by which wealth is gained less by society through employment, but more through returns to capital, extracted by investors. As it continues, automation will increasingly drive down wages and reduce the share of income through labour. The immediate impact will be more and more people trapped in inferior, robotic, low-productivity and low-wage jobs. The long-term solution is, therefore, to redirect wealth and economic activity to employees and communities. This can be achieved through broader owner-ship models, such as cooperatives and community benefit socie-ties, where more people have a stake in production and where wealth is reinvested for the local good.

This maturing of capitalism means that higher levels of social inclusion demand more self-generation, where social gains are

wedded to the actual workings of the economy, rather than to some after-the-fact corrective measure.

These features may be conceptual, but the response is real and growing. The new economic movement is lodged within European and UK social democratic traditions, but it is advancing from it. This is political, social and economic. Politically, we are seeing the rise of new plural democratic movements and municipalisation, perhaps exemplified within Barcelona and new global networks such as Fearless Cities. In cities and localities, it is highlighted by a new plurality of social movements, often fuelled by social media and digital connectivity. Socially, new community action and innovation are finding alternative ways in which people, businesses and the state organise themselves to meet social needs and issues. Economically, the collaborative and sharing economies are shortening supply chains and blurring the boundaries between production and consumption. In this a new horizontal flourishing of 'on-the-ground' political, social and economic innovation is starting to infect vertical power. Key among this are the community wealth-building movement and particularly the work that has been undertaken collaboratively by Preston and CLES to shift the identity, function and purpose of the Preston economy.

The Preston Model

Preston is a comparatively new small city in central Lancashire, hosting a population of 130,000 people who proudly won city status in 2002. What is even newer is the way Preston has embarked on a fascinating journey towards local economic democracy that has the potential to be transformative for its people.

In the nineteenth century, Preston was a boom town of the Industrial Revolution at the centre of the expansion of textile manufacturing, with Sir Richard Arkwright, the inventor of the spinning frame, born there. Sadly, its textile sector fell into terminal decline from the mid-twentieth century, and like many other

areas in the north of England it experienced large amounts of deindustrialisation, inequality and deprivation accelerated by the onslaught of neoliberal economics from 1979 onwards.

Unlike some areas in the north, however, Preston is very fortunate. It hosts the administrative headquarters of both Preston City Council and Lancashire County Council. It has an expanding and vibrant university, a large tenant-led cooperative housing association, advanced manufacturing nearby, many independent businesses and a thriving arts and cultural scene. The majority of its local public sector institutions, as is the case elsewhere, are 'anchored' in its community and unlikely to get up and leave.

The 2007/8 Global Financial Crisis hit Preston very hard. Since the late 1990s the city council and its partners pursued the £700 million Tithebarn regeneration project in partnership with two large global developers, which they hoped would see an influx of inward investment and provide the revenue needed to upgrade many of Preston's public assets that had been starved of investment for years, including its iconic bus station and outdoor markets.

However, in 2011 the scheme was abandoned after its main anchor store pulled out, with Council Leader Peter Rankin declaring, 'We are in one of the worst economic and financial situations since the 1930s.' Within a similar period one of Preston's oldest printing businesses, which in its heyday employed 1,300 people, relocated production abroad, reducing its Preston workforce to less than a hundred.

Preston's Labour Group in opposition had adopted a more radical approach before winning a majority on the council that year. Despite Tory opposition they pushed through a policy ensuring Preston City Council became the second local authority in the UK to pay the real living wage in 2008. Two years later they worked with Preston Bus workers who bravely tried to buy their own enterprise as a democratic employee-owned firm after the Competition Commission declared its acquisition by Stagecoach to be anti-competitive.

The first years of the Labour administration from 2011 saw support for policies to promote the real living wage, with the majority of the local public sector and many private and voluntary sector organisations joining the council in becoming living wage employers. Labour also began the process of re-establishing a city-wide credit union, now known as Clevr Money, with some 500 members in the city at present.

Labour then began considering how to challenge locally the systemic problem of deepening austerity and disinvestment caused by the failure of corporate capitalism. What had interested the administration for some time were the highly successful experiments with economic democracy both here and overseas. These included the Mondragon Cooperative Corporation in the Basque region of Spain, with its highly sophisticated network of 250 worker-owned businesses, that had raised average wage levels to over a quarter more than their capitalist counterparts.

North Dakota in the United States also had a century-old state bank linked to hundreds of community banks and credit unions that kept 70 per cent of deposits in the region, keeping unemployment to one-third of the national average when the recession hit. At home in Manchester, and in Cleveland, Ohio, thousands of jobs had been added by large public sector organisations buying from local suppliers, creating entrepreneurial states locally and keeping wealth in place.

Two of the present authors – Neil McInroy and Matthew Jackson from the CLES – soon became regular visitors to Preston, working with the administration to take the best traditions of economic democracy and apply them to Lancashire. Preston also drew on the inspiration of another of the present authors – Ted Howard from the Democracy Collaborative – and the Cleveland Model, as described above.

Key to bringing these ideas to scale was the need for collaboration. As a large district authority Preston could not achieve what it wanted alone and needed others to join in. This led to community wealth building as a new approach to local economic development formally being adopted in 2013.

From 2013, key players in the local public sector received visits to look at how, as anchor institutions, they could work collaboratively with the council. Five other anchor institutions signed up, namely Lancashire County Council, Lancashire Constabulary, Preston's College and Cardinal Newman College and Community Gateway. The collective spend of these institutions on goods and services was significant, at £750 million every year, and the aim was to increase that spend in the local economy. Helped by Labour's police and crime commissioner, Clive Grunshaw, and the then Labour-led county council, tens of millions of pounds are now repatriated each year to local suppliers, creating jobs and expanding social value outcomes, including the number of people receiving the living wage.

Other anchor institutions later joined the initiative, including the University of Central Lancashire (UCLan) and Lancashire Teaching Hospitals, expanding the entrepreneurial local state, acknowledged by Shadow Chancellor John McDonnell during visits in 2016 and 2017. While increasing spend to local suppliers has had a profound effect on the local economy, the long-term aim was always to use public procurement to expand the cooperative economy on similar principles to those of Evergreen. Dr Julian Manley and others at UCLan are now working with its business school to identify gaps in its procurement chain to potentially support new co-ops and graduate employment. Platform cooperatives like Co-Tech and the Open Food Network are preparing to bid for IT and food contracts from the anchor institutions, and the renewable energy movement is committed to establishing energy cooperatives linked to the requirements of the local public sector.

The impact of this activity has been telling. As a result of new policy and action between 2012/13 and 2015/16, Preston City Council alone was able to more than double the proportion of its local procurement spend, from 14 per cent to 30 per cent, with local businesses, social enterprises and cooperatives beginning to benefit. While repatriating spend was and is an important component, the primary purpose has been to shift the behaviour

of the anchor institutions so that they think more progressively about their local processes and choices, and the impact they have on the local economy.

To bring further democracy to the local economy, Preston City Council worked with the Lancashire County Pension Fund to invest locally through its City Deal. The £100 million earmarked by the fund has seen a new student flat development regenerate a rundown part of Friargate (a key retail promenade), and the palatial Park Hotel will be brought back into use and redeveloped, creating new jobs and a virtuous circle of local wealth flow. In the longer term, there is hope the fund will adopt the recommendations of the Lancashire Fairness Commission and invest in local affordable housing and renewable energy, with public sector workers needing the opportunities cheaper housing and energy provide, as well as securing a sustainable return for their future pensions.

Energy democracy forms a key part of the approach in Preston, with Labour elected on the promise of ambitious plans for a city-owned wind farm to generate affordable electricity for its residents and reduce fuel poverty. This planned £20 million investment ceased to be viable when the renewable energy subsidies were slashed by the Conservative government. As an alternative, Preston will be leading an energy supply partnership, Red Rose Fairerpower, to offer a local alternative across Lancashire to the Big Six energy firms and hopefully reduce household bills. This, with other measures, is a positive step towards the municipalisation of energy which Labour in Nottingham and elsewhere has begun so well.

Underpinning this agenda is the need for local and democratic control of finance. Preston City Council is working with Professor Richard Werner from the University of Southampton to establish the Lancashire Community Bank. This should see the first phase of not-for-profit community banks across the UK based upon the German *Sparkasse* model that is so central to everyday German life. Already local authorities and universities in Lancashire are examining how they can invest in the bank to

lend to small businesses and individuals, many of whom have difficulty accessing finance from the mainstream banking system.

So what has this movement towards a democratic local economy actually helped deliver on the ground? While Preston still has significant challenges, official statistics show it is in the top 10 per cent for part-time female workers receiving the living wage or more in the North West. Earnings for full-time workers in the Preston economy nearly equal the average in the North West, and those for part-time workers exceed it. After years in the bottom 20 per cent of most deprived areas in the UK, Preston is finally out of it, and a Demos/PwC report recently declared the city to be the 'best place to live and work' in the North West.

Conclusion

What is happening in Preston is part of a movement of post-capitalist responses around the world, from Barcelona to Cleveland and elsewhere. In the UK and Europe, CLES is at the forefront of policy and practice in this area, working in Belfast, Preston, Birmingham, Oldham and ten cities across continental Europe.[1] The Democracy Collaborative is working to take the lessons of Cleveland elsewhere, working in some twenty cities across the United States.

Through local/community wealth building we are seeing a new democratic, social and economic movement, which seeks to provide resilience where there is risk and local economic security where there is fragility. We are in a moment of great political and economic uncertainty. As such, the energy that fuels this movement is growing and the range of community wealth-building work is delivering demonstrable outcomes. The task now is to celebrate – but also to accelerate. On the basis of these new principles and approaches we can reorganise the economy for all.

To this end, local government must become a little less managerial and a lot more transformative. Trade unions should consider working with councils to divest their member's pensions from fossil fuels and invest instead in networks of locally owned

municipal energy generation across the UK. The trade union and cooperative movements should work together to form member-owned union co-ops to actively bid for the billions spent each year by local government on construction and social care.

Taken together, all this can begin to transform society right here, right now. This is a big opportunity to create the society we want, at every level. Let's take it! *The movement grows!*

Debt Dependence and the Financialisation of Everyday Life

Johnna Montgomerie

This chapter explores how finance has become deeply embedded in the daily life of many UK households. It begins with a brief outline of finance-led growth, then details how this affects the average household in three distinct ways: (1) decimating long-term cash savings in favour of asset-based welfare, (2) transforming housing into a highly leveraged financial asset and (3) relying on debt for economic participation and as a safety net. The chapter concludes by considering why there continues to be a strategic silence about household debt within public policy when it is clear that current levels of household indebtedness are unsustainable over the long term.

Initially the term financialisation described how the corporate governance priorities of large firms prioritised profit-making through equity markets (stock price) rather than product market competition (price of goods and services).[1] Lazonick and O'Sullivan succinctly describe financialisation as ushering in a profound shift in the corporate governance strategies of large firms from 'accumulate and reinvest' to 'downsize and distribute', which meant routine cuts to labour costs, including wages and pensions, or selling off or closing down whole divisions to realise short-term profits that amplified stock market performance.[2] Gradually the term financialisation came to encompass a wider set of economic transformations: from 'advanced industrialisation' to finance-driven expansion, in which patterns of

accumulation could be observed shifting from productive to financial activities.[3] This is particularly true for the Anglo-American economies, where key interrelationships between low interest rates, private debt, domestic demand, asset markets and consumption coalesced to produce a period of stable growth.[4] The simplicity of the finance-led growth model is also its fundamental fragility: private debt generates demand that would not otherwise be there – driving up property prices and fuelling the consumer economy.[5] The events leading up to the 2008 Global Financial Crisis exposed the fragile balancing act of finance-led growth to manage a rapidly growing private debt stock with stagnating income flows.

This chapter focuses on the central, but often overlooked, role of the household sector in driving, sustaining and reproducing finance-led growth. A clear majority of UK households are dependent on wages and salaries for their income, which have remained stagnant and, for some, even declined in real terms in the period of finance-led growth, creating a demand for debt to plug the gap.[6] Looking at both sides of the household balance sheet it becomes clear that the household sector is the feedstock of finance-led expansion by regularly remitting present-day income every month into global financial markets, either as payments into portfolio investments (mainly pensions) or as payments on debts (mortgages and other loans). By considering the claims on monthly household cash flow, we begin to catch a glimpse of the absolute limits of finance-led growth.

It is not just the role of the household sector within the macro-economic phenomenon of financialisation that is relevant to daily life, but also how sociocultural dynamics shape the ways in which the different groups within society can participate in and benefit from finance-led growth.[7] Financialisation has brought with it a wider cultural shift within British society in which cultivating financial or entrepreneurial forms of citizenship is paramount for participation in the economy. The power of finance within daily life is not simply reducible to large macroeconomic structures, but mediated through cultural conversations that

make finance the legitimate means through which individuals access and participate in the economy.

Financialisation Destroys the Small Savers

Falling real interest rates since the mid-1990s instigated the financialisation of households by slowly eroding the incentives to save cash in interest-bearing accounts, and pushed many households into portfolio investment vehicles in the hope of capital gains. Dwindling household savings ratios (the value of new household savings expressed as a proportion of gross household disposable income) over the past thirty years are obvious: in 1997, households saved 10 per cent of disposable income; in 2007, just before the credit crunch hit, it was 6.8 per cent, and most recently, 2017, the national household savings ratio hit an all-time low of 1.7 per cent.[8] This national aggregate measure does not account for how savings habits differ based on income level and age, but nevertheless the trend is clear: in 2017, it is estimated that 9.45 million people have no savings at all, and it is believed these 'non-savers' are mostly young people and those at the bottom half of the income scale.[9]

Public policy actively supported households in their switch from cash savings to investment in appreciating asset classes, including property, in what came to be called 'asset-based welfare'.[10] This group of policies encouraged citizens to think of their asset purchases as investments which they might cash in to fuel their consumption. For example, in retirement, as the state withdrew from pension provision in times of economic difficulty; after redundancy, as the state withdrew unemployment benefits; or for education, as the state increased tuition fees. The downsides to asset-based welfare are many, chief among them being the destruction of households' liquid savings. Since holding cash over the long term is not profitable because of (artificially) low interest rates – liquid savings, like wages, are eroded by inflation. Another important downside is that savings deposits are protected by deposit insurance and investment savings are

not – meaning households hold all the risk during a market downturn. For example, in 2008, when the IceSave bank went under, large numbers of British small-saver households, enticed by interest rates of 5–8 per cent on savings deposits, were exposed to the bankruptcy of the Icelandic bank that was ultimately guaranteed by the UK Treasury. Unfortunately, those people who invested the same amount into investment savings accounts (ISAs) were not entitled to compensation.

Since the 2008 Global Financial Crisis the macroeconomy has been governed by 'unconventional monetary policy' which has actively sought to keep interest rates artificially low (even below zero in real terms) with successive rounds of quantitative easing (QE) – this has only served to further decimate households' savings, in the present day and in the future: first, because the banking system can no longer offer any meaningful form of low-risk, long-term cash savings; and second, because QE is driving down bond yields to such an extent that it will eventually bankrupt most pension funds. This reality points to a systemic market failure in which banks and monetary authorities cannot offer households a meaningful low-risk savings vehicle, only high-risk portfolio investments or mortgage loans. A key reason for this is that financial markets benefit hugely from the steady influx of 'dumb money' from the household sector because it remits income from monthly pay packets (with commensurate tax concessions) into pension/investment schemes whether markets are at a peak or a trough, and they are under a legal obligation to pay mortgages whether property prices are high or low. In the aggregate, these monthly income remittances amount to huge tides of guaranteed revenue flowing to institutional investors irrespective of firm- or market-level performance. Asset-based welfare effectively transfers all the risks of market crisis – like those experienced in the 1997 East Asian Crisis, the 2001 Dot Com Crash and the 2008 Global Financial Crisis – onto the household sector without any protections against losses, unlike the financial actors themselves who have received ever-larger bailouts in response to successive market downturns.

Homeownership Is a Highly
Leveraged Investment Savings Vehicle

Perhaps the most profound way in which finance-led growth transforms everyday life is through residential housing. With savings rates falling, residential housing has become the only 'safe' financial investment vehicle – less volatile than portfolio investment and capable of making inflation-proof gains over the long term. Residential housing is also an engine of finance-led growth, resulting in many households becoming highly leveraged investors. Housing-based welfare is enthusiastically supported by public policies that continue to promote homeownership as a key benchmark of economic citizenship without acknowledging its failings.[11]

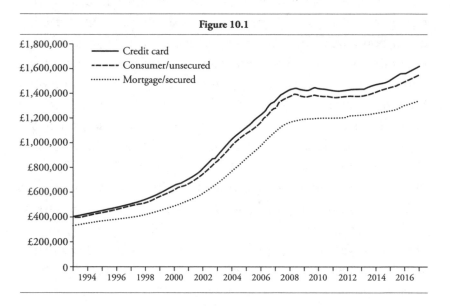

Figure 10.1

Taking the most recent measurements from Figure 10.1, in July 2017 the total stock of debt owed by the household sector was £1.545 trillion, of which 86 per cent was debt secured or mortgage debt (£1.344 trillion). As banks developed their 'originate-and-distribute' business model, residential mortgages became the main way to create money and generate additional

revenue for lenders, by bundling together anticipated future interest payments and reselling them multiple times across global financial markets. Residential property mortgages are a key source of new money creation in the UK economy, as banks create money when new debt deposit accounts are made and when issuing mortgages.[12] More importantly, creating debt deposits secured against residential property is almost risk-free for lenders because the UK has 'full-recourse' mortgages, allowing the lender to not only keep all collateral but also pursue the full value of the debt from the borrower regardless of the value of the asset – a stark difference compared to the American 'non-recourse' mortgage that entitles the lender only to repossess the property and sell it to recoup costs. Put simply, if the UK housing market takes a downturn all the costs are disproportionately incurred by the borrower, posing a major systemic risk to the rest of the economy.[13]

The everyday realities of housing-based welfare are far more complicated and differentiated than is widely assumed.[14] This runs counter to popular assertions that mistakenly generalise the wealth gains from housing over the past thirty years to the next thirty years. This assumption fails to consider the present-day limits of household incomes or the existing historically unprecedented mortgage debt overhang. It is more accurate to understand wealth gains from housing as a form of intergenerational (age-based disparity) and/or regional (urban/rural or north/south) inequality. Age and place significantly shape who are the winners and the losers in the residential housing game. These factors demonstrate why housing cannot provide a generalised welfare function and why it is, arguably, wholly unsustainable over the long term.

Figure 10.2 shows the UK residential house price index, the main engine of finance-led growth and an underlying justification for asset-based welfare. However, looking at Figures 10.1 and 10.2 together, both starting in 1993, it is obvious that mortgage debt and property prices rise in step. As interest rates remain low, even falling after 2008, property prices continue to increase,

giving new incentives for individuals to accumulate more debt to stretch themselves in the housing market to avoid missing out on the potential return on their investment that property offers.

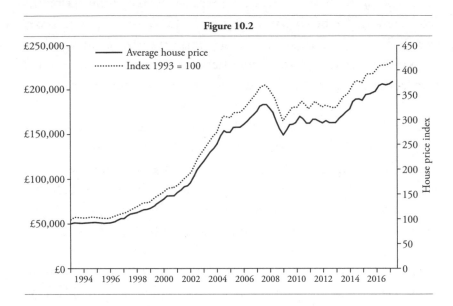

Figure 10.2

Credit-fuelled asset appreciation in residential housing is a driving force of finance-led growth. Mainly because it serves to bolster aggregate demand as house prices increase, homeowners can more easily remortgage their properties, releasing the equity built up in their homes to fuel additional consumption. The rapid uptake in home equity loans shows the degree to which many UK households see their house not only as a source of long-term savings ('my house is my pension') but also as a source of cash that serves to shore up aggregate demand. Interestingly, there is no national data collection on the stock of outstanding home equity loans (second lien mortgages). Instead the Bank of England measures 'housing equity withdrawal' as the change in the total stock of housing equity (not debt) as households secure lending to take out or repay debt against residential property, as well as changes in the stock of housing wealth (e.g. when new properties are built or improvements are made to existing properties but not changes in house prices).[15] However, property

prices are the biggest determinant of whether households with-
draw equity, and there are clear downsides to converting equity
into cash – namely the household's (often only) financial asset
becomes highly leveraged, transforming the overall financial
security of the household sector and the wider economy. Put
simply, increased uptake of home equity loans means that even
those households with asset holdings – those considered more
financially secure than households without any assets – are more
vulnerable to income shocks, like all overleveraged investors are.
The ability to use residential property as a source of cheap credit
creates pronounced, yet largely unseen, inequalities between
homeowners that are asset-rich and those with leveraged homes,
in which the latter are vulnerable to every manner of financial
market or economic shock.

Financing Daily Life with Debt

The final pillar of the financialisation of everyday life is the
growth in non-mortgage (or consumer) debt in the UK over the
past twenty years. From Figure 10.1, the June 2017 figures put
consumer debt at an all-time high of £201.5 billion and credit
card debt at £68.7 billion. That puts the average total debt per
household – including mortgages – at £57,005, which is approx-
imately 113.8 per cent of average earnings. The total interest
repayments on personal debt over a twelve-month period is
roughly £50.149 billion, meaning an average of £137 million per
day is remitted to banks to service this debt stock.[16]

Understanding the unrelenting rise in consumer debt involves
a more sociocultural explanation of norms around consumption,
including issues like middle-class entitlements such as a univer-
sity education and annual family holiday, which are increasingly
funded by debt rather than forgone altogether.[17] In the early days
of finance-led growth, consumer debt expansion was typically
understood as a direct consequence of hyper-consumerism. This
is much less the case since 2008. Now it seems that many house-
holds use debt to participate in economic life.[18] For example,

most young people must borrow heavily to access higher education: here policy promotes private debt directly replacing public provision. In less than a decade, increases in university fees and cuts to student subsidies for higher education meant that outstanding UK student debt increased from £15 billion in 2005 to £54 billion in 2014.[19] Also, many households borrow to sustain cash flow to make ends meet each month. An in-depth UK-wide study found that four factors trigger households having debt problems: *a drop in income* (32.5 per cent), most often from unemployment; *a change in circumstances* (28.5 per cent), mostly an illness in the family, an elderly parent needing care or a new baby arriving; *increased outgoings* (20 per cent); *unexpected expenses* like needing a new car or a rent increase; and *overspending* (15 per cent), buying high-cost consumer goods or holidays.[20] Increasingly, it seems that surviving in this 'age of austerity' – in which falling income levels in real terms exist alongside drastic cuts to social security – means many households use debt as a safety net.

Conclusion

There is a 'strategic silence' in public policy understanding and response to the problems precipitated by widespread household indebtedness. Since the 2008 Global Financial Crisis, the UK financial sector has enjoyed an unprecedented amount of public subsidy in the hope of shoring up confidence in this strategically important sector. However, this requires a continued reliance on debt-driven growth: the very cause of the financial crisis in the first place. Therefore, the question of what to do about indebtedness is the central economic problem that must be dealt with, particularly because current economic policy is to the detriment of the household sector. The entire economy is dependent on household debt levels continuing to grow unabated. The Office for Budget Responsibility (OBR) predicates its growth forecasts on ever-rising household debt-to-income levels. Most recently, in March 2017 the OBR estimated that the present-day 145 per

cent of gross debt-to-income would reach 153 per cent over the following four years.[21] Therefore, households are expected to absorb public spending cuts, job losses and wage stagnation at the same time as using debt to consume as if the economy was booming. This situation cannot last forever, and anyone can see that if only they care to acknowledge it.

For those people living under this debt-driven growth regime, everyday life is a vice-like grip of countervailing forces, which are experienced personally but can be refracted onto the national economy. If every household struggling with debt decided to pay down their debts the national economy would be plunged into depression, with the global economy following closely behind. However, if every household struggling with debt continues to take on more debt to maintain their standard of living, soon there will be rising insolvency rates. Currently, most households do keep up their debt repayments and regularly remit a growing portion of their present-day income to pay for all their past economic activity – creating debt-deflation pressures that are bleeding the economy by a thousand small pinpricks. However, if for whatever reason households are unable to make these regular repayments, a worse scenario will unfold in which default rates add to the portfolio of non-performing loans on banks' balance sheets. As the 2008 financial crisis revealed, the elaborate network of financial claims flowing through the global financial system are vulnerable to default on even small-scale household-level loans (US sub-prime mortgages). Rising default rates of the household sector would, once again, start letting off sparks that could ignite another firestorm across global markets.

Platform Monopolies and the Political Economy of AI

Nick Srnicek

As I write this, seven of the top-ten largest companies in the world are tech firms.[1] Our newspapers and televisions (not to mention our Facebook feeds) are littered with discussions of their developments and controversies. This fervent interest among the business press, stock markets and general public alike is indicative of a particular inflection of the capitalist mode of production – one whereby data has become an increasingly accessible resource for firms to extract and use for their own advantage. The result has been the rise of a distinct and novel type of business model: the digital platform. At its most basic, the platform is an infrastructure that connects two or more groups.[2] Facebook, for instance, connects senders and receivers of messages, consumers and advertisers, users and companies. Uber, by contrast, is a platform that connects riders and drivers. Platforms operate according to a logic distinct from a traditional goods-producing business model. In particular, they are acutely adapted to a data-centric economy. As platforms invite users to interact via their infrastructures, they are positioned to capture, extract and analyse the data produced by those interactions. The result is that platform companies are now the leaders in the data-centric economy, and as data becomes ever more important for gaining competitive advantage, it is these firms that are primed to take the lead. Platforms are effectively a business model for the twenty-first century.

With their unique approach to business, they bring unique dynamics. Most important is their reliance upon network effects: the fact that a platform typically becomes more valuable as more users join and use it.[3] A prominent example of this is Facebook, which has become the first choice for people looking to join a social networking site simply because so many other people are already on it. Indeed, people continue to do so even if they disagree with Facebook's handling of fake news, the Cambridge Analytica controversy, their surveillance and their omnipresent advertising. The same holds for Uber: as more drivers join, more riders are likely to use the app because it has a better chance of finding you a taxi while the rain pours down late at night. And as more riders use the platform, more drivers are attracted to it since it provides a more reliable source of work. A virtuous cycle is created between the network effects on both the drivers' and the riders' sides of the platform, and this has propelled Uber to the forefront of this industry.

The centrality of network effects means that generating them is a key strategic focus of these businesses, and every effort is made to reach the critical mass required for them to start taking off through their own volition. Two strategies are particularly important. The first is cross-subsidisation – a characteristic which exists in other business types, but is raised to a central position in platforms. This term refers to the fact that platforms can (and often do) raise the prices on one side of the platform in order to subsidise costs on the other. Google, for example, can use its advertising revenues in order to provide free email, calendars and other services to its users. Using cross-subsidisation enables network effects to take hold as more users join, providing more eyeballs for potential advertisers. Likewise, although the Amazon Prime service (which provides rapid delivery and access to content) is offered below cost, the added engagement from Prime users makes the e-commerce platform more valuable for sellers, feeding the network effects and drawing people in. In addition to cross-subsidisation, platforms try to generate network effects by designing their infrastructures in ways that entice the different

groups into engagement. One of the more subtle and nefarious examples is Uber's use of surge pricing and 'phantom cabs'. Surge pricing is the platform's way of indicating to drivers that demand is forecast to rise for a particular area, while phantom cabs are the appearance of non-existent vehicles in the riders' app interface. Both supply (of taxis) and demand (for taxis), in other words, are to some extent creations of the platform. Such politics of the platform are an essential element to getting users on board and keeping them engaged in ways that are useful for the business.

The endgame of all this manoeuvring is to reach a critical mass and have network effects take on a life of their own. The self-perpetuating nature of these effects means that platforms have a strong tendency towards monopolisation (i.e. greater market concentration in the hands of the top firms in a sector). This is a tendency that has been growing across the advanced capitalist economies in the past few decades (and was long ago argued by Marx to be a central consequence of capitalism), and that has recently become the focus of much mainstream concern.[4] Yet with platforms, the drive towards monopolisation is particularly strong. The first reason for this is simply the network effects we have already seen. But platforms also consolidate monopolies through path dependency and data moats.

In the first case, as a platform gains a foothold in the market and starts to expand, it begins to have groups adapting to its particular infrastructure. On Facebook, for instance, users input an immense amount of data into their profiles, and they have a long history of messages and interactions with others. Moving to a new platform would mean losing all of that history and person-alisation, and thus competitors find it difficult to convince people to move. Likewise with software developers for a platform, who may find it difficult to port projects developed for one platform to another platform. In one of the most striking examples of path dependency, a number of media companies have pivoted to Facebook video as their primary mode of producing content, and in the process have cut staff and resources from other areas. Entire business ecosystems are now dependent on Facebook's

newsfeed, thereby making these companies unlikely to move to a competitor. Likewise, Google provides search results on the basis of ten or more years of personalised data extraction. To adopt a different search engine would mean losing all that customisation. So while defenders of platform monopolies will often argue that there is plenty of competition, and note the ease with which a user can sign up to a new platform or how cheap it would be to build the software for an Uber competitor, the reality is very different. Path dependency means that the groups on a platform become tied to it, and in fact invested in its continued existence and dominance.

However, the major barrier for new competitors is access to data. As data is the fuel behind many of these platforms' competitive advantages, the more data they extract, the more difficult it is to dislodge them. There is a data-driven network effect as well: the more users on a platform, the more data it extracts, and the more potential it has to use that data to improve its services – thereby attracting more users and reigniting the cycle. Building up this data collection enables companies to build a moat around their business, protecting them from the imperatives and demands of capitalist competition.

Thus, at the very heart of platform capitalism is not only a tendency towards monopolisation, but also a drive to extract increasing amounts of data. One common tactic for achieving this is to drive users to be engaged on the platform for longer periods of time. Facebook, for example, has a team of people who effectively design addiction into the interface in order to keep people coming back.[5] A slightly different approach holds with Apple, which has built a walled garden of consumer goods and approved software – once one buys into the Apple ecosystem, you are more likely to remain within that platform's remit.

Perhaps most important way to collect more data is to expand the apparatus of extraction. This can be done by building up increasingly extensive infrastructure (which is Amazon's strategy), but more often it is done simply through mergers and acquisitions. This search for data helps explain many of the

seemingly mysterious acquisitions made by tech companies. On the face of it, it may seem odd that a search engine would be interested in the consumer internet of things (Home/Nest), self-driving cars (Waymo), virtual reality (Daydream/Cardboard) and all sorts of other personal services. Yet each of these acquisitions has been another rich source of data for Google, and another point of leverage over their competitors. The other top-tier platforms have all followed the same path. Facebook, for example, has bought up Instagram (US$1 billion), WhatsApp (US$19 billion) and Oculus (US$3 billion), while investing in drone-based internet, e-commerce and payment services. It is hard to make sense of the astronomical amount paid for WhatsApp – a company that had never posted a profit – unless one recognises the network effects and data that come along with it. Nothing seems safe from the encroaching grasp of the top platforms: Microsoft purchased LinkedIn (US$26 billion), Amazon purchased Whole Foods (US$14 billion) and Twitter seems destined to be bought up at some point. Facebook has raised the barriers to entry so high that it even has a warning tool (again, based on its data) that alerts them when a start-up is becoming sufficiently popular or innovative to pose a potential threat.[6] The picture that emerges is one of increasingly sprawling empires designed to hoover up as much data – and as many competitors – as possible.

While platforms have gained particular prominence in the tech world, their ability to siphon off data, combined with their tendencies towards monopolisation and market power, have made them attractive models for the non-tech world as well. And as more and more of the economy becomes digitised, we will see platforms spread. Uber is the first salvo in this colonisation of traditional industries, turning the rather staid business of taxi provision into one of today's most fashionable platforms. Billions of dollars are already being put into developing platforms in other industries as well. Siemens and General Electric (GE), two manufacturing powerhouses, are currently fighting it out to develop platforms for the industrial internet of things: effectively

a cloud computing infrastructure for the factories of the future. Similarly, Monsanto and John Deere are looking to build agricultural platforms and turn food production into a data-centric industry. Everywhere we look, platforms seem to be turning up. Knowledge of their nature and their tendencies is therefore increasingly important for an understanding of where our economies are headed.[7]

This becomes all the more pressing with the introduction of artificial intelligence (and particularly its popular, data-intensive version – deep learning). In the past few years, every major platform company has turned its focus to investing in this field. All the aspects of platforms that we have seen so far are supercharged with the introduction of AI: both the insatiable appetite for data and the monopolising dynamic of network effects. And there is an additional positive feedback loop here: more data means better machine learning, better machine learning means better services and products, better services and products means more users and more users means more data. Data-driven innovation, built upon machine learning, is set to consolidate power and profit in the hands of the few companies with the capacity to build it. Among other things, Google is using AI to improve its targeted advertising,[8] its search results, its translation services and its digital assistant; Amazon is using AI to improve its highly profitable cloud computing business,[9] recommendation algorithms and dynamic pricing mechanisms; and Facebook is using AI to improve translation services and create social connections across language barriers,[10] as well as to tinker with its newsfeed and develop its own digital assistant. As one AI company starts to take a significant lead over its competitors, these dynamics could propel it to an increasingly powerful position.

The demand for data and the barriers to entry it poses are also heightened by the introduction of AI. Perhaps surprisingly, much of the latest AI research and software is open-source and freely available to anyone who wants to use them. Google, for example, has open-sourced much of its AI engine, TensorFlow, and the Chinese tech monopoly Baidu has done a similar thing with its

software, PaddlePaddle. This giving away of research and development seems out of character for capitalist firms, until we recall that it is data that trains these algorithms into their increasingly sophisticated forms.[11] Any company may be able to acquire and develop the same basic face-recognition software as Facebook; but only Facebook has access to the billions of uploaded photos that can be used to train those algorithms into the most accurate recognition software available. With current approaches to artificial intelligence, researchers have found that AI can be improved significantly just by throwing masses of data at it – leading them to marvel at the 'unreasonable effectiveness of data'.[12] All of this means that there are even stronger incentives to expand and extract as much data as possible (we should also include non-human data here – one of the reasons behind IBM purchasing the Weather Channel).

The rise of AI adds a further wrinkle in that market concentration is no longer limited to a single industry (as in previous monopolies), but increasingly implies control over the tools and infrastructure of much of the economy. As 'software eats the world', more of the economy becomes inseparable from its digital representation, and therefore subject to the optimisations and manipulations of machine learning.[13] Uber's use of artificial intelligence to predict service demand is one recent example,[14] Ocado's 'internet of vans' for organising grocery deliveries is another,[15] while Siemens and GE are building the tools to do likewise in manufacturing. But Google and Amazon are showing the path forward, swallowing up entire industries and bringing them within their control. The data imperatives of platforms are only made more intense by the demands of AI. As a result, these new monopolies pose different – and potentially bigger – challenges than the classic monopolies of the late nineteenth century.

So how can policymakers respond to this rising concentration of market and political power? The European Union's new General Data Protection Regulation (GDPR) is a good place to start, providing a meaningful amount of control over personal data and applying it to all residents of the European Union

regardless of where the company or data is located. Three features are particularly significant. First, the 'right to be forgotten' means that users can request that personal data on themselves be removed from a service (within particular limits). This right originates from a 2014 European Court of Justice ruling in which a Spanish man won his request for Google to remove an outdated page about him from their search results. A second key element of GDPR is data portability – the ability to request that much of one's data be made available in an accessible format and that it be provided to a different platform if so desired. One of the important consequences of this rule is that path dependencies have the potential to be somewhat diminished. If moving away from Facebook currently means losing all of one's contacts and built-up personalised services, then data portability holds the potential of transferring contacts and personalisation over to a competitor; one need not start from an entirely blank slate. Data portability, in other words, lowers the costs of exiting from a platform and moving to a competitor.

Finally, one of the more significant changes brought in by the GDPR is the focus on opting in with regard to data tracking. This means that Google and Facebook must now specifically request from users their consent to being tracked for the purposes of advertising. The GDPR blocks the ability of these platforms to have a generic opt-in option, instead requiring that any opt-in for personal data collection be limited to specific and explicitly articulated purposes. The new regulation also means that platforms cannot refuse the service to users if they choose to opt out – subverting a common tactic today whereby if you do not fully accept the terms and conditions of a platform, you are not able to use that platform at all. All of this amounts to what one ad tech analyst calls an 'acute threat' to Google's and Facebook's advertising business.[16]

In addition to the regulations on personal data, antitrust regulation must be updated for the twenty-first century. Particularly in America, antitrust regulation has taken on an increasingly narrow scope, partly as a result of the work of legal scholar Robert

Bork.[17] Much of it today revolves around the consumer welfare criterion (looking at how a merger or monopoly affects the welfare of consumers), but in practice it avoids looking at issues of quality or diversity of the services and instead focuses solely on a merger or monopoly's impact on price. In an era in which many platforms provide their services for free, this criterion is obsolete. As a number of antitrust scholars have argued, the analysis of new mergers needs to take into account a much broader array of criteria.[18] Foremost among these is the impact of a merger on network effects and data.

The Facebook/WhatsApp merger of 2014 presents a particularly salient example.[19] The US Federal Trade Commission never commented on the case, presumably because the impact on prices was deemed non-existent. By contrast, when the European Commission originally examined the case, it also looked at non-price criteria. In particular, the commission warned Facebook about combining user data between the two platforms, and did a rudimentary analysis of the effects of the merger on data competition. However, this analysis remained crude, and neglected the entry barriers that the data merger would bring about, as well as the various ways in which it would provide important competitive advantages for Facebook in the advertising industry. In the end, the commission decided that because of their different approaches to user privacy, Facebook Messenger and WhatsApp were not competitors, and that in any case, it was purported to be easy for users to move to a different platform. Fears about the combination of user data between the platforms ultimately came to fruition, and in May 2017 led to the European Commission fining Facebook £94 million for misleading them about the technical possibility of combining user data. In general, while the European Union has led on the analysis of data competition in mergers, it still has a long way to go in terms of fully appreciating the ways that capitalist concentration and centralisation are changing in the era of the platform.

If antitrust analysis is updated, it still leaves open the question of what should be done with existing platform monopolies. One

increasingly popular response is the suggestion that they should be broken up.[20] Much of the traditional (pre-Bork) antitrust work was aimed at this goal, with the basic idea being that smaller businesses are better than big businesses in terms of competition, efficiency and overall consumer welfare. Yet even if one agreed that capitalist competition should be a desirable goal of antitrust policy (a point that is highly debatable), this approach faces challenges in the current setting. Most notably, breaking up these monopolies means eliminating the network effects that come along with them. What would it mean, for instance, to break up Facebook into competing social networks? Would this entail different regions or groups being unable to communicate across platforms with each other? Similar concerns hold for other platforms, whose value to users often lies very much in their ability to bring together large groups of people and an array of services. Even if one is willing to eliminate network effects, these markets will still invoke a strong tendency towards monopolisation. Breaking up firms would likely mean that today's monopolies are simply replaced with new monopolies in the near future. MySpace is often invoked as an example of how a dominant platform monopoly can fall – but it was only replaced by a new and more powerful monopoly in the form of Facebook.

Another, perhaps more promising, option is to think about the socialisation of platform monopolies. Much of what these platforms do is provide a public good (social networks as the digital public sphere, cloud computing as the basic infrastructure, search engines as the basic access point to the store of human knowledge and so on), and the nature of their business models makes them natural monopolies. Traditionally, those two characteristics have been a good justification for bringing firms under regulation as public utilities, or directly taking them into collective ownership. While there are legal and political precedents for such an approach, taking over a digital platform today would be very different to taking over a railway in the nineteenth century. The most obvious difference is that these platforms extract and own our data in ways that the surveillance state

would be eager to have access to. There are no easy solutions to that problem, but one can imagine technical, legal and political firewalls being built. The postal service is one example of a publicly run infrastructure that is also sensitive to privacy and potential spying issues, yet has had a long history of maintaining that balance.[21] New technologies similar to blockchain (the technology that underpins cryptocurrencies such as Bitcoin) also offer the chance to introduce significant impediments to state surveillance, via auditable data systems. One such system has been designed as a way to ensure that private health data from the NHS is not used improperly.[22] This (eventually open-source) Verifiable Data Audit system aims to record every use and access to a piece of data, and make that record tamper-free. Such a system could provide a record that ensures governments use data in ways that have been legislated for (and the audit system can also be applied to ensure that companies use data in only the permitted ways). However, all of this requires building up the legislation, the technology and, most importantly, the mass movement to ensure that any move towards socialisation simultaneously upholds individual privacy.

Another major difference today from the nineteenth century is the scalar disparity: Google, for example, is a global infrastructure in a way that earlier monopolies never were, and that poses new challenges. Who the 'public' is in terms of public ownership, or who the 'we' is in 'we should take back control', are at the moment placeholder categories rather than substantial propositions. There is no reason why we need to maintain the equivalence between nation, state and people, and we can easily imagine decentralised forms of ownership that evade some of the problematic assumptions about territory and governance.[23]

In principle, we should aim for democratic ownership *and* control of these monopolies. In practice, we need to invent new ways to do that, but we do have examples to learn from. One can look at platform cooperatives as one example: for instance, the efforts to make Twitter a user-owned platform.[24] We can also look at various municipal projects in Spain, or imagine Transport

for London building a platform that superseded Uber and eliminated profit-oriented transportation firms. We can also try to build national and supranational projects to give people democratic control over what are increasingly fundamental infrastructures of twenty-first-century global society. While platform monopolies remain a problem without a solution at the present moment, their rising importance means that the search for answers will only become more significant in the coming years.

A New Deal for Data

Francesca Bria

The growing backlash against Facebook reveals the perilous foundations of today's digital economy, which thrives on monetising our personal data.[1] 'Surveillance capitalism', as some justly describe this model, is a boon to private venture capital but it delivers little public value, disrespecting our fundamental rights.

This is especially so with regard to the right to own our data, which is violated so systematically by Big Tech that labelling their controversial behaviour 'data extractivism' is an understatement. It's no surprise, then, that firms like Cambridge Analytica have found a profitable niche mixing old techniques of behavioural science and micro-targeting – honed by marketing giants and the military – with the latest tricks of surveillance capitalism.

The recent scandals are not just about violating rules of data access. They are part of a broader trend, with tech firms emerging as new feudal lords who control essential digital infrastructures – in this case, data and artificial intelligence (AI) – crucial for political and economic activity. This also carries immense implications for industrial, trade and national security policies, as not all countries find themselves equally well placed to flourish in times of digital feudalism.

From public institutions forced to purchase cyber insurance in the wake of attacks like WannaCry, to the NHS finding solutions to its funding crisis in Alphabet's AI technologies, the public sector, too, is increasingly dependent on the tech industry.

Yet, we rarely ask where this dependence comes from. Why does the immense economic value that such data represents accrue exclusively to technology firms – and not to ordinary citizens or public institutions? And what is it that we can do to ensure that we return some of that value back to citizens, while empowering them to use technology to participate in politics – a process from which they justly feel excluded – as well as to offer public services that are as slick as Uber or Airbnb?

We badly need a new social pact that will make the most of our data while guaranteeing citizens rights of privacy and information self-determination. This will require reconquering critical digital infrastructures – long surrendered to the likes of Facebook, Alphabet and Microsoft – and protecting citizens' digital sovereignty. This should help in developing decentralised, privacy-enhancing and rights-preserving alternative data infrastructures.

Given the gloomy state of politics on both sides of the Atlantic, this might seem mission impossible. And yet, there's one bright spot on the horizon: cities. They can't, of course, solve all our digital problems; many of them need urgent attention at the national and global level. No city can match the computing power of Google or Facebook or even Uber – in fact, even a coalition of cities would probably lack the know-how to compete with these firms. But cities can run smart, data-intensive, algorithmic public transportation, housing, health and education – all based on a logic of solidarity, social cooperation and collective rights. Also, many political forces questioning elements of the neoliberal agenda have considerable influence in cities, often much more so than in national terms.

The Right to the 'Digital' City

So, what can cities do? First of all, it is crucial that they manage to preserve their ability to implement independent, effective policies and decide their own fate in times of austerity and financial crisis. To do so, cities will require a new vocabulary and

conceptual apparatus to reassess their relationship to technology, data and infrastructures. When data, sensors and algorithms mediate the provision of services in certain domains – from utilities to transportation, education and health – it is obvious that the discussion should include the management of basic services and infrastructures.

When we talk about urban technology and data, we are dealing with some kind of *meta-utility* – composed of those very sensors and algorithms – which powers the rest of the city. As cities lose control over said meta-utility, they find it increasingly difficult to push for non-neoliberal models in supposedly 'non-technological' domains such as energy or healthcare.

One useful concept for cities seeking to preserve a degree of autonomy in this digital world is that of *technological sovereignty* – a simple idea which denotes citizens' capacity to have a say and participate in how the technological infrastructure around them operates and what ends it serves. The notion of 'sovereignty' – whether of finances or energy – permeates the activities of many urban social movements, including those transitioning into leadership positions in their respective cities. Concepts like energy sovereignty may be easily grasped and capable of mobilising large sections of the population, but what does energy sovereignty mean once we transition onto the smart grid, and firms like Google offer to cut our energy bills by one-third if only we surrender our energy data? Does the struggle for 'energy sovereignty' mean anything if it is not intricately tied to the struggle for 'technological sovereignty'? Probably not.

This means that we must view a radical democratic agenda for cities through the lens of technological sovereignty. What does the 'right to the city' mean in a fully privatised, digital city, where access to resources is mediated by the swiping of a 'smart card' tied to our identity? How can this right be effectively exercised when infrastructure is no longer in public hands and corporations determine terms of access? How can cities claim to be spaces of becoming, contestation and anonymity when techniques such as algorithmic regulation seek to resolve all conflicts

in real time while imprisoning us in the straitjacket of austerity? Without an accompanying struggle for technological sovereignty, the fight for the right to the city loses much of its power.

While it would be an overstatement to say that cities are aware of the importance of technological sovereignty and are actively pushing for it, it is fair to say that some are considering specific measures in keeping with this spirit. They can be roughly classified into several groups: those offering an alternative regime for dealing with citizen-produced data; those promoting an alternative, more cooperative model of service provision – including by private players – which does not rely on or promote data extractivism by a handful of giant tech firms; those seeking to control the activities of platforms like Airbnb or Uber by demanding access to their data; and those promoting and building alternative infrastructures to compete with Silicon Valley, at least in some domains.

The most important thing to bear in mind is the need for a holistic approach focused on multiple elements, whether they be data, infrastructure or transparency in algorithmic decision making. A city that manages to force technology companies to share collected data – indeed, many firms already charge for data or use it as a bargaining chip in negotiations – may find itself unable to act upon the data without an advanced computing infrastructure or access to the algorithms originally used to turn that data into, say, price signals. Thus, merely establishing a different legal regime for data is unlikely to generate adequate results – it must be complemented by a strategy to reclaim urban infrastructure as a whole.

This is where many urban social movements have appealed for *remunicipalisation*. In many cases, such appeals have been remarkably successful when it comes to efforts to reclaim and repurpose electric grids, gas pipelines and water systems. That said, remunicipalising digital infrastructure is complicated: first of all, companies often have no physical presence in the cities or even countries in which they operate, making threats ineffective. Second, much of the infrastructure they operate is not the bulky

physical infrastructure occupying our public space, like electricity pylons or water pipes. Instead, we are often dealing with sensors embedded in smartphones belonging to individual citizens, such as those Google uses to predict traffic on many roads. Absent major action on the national scale or clever strategic coordination between cities on the international scale, it will be extremely difficult to reverse this already worrying trend.

The fight for digital sovereignty should be coupled with a coherent and ambitious political and economic agenda capable of reversing the damage brought about by the neoliberal turn in both urban and national policy. Urban social movements have made impressive progress in at least identifying the kinds of practical interventions which can make a difference: auditing a city's existing contracts and debt agreements (often with the aid of mechanisms like citizen audits), requiring a certain level of transparency and commitment in the tendering process, investigating the role of consulting firms and various private contractors in the running of public–private partnerships and private finance initiatives, and naming and shaming private equity firms and alternative asset management funds that come to own important infrastructure only to neglect long-term investment in its maintenance.

Well-targeted, pragmatic interventions can have a big impact. Insofar as signing smart-city contracts requires purchasing software licenses, every effort should be made to demand free software and open-source alternatives – a measure which many cities would be well advised to codify into law. Barcelona is a pioneer on this front, pledging to drop Microsoft products from its systems, and introducing 'data sovereignty' clauses into public procurement contracts.

Ultimately, the right to the city might need reformulation as the right to enjoy rights altogether, as the alternative means risking that digital giants will continue redefining every right. What, for example, does the right to the city mean in a city operated by technology companies and governed by private law, with citizens and social communities unable to freely and unconditionally

access key resources such as data, connectivity and computing power, which could allow them to pursue self-management? And to what extent would losing control over the information-powered meta-utility undercut successful remunicipalisation campaigns, whether to reclaim energy, transport or water infrastructure, allowing the utilities in question to transition towards their own 'smart' consumption model with a new set of private intermediaries?

Ultimately, the efforts to oppose the dominance of the neoliberal smart-city paradigm will depend on the ability of the brave cities who dare to defy it to demonstrate several things at once.

First, they must show that the economic models proposed by the likes of Uber, Google and Airbnb do not deliver the promised results – at least not without causing a considerable amount of damage to the cities in question, from the rise of the speculative economy to the precarisation of labour in the gig economy and the immense blockage of social innovation by those without access to data.

Second, they must prove that key resources and digital infrastructures can be deployed under a different legal and economic model to produce outcomes which would deploy technology to benefit local residents and local industry rather than mostly transnational corporations. Retreating into technophobia and the threat of increased regulation – without offering constructive alternatives – would accrue little goodwill among citizens whose expectations for disruptive innovation have already been shaped by their experiences in the private sector.

Third, it would require constant city-scale pilot projects and experiments to zoom in on projects capable of delivering value to residents, and discard those which are not. Cities must appropriate and run collective data as a commons, on people, the environment, connected objects, public transport and energy systems.

The most ambitious programme to reclaim technological sovereignty at the city level would naturally entail efforts to reclaim or at least replicate all key elements of the emerging informational meta-utility, from sensors and computing power

to AI and data. Realistically speaking, even cities with fiscally sound budgets may prove unable to pursue this agenda in full, being forced to pick and choose if only for political reasons. Many of these steps – like building an alternative AI system – would be impossible without the participation of other like-minded cities and without stronger synergies at national, European and global level.

Alternative Ownership Models for Data: City Data Commons

Changing the data ownership regime may be an affordable option, if only because it would not require massive financial commitments and because it represents an agenda with intuitive popular appeal: cities and citizens, not companies, ought to own the data produced in cities and should be able to use said data to improve public services and put their policies into action.

In the fourth industrial revolution, data and AI are essential digital infrastructures that are critical for political and economic activity. Data has become the most valuable commodity in the world. It is the raw material of the digital economy, and fuels AI. Companies in every industry are counting on AI to drive growth over the coming years, and machine learning will increase their return on investment by anywhere from 10 to 30 per cent. Data cannot be controlled by a handful of tech giants. Business models that exploit personal data to pay for critical infrastructures are broken. We need to democratise data ownership and AI, and move from data extractivism to data commons.

Taking a firm stance on data ownership may accomplish several goals at once. First, it would make the rampant real estate speculation facilitated by the likes of Airbnb much more diffi-cult: cities and ordinary citizens would be able to check whether the claims frequently made by Airbnb in its defence – that it primarily benefits ordinary users – are empirically verifiable. Second, placing cities in charge of their own data would remove one of the main bargaining chips that firms like Uber now have

when negotiating with regulators: in Boston, for example, Uber offered the authorities access to traffic data, expecting lighter regulation in return. Third, it seems highly unlikely that cities could stimulate the growth of an alternative digital economy with robust local and decentralised alternatives to Uber and Airbnb without a robust alternative data regime: without the troves of data available to these giants, these smaller contenders may prove unable to compete.

The immense economic value that such data represents should be returned to citizens. By helping them regain control of their data we can generate public value, rather than private profits. To take one of the most ambitious examples, Barcelona is betting on a new approach to data called 'city data commons', meaning to strike a *new social pact on data* to make the most out of data, while guaranteeing data sovereignty and privacy. Data is key to a city's infrastructure, and can be used to reach better, faster and more democratic decisions, incubate innovation, improve public services and empower people.

Barcelona is experimenting with socialising data in order to promote new cooperative platforms and democratise innovation. This is the objective of DECODE,[2] a project Barcelona leads with thirteen partner organisations from across Europe, including Amsterdam. The DECODE project develops decentralised technologies (such as blockchain and attribute-based cryptography) to give people better control over their data, in part by setting rules on who can access it, for what purposes and on what terms.

By helping citizens regain control of their data, we aspire to generate public value rather than private profit. Our goal is to create 'data commons' from data produced by people, sensors and devices. A data commons is a shared resource that enables citizens to contribute, access and use the data – e.g. about air quality, mobility or health – as a common good, without intellectual property rights restrictions.

Barcelona envisions data as a form of public infrastructure alongside roads, electricity, water and clean air. It is a meta-utility

that will enable cities to build future smart public services in transportation, healthcare and education. However, the aim isn't to build a new panopticon. Citizens will set the anonymity level, so that they can't be identified without explicit consent, and they will keep control over data once they share it for the common good. This common data infrastructure will remain open to local companies, co-ops and social organisations that can build data-driven services and create long-term public value.

Involving citizens in Amsterdam and Barcelona, DECODE addresses real-world problems: e.g. it's integrated with the participation platform Decidim Barcelona, which is already used by thousands of citizens to shape the city's policy agenda, with over 70 per cent of governmental actions proposed directly by citizens. Rather than using the personal information of voters (furnished by the likes of Cambridge Analytica) for manipulation, the plan is to use data-intensive platforms to boost participation and make politicians more accountable.

Data commons can also help cities develop alternatives to predatory on-demand platforms like Uber and Airbnb. Introducing fair regulation and algorithmic transparency to tame the on-demand economy, as many cities are currently doing, is necessary but insufficient. Barcelona has launched a variety of initiatives to empower sharing-economy alternatives such as *platform cooperatives* and experiments with next-generation collective platforms based on data commons, where citizens own and control their data and where the rights of workers and citizens are respected.

Starting in cities, we can challenge the current narrative dominated by Silicon Valley's leaky surveillance capitalism, and dystopian models such as China's social credit system. A new deal on data, based on a rights-based, people-centric framework, which does not exploit personal data to pay for critical infrastructure, is long overdue.

The rise of digital capitalism brings many challenges – from monopoly power to the need for a new tax on digital platforms, trade regulations, unemployment due to automation and

questions around civil liberties. Large tech firms have offshored around US$1 trillion in the last decade, while they are issuing debt on the US public market at very low interest rates and using it for share buybacks. This is leading to increases in corporate profit, stock prices and wealth inequality. As we ask how we could create a financial sector that serves the real economy, we should also be asking how we could create a digital sector that serves the real economy.

Europe just passed new data protection rules based on worthy principles such as 'privacy by design' and 'data portability'. Coupled with new regulatory instruments in the areas of taxation and antitrust, such bold interventions can create alternatives where citizens have greater power over their data and the future built with it. Cities like Barcelona can show the way and open a path for a network of digital sovereign cities reclaiming democratic governance of twenty-first-century infrastructures, including data sovereignty and ethical AI for citizens. We should shape a digital future for the many, not the few.

Rethinking Economics for a New Economy

J. Christopher Proctor

Most of the chapters in this book are about visions of a new economy. This one is about a vision of a new economics. In 1936, John Maynard Keynes wrote the now famous quotation that 'practical men, who believe themselves to be quite exempt from any intellectual influence, are usually the slaves of some defunct economist', and that 'madmen in authority, who hear voices in the air, are distilling their frenzy from some academic scribbler of a few years back'.[1] The eighty years since his writing have seemed to prove him correct. As the Western world lurched from Keynesian mixed economies to neoliberal 'hyper-capitalism', politicians and policymakers like Margaret Thatcher and Ronald Reagan seemed to be acting out the scripts that had been written years earlier by men like Friedrich Hayek and Milton Friedman.

Most readers are probably familiar with this story of the tumultuous 1970s and the new era of politics that followed. What is less obvious is that, despite the dramatic shift in policies, within academic economics the core theoretical framework remained essentially unchanged. Both Keynesian planning and laissez-faire neoliberalism had their theoretical roots in what is called 'neoclassical' economics. Neoclassical economics is an impressively flexible tool – it provides a framework from which academics can draw radically different conclusions. But it is not all-powerful. It has substantial blind spots, and excludes many questions and lines of reasoning that could be helpful in meeting the economic challenges of the next century.

Neoclassical economics is now synonymous with 'economics' throughout much of academia. It is what is taught to students, it is what is published in major journals and it is what backs up the 'sound' economic advice presented to policymakers of all parties. Students around the world have begun to protest this narrowness, arguing that they are being short-changed out of receiving the critical examination of the economy they expected when they decided to study economics.

The political left is being short-changed as well. The dominance of neoclassical economics ensures that economic debates are framed in a way that limits what progressives see as possible. Indeed, it is part of the reason why left-of-centre parties have so often struggled to come up with bold new ideas to face the challenges of the twenty-first century.

Over the years, conservatives have not been shy about making investments in academic infrastructure that supported their political goals. It is time for progressives to start taking economics seriously. If we want to create a truly new economy, we need to work to open the discipline of economics to new ideas and new approaches. In short, we need to invest in the next generation of 'academic scribblers' who will be writing the political scripts for decades to come.

What Is Neoclassical Economics?

Neoclassical economics is a branch of economic thinking that developed in the late 1800s out of the 'classical' tradition of economists like Adam Smith and David Ricardo. As mentioned previously, neoclassical economics forms the backbone of the vast majority of economic teaching and research – so much so that economic approaches or schools of thought that do not have neoclassical foundations are often labelled 'heterodox'. As neoclassical economics represents the bulk of modern economic theory, this section can only give the briefest introduction. As such, I will try to show what it looks like to 'do' neoclassical economics, especially as it relates to issues of economic policy.

For a more thorough theoretical explanation of neoclassical economics, *The Econocracy*, a book written by members of the Rethinking Economics network, is quite helpful.[2]

Neoclassical economics operates in a world of markets. One of the key innovations of neoclassical economics was that economic value derives not solely from the cost of producing something, but also from how much people want that thing. Thus, both supply and demand work together to determine prices. When markets work well, prices are set at a level where supply meets demand. Everyone who is able and willing to pay the price for a good can do so (there are no shortages) and there are not large numbers of unsold goods (surpluses). These markets are 'efficient' in the sense that nothing could be done to make any market participant better off without also making someone else worse off – i.e. the economic pie is as big as it could possibly be with the resources available.

Much of the work of economics then turns to looking at situations where markets do not work so well – where something *can* be done to make the economic pie bigger without adding more resources. These situations are called 'market failures' or 'market imperfections', and they are caused by 'frictions' which make a real-world market deviate from a 'perfect' market. There are a large number of market failures, and the concept is used by economists to explain quite a lot.

For example, when a market transaction affects a third party other than the buyer or seller – a situation called an externality – markets can produce too much (an inefficiently high amount) of something like pollution or too little (an inefficiently low amount) of something like education. Externalities can lead to policy recommendations which aim to balance the market by, for instance, taxing or regulating pollution and subsidising education. In a similar vein, goods that can be used by everyone can be hard to fund with a market because everyone has a big incentive not to pay. That's why, without government help, markets might build an inefficiently low number of roads or other elements of public infrastructure. Differences, or asymmetries, in who knows

what within a market can also cause markets to operate inefficiently or break down entirely.

Using frictions, neoclassical economics was able to incorporate many of Keynes's key insights about how governments can respond to economic depression (an adaptation called the neoclassical–Keynesian synthesis). For instance, because there is often a practical cost to changing prices (whether reprinting menus or renegotiating contracts), some prices can be thought of as rigid, or 'sticky'. Wages are a particularly sticky price, as pay rates are sometimes locked into long-term contracts, and workers will often resist attempts to lower their wages. When the economy faces a general decline in demand for goods and services (typically characterised as coming from an 'outside shock', like a change in trade relations or the development of a new technology) the market price for labour should decrease. But, because wages are difficult to bring down, employers will instead lay off workers, creating a surplus of labour (i.e. higher unemployment). Governments can respond to this situation by temporarily propping up demand (by borrowing and spending money), either to allow a temporary demand shock to pass, or to give wages time to adapt downward to a more permanent decline in demand.

Using logic chains like this, a pretty large range of economic ideas can be expressed in terms of 'deviations' away from perfect markets, and a wide range of government action (or inaction) can be justified. That's how both Keynesian economics and neoliberalism – the set of ideas arguing for freer markets and less government – came to share the same theoretical framework. The policy differences can often be boiled down to questions about the size of a given market failure and the corresponding efficiency of a given government response.

However, while neoclassical economics can certainly bend, it is only so flexible. By viewing a diverse array of social phenomena – from work to our relationship with the environment – as markets, neoclassical economics offers a toolkit that aims at improving or fixing those markets. Fixing markets is obviously a

useful pursuit, but it will not be enough to face the myriad challenges of the twenty-first century.

How Does Neoclassical Economics Limit Progressive Politics?

The dominance of neoclassical economics limits the horizon of what is possible for progressive politics. The neoclassical framework limits the conceivable responses to familiar economic problems like unemployment or slow economic growth. It also has a tendency to frame most social phenomena as markets, even if other mindsets might be more useful in solving the economic problems at hand. Finally, by focusing primarily on markets and exchange, neoclassical economics takes many major economic issues off the table entirely.

HOW NEOCLASSICAL ECONOMICS SUGGESTS
ANSWERS TO FAMILIAR PROBLEMS

A good example of the 'limiting' power of the neoclassical framework can be seen by expanding on the logic chain about unemployment explained above. In this story, unemployment in recessions is caused because some shock knocked the economy out of a full-employment equilibrium, and certain frictions (like price-stickiness) are keeping the economy from returning back to a full-employment equilibrium. As explained earlier, this story can be used to justify Keynesian government spending – a traditionally progressive policy – but in doing so it accepts some fairly important claims about the nature and causes of unemployment that imply far less progressive policies in other situations.

Unemployment in this framework is fundamentally caused by 'frictions' that keep prices from adjusting to changes in demand. In a perfect market, there should be no involuntary unemployment – wages should adjust up and down such that the supply of labour matches the demand for labour so that everyone can work as much as they want for the going wage. If a new technology is introduced that decreases demand for labour, wages should fall

and everyone who wants to work at the new, lower wage should be able to. The only people who would be considered 'unemployed' in such a market would be those temporarily transitioning between jobs.

This framework prompts a division of unemployment into two categories: short-term and long-term. Short-term unemployment is caused by temporary frictions that keep prices from adjusting quickly to changes in demand. This is the kind of unemployment we see in depressions and recessions, and the kind which government deficit spending can alleviate. Long-term unemployment is then caused by non-temporary frictions that either permanently keep wages above the market rate, or make it harder for potential workers to match up with potential bosses. Unions, and other labour regulations, are often blamed for keeping wages above market rates (and creating unemployment for non-protected workers), and a host of 'matching frictions' like generous unemployment benefits are invoked to explain why potential workers may not be properly incentivised to find potential employers.

The impact of this kind of thinking on left politics is pretty clear. While the United Kingdom's GDP (a common measure of economic activity) is still well below its 2007 peak, Jeremy Corbyn's 2017 campaign effectively took government deficit spending off the table by promising to balance the government budget within five years.[3] Politically this move feels strange – the most left-wing leader the UK has seen in decades decided to throw out the Keynesian playbook and instead promised rigid fiscal conservatism, despite the lingering sluggishness of the UK economy.

However, within the logic of the neoclassical–Keynesian synthesis, it's hard to see what else could be done. Government deficit spending is designed to allow the economy to weather, or adjust to, temporary shocks. To argue for significant fiscal stimulus ten years after the crash, one would have to argue that either the shock of the financial crisis (or some other, similarly sized shock) is still somehow hitting the economy, or that downward

wage adjustments are still ongoing. As neither of these seem likely, fiscal stimulus would not be an effective solution, and any lingering unemployment can be regarded as a longer-term, structural problem.

Where this story leads next can be seen quite tragically across the Channel in France, where socialist president François Hollande's battle against long-term unemployment consisted almost entirely of attempts to make labour markets more 'flexible' by removing the various 'frictions' imposed by France's relatively strict labour codes and strong unions. It is telling that France's new president, Emmanuel Macron, for all his appearances of change, seems to share the same understanding of what is causing French unemployment, and likewise is proposing similar reforms to make French labour more flexible.

IF ALL YOU HAVE IS NEOCLASSICAL ECONOMICS, EVERYTHING LOOKS LIKE A MARKET

If all you have is a hammer, then the world looks like a nail. Something similar happens with neoclassical economics. Neoclassical economics is quite good at studying markets, so when neoclassical economists want to study something a natural first step is to conceptualise that thing as a market.

One particularly funny-sounding example of this tendency is the 'family economics' that developed in the 1960s to explain things like marriage, the sexual division of labour and altruistic relationships within families. This approach led to conversations about the market for marriages, the expected returns of raising children and the opportunity costs for men doing household work versus working outside the home.

However, if you were to actually ask people questions like 'why did you marry your spouse', 'why did you have children' or 'how do you decide who does what kind of work within your family', you would probably not get the same picture of the calculating decision makers described by family economics. That's not to say that there's no value in trying to think of families as if they were governed by the same logic as markets, but it

should imply that relying entirely on a vision of families that ignores things like cultural and religious practices, or deeper human feelings like love or obligation, is at best a limited approach.

A more concrete policy example of this phenomenon can be seen in the British higher education system.[4] Universities around the world face a similar squeeze: for decades, enrolments have increased while the costs per student of providing education have increased. The British response to this problem was to try to treat higher education as a market, and create competition between universities for students and the government funding that follows them.

Starting in 1997, Tony Blair's Labour government allowed English universities to start charging £1,000 per year in tuition fees for British and EU students. This amount would subsequently be increased to £3,000 in 2004 and £9,000 in 2010.[5] Part of the idea behind this move was to allow universities to differentiate by price, giving prospective students the option to 'buy' a higher- or lower-quality education as they saw fit.

The obvious problem with this plan is that most universities believe they are in the business of providing a high-quality education. Setting tuition fees under the cap simultaneously deprives a university of much-needed funds and signals to students and the wider academic community that they are a 'low-quality' option.

For the 2015/16 academic year, 113 of 120 English universities surveyed charged the full £9,000.[6] Instead of offering students more options, this attempt to treat higher education as a market has left students with uniformly high tuition fees. Instead of rethinking the flawed market approach itself, much of the economic advice about fixing the higher education 'market' has centred around removing 'barriers to entry' so that newer, more competitive universities can enter the market.[7]

Healthcare reform in the United States has told a similar story. The American healthcare system is quite complicated. Most working people receive health insurance from their employers and most retired or very poor people receive insurance from the

government, but everyone else is essentially on their own and has to buy insurance independently from private insurers. One of the big aims of the Democrats' 2010 Patient Protection and Affordable Care Act (better known as Obamacare) was to help this third group of people by making the market for private insurance work better.

The broad strategy was to set up well-regulated, localised markets for insurance, where insurers would have to offer plans that met government standards, and people buying these plans would be eligible for government subsidies. In theory, competition would bring down costs and increase quality of insurance, as insurers fought over potential customers and the government subsidies that came with them.

Unfortunately, simply keeping the markets running has proved to be quite a difficult task. On one side, the government has had to spend significant amounts of money to advertise the markets to potential buyers to keep enough people in the insurance risk pools to make the markets viable. On the other, the government has had to constantly lobby (and provide additional subsidies to) insurance companies to convince them to actually participate in the markets. Each year there are worries about regions with either too few buyers or too few insurers to make the markets operate. For 2018, roughly one-third of the people buying insurance on the marketplace will only have one insurance company to choose from.[8]

Markets are powerful tools, but they are not the answer to all of society's problems. The dominance of a branch of economics that thinks almost exclusively in terms of markets blinds policymakers to other alternatives that may be more appropriate.

TAKING ISSUES OFF THE TABLE

Neoclassical economics is designed to optimise the economic system we currently have, but it is much less equipped to think critically about some of the core features of the system itself. From economic inequality to our relationship with the environment, many of the biggest issues facing the world are effectively

omitted from the neoclassical radar. This leaves policymakers with a shortage of rigorous economic proposals that do more than just tinker around the edges of the status quo.

One of the core conceptual tasks of neoclassical economics – to identify and remedy market failures – is very poorly suited to addressing economic inequality. As stated earlier, the primary definition of 'efficiency' used in economics is a situation in which no one can be made better off without making someone else worse off – when the pie is as big as it can be without adding more ingredients. Efficiency is, then, by definition, a very good quality for a system to have, as it simply ensures resources are not wasted. The goal of much of economics, then, is to think about how to make markets more efficient so they can operate at full capacity.

However, this concept of efficiency says nothing about how the wealth produced by said markets is distributed. Economists often refer to this as the divide between efficiency and equity. Equity is about fairness, about the really big picture of how society thinks a just economy should operate. Equity is sticky, and is best left to political systems to figure out. Efficiency is a more technical matter, and is the preferred domain of economists. Unfortunately, because of the critical position of economists in the decision-making processes of modern societies, this means questions of equity often get dropped entirely in favour of work focusing on efficiency.

This doesn't mean that economists are incapable of studying inequality. But when they do try to take questions about power and distribution seriously, they often do so with empirical studies like, for example, analysing the statistical relationship between various measures of inequality and economic growth. This work is important, but without more substantial theoretical foundations it can only provide so much insight. For instance, empirical studies can suggest that very high levels of inequality dampen growth, but they cannot offer much insight about the deeper role of (or need for) inequality within a capitalist system, or the pervasive relationship between economic inequality and political

power. Questions about the causes and consequences of inequality cut to the core of modern political debate, but in neoclassical economics they are uncomfortable side topics.

Neoclassical economics has a similar problem when it comes to the environment. While neoclassical economists do often talk about the environment – there is an entire sub-discipline called environmental economics – these conversations once again tend to frame environmental problems using the language of market failures and inefficiencies. Pollution is a negative externality, so left to their own devices markets will produce a sub-optimal level of pollution. With taxes and regulations, governments can then adjust the markets to create an 'optimal' level of pollution. Again, while this kind of work can be useful, it misses some of society's biggest and most fundamental questions regarding the environment, sustainability and the future of our economy.

Investing in Ideas

Economics doesn't have to be like this. Many of the theories that can supplement neoclassical economics already exist. For instance, post-Keynesians have very different notions of what causes (and cures) unemployment, while institutionalist economists are working to identify specific legal structures that exacerbate inequality. Ecological economists view the economy as a subsystem of the environment, and are starting to work out the details of how modern economies could operate without perpetual growth. Feminist economists examine the rich world of economics that exists outside of formal market structures, while cooperative economists think of alternative ways to organise both production and consumption without traditional, profit-driven markets. These examples are just the tip of the iceberg of the wealth of economic diversity out there.[9]

Unfortunately, much like an iceberg, most of these ideas remain below the surface, without the resources, publicity and perceived legitimacy needed to influence progressive policy in a meaningful way. Progressive politicians, activists and donors

should take this problem seriously. It's time for the left to start looking beyond the immediate economic fights of the day, and start working towards removing the deeper theoretical and institutional constraints that prevent more inclusive and progressive economic ideas from flourishing.

Conservatives have not been shy about investing in the 'production' of economic ideas, and for decades they have funded an endless stream of think tanks, research grants, popular publications and even university economics departments. This has allowed them to ensure that issues that are important to them (like debts and deficits) receive a central treatment by economists and the economics press, and has also helped subtly direct policymakers on both the right and the left towards policies that are agreeable to a broadly 'neoliberal' worldview.

Luckily, a movement to open economics to new ideas is now in full bloom. Student organisations like Rethinking Economics and the International Student Initiative for Pluralism in Economics have been working for the past five years to build a movement that can alter economics education to make it more open, diverse and relevant to the real world. Other groups, like Promoting Economic Pluralism, have taken the movement outside of the university to both civil servants and the private sector, while the organisation Economy (ecnmy.org) is working to make pluralist economics engaging and understandable for a wider audience.

There's plenty of work to be done, particularly in funding spaces like think tanks and policy shops where non-neoclassical policy work can receive serious attention. While much of the movement to reform economics is non-partisan in nature, that does not mean partisans should ignore the action. Many of our economic problems can be traced back to decades-old trends in economic thinking. Now is the time to start the hard work of creating a new economics that will be receptive to bold ideas for a new economy. In short, if there really is a 'marketplace for ideas' it's time for progressives to start investing.

Public Investment in Social Infrastructure for a Caring, Sustainable and Productive Economy

Özlem Onaran

Introduction

Public discontent with austerity and neoliberal economic policies are offering an increasing space for progressive economic policy alternatives. What should alternative policies target? The aim of policy should be to improve the well-being of people, and target the multiple goals of creating full employment with decent jobs, decent pay and decent working conditions for women and men, equality, and ecological and social sustainability. The success of economic policies could be assessed against a multitude of measurable targets such as employment of men and women in jobs with decent incomes, job security and satisfaction, free time for voluntary activities, low inequality, gender parity, social security, equal universal access to high-quality public services in health and social care, education, childcare, housing, public transport, clean air and green space.

This requires mobilising all the tools of economic policy, but in particular a large and well-planned public-spending programme to steer the direction of the economy, particularly because many of these services can be characterised as public goods. While green physical infrastructure in renewable energy, public transport and social housing, as well as public

spending in health and education, are often embraced by most progressive economists, there is less awareness that public spending in health, social care, education and childcare should be considered as investments in social infrastructure at the same level of priority as physical infrastructure, as recommended by the UK Women's Budget Group and the Scottish Women's Budget Group.[1]

What Is Investment and Why Should We Invest in Social Infrastructure?

Public spending should address the care deficit in our society and fill the gap in social infrastructure, i.e. in health, education, childcare and social care, which cannot be provided adequately by private investment based on the profit motive. The need for social infrastructure is not sufficiently met under the present circumstances, with inadequately low public spending in this field; currently private providers fill in the gaps by supplying these services, which are provided either at very low wages and low quality (to ensure an adequate profit) or as luxury services for the rich. This leaves a large unmet demand for social services, and a large part of the remaining care deficit is currently being covered by women who go unpaid within the gendered division of labour in the private sphere at home, i.e. invisible unpaid female labour. A substantial rise in spending in social infrastructure by the state or by non-profit/community organisations is required to cover this care deficit.

Despite the value of these services to society, day-to-day spending in these sectors, e.g. the wages and salaries of teachers, nursery teachers, nurses, doctors or social care workers, are considered as current spending in our public finance and national accounts; thus they are not considered as investments in assets (or capital spending) which will produce future streams of output. This is inconsistent with the notion of investment, because public spending in education or health services delivers benefits over a long period both to the people

who receive these services and also to businesses and society as
a whole, with substantial productivity impacts on all other
sectors of the economy, by increasing the skills, health and
innovative capacity of people. Childcare and early-years educa-
tion can substantially contribute to developing the cognitive
and creative capacity of children, and benefit society by not
only increasing their future productivity, but also increasing
social cohesion, integration and equality between children
from different backgrounds. Therefore, the Women's Budget
Group argues that spending on social infrastructure in educa-
tion, childcare, health and social care should be classified as
investments in infrastructure for two reasons.[2] First, it should
be defined as investment because it is spending on an asset that
produces a net return in the future, in terms of increased
productivity or well-being. Second, it should be defined as
infrastructure because some of those benefits do not just accrue
to individual users but are public goods and accrue to society
as a whole. The Commission on the Measurement of Economic
Performance and Social Progress has also recommended that
expenditure in health or education should be seen as invest-
ment in human capital.[3]

At first glance it may sound less trivial to justify spending on
social care services for frail elderly people, i.e. those who will
never be future workers in the market economy, as investments.
Diane Elson argues that to include such spending as invest-
ments we have to look at the returns as measured by increases
in future well-being beyond simple economic returns, and
investments in the social fabric for a decent society where both
young and old can live in dignity.[4] Furthermore, an economic
justification can also be provided in terms of releasing carers, in
particular women, from unpaid care duties, and giving them
the choice to participate in paid work if they wish to do so.
Also, a more developed social security system, including a
decent old-age care system, may lead to more innovative and
productive workers, free of worries about those they care for as
well as their own future.

Social Infrastructure as Both Purple and Green Investment

Crucially, strong investment in public services and social infra-structure improves gender equality, and reverses one of the most persistent dimensions of inequality in our society, as they provide crucial services which are otherwise delivered by the unpaid, invisible domestic labour of women. Public provision of these services offers women a genuine choice to participate in social and economic life more equally, if they wish to do so. This in turn further increases productivity, by unleashing the full poten-tial of women. Moreover, in current gendered and occupation-ally segregated labour markets, these sectors employ predomi-nantly women, and more social public spending leads to closing the gender gap in employment. This is why they are labelled as purple public investment by feminist economists.[5]

However, these jobs need to be made attractive to both men and women by improving pay, working conditions and job satis-faction as well as training and education requirements in these industries. A new orientation of policies towards creating high-skilled, decent jobs in the social infrastructure sector should be promoted instead of the current reliance on low-pay service jobs and weak labour unions in this sector. Such policies would put gender equality in pay and employment at the heart of an equal-ity-led development strategy. However, if women are concen-trated in the types of paid work where the prospect of higher wages does not exist, these policies may still be insufficient to significantly improve women's incomes and equality. Wage poli-cies should reflect the added value of social infrastructure for society, and should gradually target the problem of occupational segregation.[6] The public sector can contribute to making sure that we value adequately what matters for our society. This is a clear break from current policies of low pay in the care sector as well as pay freezes for public sector workers, who are predomi-nantly women.

While recognising the vast amount of time women spend on unpaid care and the importance of their work – which is not

accounted for in the standard national accounts or measures such as GDP – is crucial, this policy aims to publicly provide the necessary social services, i.e. to socialise these activities and radically decrease the amount of unpaid private care. For example, there could be universal free childcare and nurseries open for sufficiently long hours to benefit mothers and fathers by giving them an equal chance to balance work and social, cultural and political life. Needless to say there will always be the need and desire for care provided by family members for children or the elderly in the domestic private sphere, and regulations such as sufficiently long paid parental leave, equally available for both mothers and fathers, and working-time arrangements that facilitate combining care and work for both men and women, should ensure that time for caring can be shared equally. Diane Elson calls for a reorientation of economic policy with an aim to 'recognize, reduce and redistribute' unpaid care work.[7]

There is also an important alliance between the agendas for green development and gender equality. A larger proportion of society's time spent caring for each other is also a greener alternative, whether that is in paid or unpaid time, as these activities are much less carbon-intense. Furthermore, social infrastructure services are very labour-intensive and therefore public investment in this area is a vehicle for generating more employment for a given rate of growth in national output – a target more consistent with low carbon emissions.

The Effects on Private Investment, Growth, Public Budget Balance and Employment

Conservative policies consider public spending as undesirable, based on the myth that it would lead to low private investment and productivity in the long term due to either higher taxes or higher interest rates as a consequence of public borrowing to finance public spending. This assessment is rather static and short-sighted as it ignores the positive impact of these policies on macroeconomic demand, and in turn on productivity and private

investment both in the short and the long run. This is a myth based on incorrect assumptions about the behaviour of private investors and is inconsistent with the empirical facts about the performance of the British economy. Despite decreasing corporate tax rates and increasing profits since the 1980s, Britain has one of the lowest productivity rates and lowest ratios of private investment to national income among the developed countries. Historically very low interest rates since the Great Recession of 2008 have also not been enough to stimulate private investment. There is a missing link between increased profits and investment. Rising inequality and financialisation have been the main reasons behind this missing link. Private investment requires both demand and public infrastructure, and not just profitability.[8]

In terms of the first reason for the missing link between investment and profits, Britain's reliance on a low-road strategy of low public spending and low wages has led to a fragile, unstable growth policy based on high household debt, further discouraging investment. Rather than investing, firms have exploited low labour costs. On the labour market front, stagnant wages caused by zero-hours contracts, dodgy self-employment practices, public sector cuts and pay freezes, and decades of attacks on trade unions have led to high household debt and shaky debt-led consumption-driven growth in Britain.[9] Stimulating private investment and productivity requires a high-road strategy of high wages and high public investment in both social and physical infrastructure.

Financialisation is the second cause of the missing link between investment and profits. Firms have increasingly directed their profits towards financial speculation. Non-financial corporations' profits devoted to real investment declined from about 80 per cent in the 1980s to less than 50 per cent in the last decade, while their financial assets increased substantially.[10] High dividend payments and surging financial activities have crowded out private investment in physical machinery and equipment. To stop this, instead of lowering corporate taxation we need to develop corporate governance policies to create incentives for long-term investment

and disincentives for short-term speculation, e.g. by setting a higher rate of taxation on corporate profits which are not invested. This way we can have an adequate tax base to finance a decent public infrastructure for society and businesses.

At the University of Greenwich, our recent research shows that a policy mix of higher public spending, progressive taxation (i.e. a higher tax rate on high capital income and a lower tax rate on low labour income) and higher wages would have a strong positive impact on growth and private investment as well as public finances in Britain.[11] This is because of the 'multiplier' mechanism in the macroeconomy: a rise in public spending generates sales for businesses as well as public and private sector jobs; then employees spend their income, leading to further increases in sales for private businesses. Additionally, an improved business environment due to better provision of infrastructure and increased productivity in the longer term leads to further positive impacts on private investment, which in turn leads to additional increases in national income. All these dynamic multiplier effects of public spending are ignored by conservative economic policy analyses. Our research indicates a multiplier in the UK of about 2.2; i.e. a £1.00 increase in demand due to higher public spending would lead to a £2.20 increase in national income (measured as GDP). Higher national income leads to further increases in tax revenues beyond the impact of increases in tax rates, and more than offsets the impact of higher public spending on the budget; i.e. such a policy mix of public spending, combined with progressive taxation and higher wages, leads to an improvement in the budget balance. Even when tax rates do not increase, an increase in public spending alone would also increase tax revenues substantially as it has a very strong positive impact on the national income.[12]

The multiplier effects of higher public spending, i.e. the effects on national income, are likely to be higher in the long run than in the short run, because in the short term economy benefits are only realised from the demand effects, whereas productivity gains kick in over the longer term with a time lag, which further

increases profitability (by decreasing unit labour costs for a given wage), and further stimulates demand and private investment.[13]

Furthermore, both the short- and long-term multiplier and productivity effects of public investment in social infrastructure are stronger than those of public investment in physical infrastructure in the UK.[14] Consequently, and in particular due to the labour-intensive nature of social infrastructure and occupational segregation, such investment leads to very strong increases in employment of women as well as creating a substantial number of jobs for men in all sectors of the economy due to spillover effects of demand from the social sector to the rest of the economy.[15] This policy thereby also contributes to closing the gender gaps in employment. In comparison, public investment in physical infrastructure creates fewer jobs in total, and most new jobs are predominantly male jobs.

The positive impact of public spending on national income and investment is further enhanced when it is combined with labour market policies improving wages, as higher wages lead to higher sales for businesses and higher private investment. Ending public sector pay freezes and cuts to local councils, in order to provide decent pay for teachers, nurses and care workers, has similarly strong multiplier and productivity effects. Along with the income of public sector employees, national income and tax revenues of the government also increase; hence again, public spending can partially finance itself. In the longer term, higher wages also lead to better-quality services and a more productive workforce, further stimulating private investment, leading to an even stronger positive impact on the economy and the budget.

Finally, progressive taxation is particularly important in our policy mix as it provides for public spending on non-means-tested services such as universal health and social care, education and childcare. A higher tax rate on higher incomes is a way to ensure that those who can afford to contribute more towards universally provided public services do so.

Conclusion: Social Infrastructure as a Core Element of Fiscal and Industrial Policy

Recognising the long-term positive impact of social infrastructure and its investment character has crucial implications for defining fiscal policy as well as industrial policy priorities, and potentially the financing of social infrastructure in the context of a fiscal credibility rule, which allows borrowing for investment in infrastructure. Conventionally, industrial policy is too often seen through the narrow lens of public physical infrastructure as a stimulus to private investment. However, public social infrastructure is a crucial ingredient in a productive and innovative society, and in a business environment that stimulates the 'animal spirits' of entrepreneurs. Hence, we cannot have a coherent industrial policy that does not adequately provide a developed public social infrastructure.

Public investment in social infrastructure addresses some urgent destabilising economic and social issues in the UK, such as stagnation in productivity, the demographic and care crises, unemployment and unhealthy growth driven by private debt. Increasing public investment in health, social care, childcare and education generates higher employment for both women and men, higher national income, higher productivity and eventually higher tax revenues, and as such partially funds itself. An appropriate mix of fiscal, labour market and industrial policies will help to achieve a stable macroeconomic environment, equality, full employment, social cohesion and ecological sustainability.

Equitable and sustainable development needs green and purple public investment in both physical and social infrastructure and a pay rise for both women and men. Given the challenges of our time, my advice to the Chancellor in the twenty-first century is to take care of full employment with decent pay for women and men, equality and ecological sustainability, and the budget will take care of itself.

Rentier Capitalism and the Precariat: The Case for a Commons Fund

Guy Standing

Every upsurge of progressive politics is led by demands from the emerging mass class, or, if preferred, by the emerging mass within the working class. Today we are in the midst of the Global Transformation, the painful construction of a global economy. The context is that after three decades of 'neoliberalism' a system of rentier capitalism has emerged, with a bully of a superpower demanding more of its largesse.[1]

We must understand rentier capitalism if a viable progressive politics and economic strategy are to be built. Essentially, the neoliberal phase, ostensibly promoting 'free markets', is dead. Globally, there is the most unfree market system ever conceived. It must be dismantled.

The neoliberalism that began under Thatcher involved financial market liberalisation, commodification, privatisation and labour market reregulation (not deregulation) in favour of labour flexibility and capital.

It ushered in a period of financial domination led by US institutions, notably Goldman Sachs. These steered successive US administrations, backed by Britain and the EU, into constructing an international architecture of rent-seeking, under the aegis of the World Trade Organization and World Intellectual Property Organization that in 1994 adopted the epochal TRIPS (Trade-Related Aspects of Intellectual Property Rights), which globalised American-style intellectual property rights, entrenching monopolistic rent-seeking by multinationals.

While that was taking shape, a technological revolution took off. That made it easier to switch production and employment to where costs were relatively low, and easier to fragment occupations and job structures. It was also to lead to platform capitalism, a feature of which is that owners of apps and so-called 'requesters' are effectively brokers extracting rental incomes.

Another aspect of rentier capitalism has been the plunder of the commons, pursued by successive governments through privatisation of public land, water, other public utilities, social services and much more. Accelerated by the post-2010 deceit, this plunder is a feature of class politics that commentators have largely neglected.

The intellectual property rights regime has fuelled the growth of monopolistic corporations, the CEOs of which reject free market competition. They just buy up potential competitors.[2] They also gain from government subsidies, which have contributed to budget deficits, and from generous tax cuts, falsely rationalised on the grounds that if not given the corporations will go elsewhere. On one estimate, corporate welfare in Britain swallows up over £93 billion a year.[3] This will rise with Brexit.

Meanwhile, financial institutions and government have created new and intensified forms of private indebtedness. Debt has become a structural feature of an overfinancialised economy, earning financial capital vast revenue.[4]

Finally, a globalised labour market has taken shape, in which wages in China and other emerging market economies are gradually rising while continuing to pull down wages in all OECD countries. This trend has many years still to run.

In the years leading up to the financial crash of 2007–8, governments made a Faustian bargain. While real wages and social income were falling for more people, they propped up consumption and living standards with cheap credit and subsidies, mainly in the form of tax credits, which were a subsidy to capital, allowing real wages to fall. They were to fall more in the wake of the crash.

Put bluntly, the twentieth-century income distribution system has broken down, along with the social compact of the post-1945 era. The collapse is global, even greater in the US and China than in Europe. All over the world, the share of income going to capital has risen and the share going to those relying on labour has fallen. Even more relevant for reformulating progressive economic policies, the share of capital derived from rent has risen faster, and the share of rentier income going to the higher echelons of those relying mainly on labour has risen.

Reflecting the collapse of the old system, it used to be that when productivity rose real wages rose in parallel. Now there is what is called the opening of the jaws of the snake. When productivity rises, wages do not follow. The links between profits and wages, and between employment and wages, are also broken. We would be unwise to think they will be resurrected or that wage stagnation can be overcome by much. The past is another place.

All of this has generated a new global class structure – indeed, every transformation produces a unique class structure. Today's is characterised by a plutocracy of multibillionaires with absurd power, an elite serving them, a shrinking salariat with employment security and a growing array of non-wage benefits, a shrinking industrial proletariat and a growing precariat. I plead with those clinging to dualistic perspectives drawn from a reading of the nineteenth-century Marx to understand that these groups have distinctive relations of production (work patterns), relations of distribution (sources of income) and relations to the state that make it desirable to identify with the precariat as a group. We must craft a vision and an agenda for it.

As commentators and politicians are learning, the precariat is profoundly different, in experience and outlook, from the proletariat that long dominated their imagery. The outcome of globalisation, a technological revolution and reforms promoting 'labour flexibility', the precariat suffers from pervasive insecurity, which makes it a dangerous class.

On the first page of a book published in 2011, I wrote that unless the precariat's insecurities were addressed urgently, a

'political monster' would emerge.[5] After the US presidential election in 2016, I received numerous emails saying 'the political monster' had arrived. Insecure people tend to vote emotionally, not rationally in defence of Enlightenment values.

The precariat, which exists in Britain as elsewhere, and in almost all occupations, has three dimensions. First, those in it have a distinctive work pattern. They are being habituated to a life of unstable, insecure labour. Casualisation, temping, on-call labour, platform cloud labour and so on are spreading. But more importantly, they lack an occupational identity or narrative to give to their lives, or any organisational one.

They must do a vast amount of work-for-labour, not counted in official statistics or political rhetoric, but which if not done can be costly, such as endless retraining, networking, refining CVs, filling forms and waiting around for jobs. Typically, they obtain jobs below their education or qualifications, and have low mobility upwards. All this creates frustration, insecurity and stress.

Second, the precariat has a distinctive social income. They rely almost entirely on money wages or earnings. They do not obtain the non-wage benefits that the proletariat obtained, such as paid holidays, medical leave and the prospect of a meaningful pension. While the salariat gain more non-wage perks, the precariat lose even those they had. As a result, the growth of inequality exceeds what income statistics suggest.

Their real wages have fallen, and are more volatile. This means more uninsurable uncertainty and life on the edge of unsustainable debt, knowing that one illness, accident or mistake could tip them into a financial abyss. Most rely on privately rented accommodation, without security of tenure, without an assured level of rent, constantly worried that an interruption in earnings or suspension of some discretionary benefit will tip them into homelessness.

To compound their economic insecurity, successive governments have shifted to means-tested social assistance, which has disastrous effects, reducing social solidarity and plunging millions into poverty traps, whereby if they try to raise their income by

taking low-wage jobs they lose in benefits almost as much as they gain in wages. Even the Department of Work and Pensions, albeit hardly the most reliable guide to reality, has estimated that the poverty trap is huge.

Their estimates mean that if somebody on benefits obtains a low-wage job they face a marginal tax rate of 80 per cent. Imagine what the *Daily Mail* and Conservatives would shout if the salariat faced a marginal tax rate of anything like that. Yet that is what they accept for the precariat. It means that as there is no incentive to take low-wage jobs, the government resorts to coercion, sanctions and moralistic condemnation to justify lowering benefits.

The situation is actually worse, because the precariat also face a precarity trap. If you become eligible for benefits you must usually wait for many weeks before starting to receive them, if at all. Once you obtain anything, you would be a fool to take a short-term, low-wage job, not just because of the poverty trap, but because you would have the prospect of soon being back without earnings and having to wait for weeks before reobtaining benefits. This cruel system is being worsened by the rollout of the cynically named Universal Credit. In sum, the precariat suffers from chronic economic uncertainty.

The third dimension of the precariat is distinctive relations with the state. It is losing citizenship rights, often not realising until they need them. This is happening most to migrants, but is also the lot of others, who are losing cultural, civil, social, economic and political rights. They feel excluded from communities that would otherwise give them identity and solidarity, they cannot obtain due process if officials deny them benefits, they cannot practice what they are qualified to do and they do not see in the political spectrum leaders who represent their interests and needs.

This leads to the worst feature, being a *supplicant*: having to ask bureaucrats, employers, relatives, friends, neighbours or charities for help or favourable decisions. They must bend the knee.

However, all is not negative. Not everybody sees themselves as victims or failures. Many do not want long-term boring jobs. They are seeking work and leisure in new ways. But it is the insecurities that engender the anger.

As with all emerging groups, there are internal divisions. Part of the precariat are Atavists. Having fallen from working-class or proletarian communities, they feel they have a lost past. This part has relatively little formal schooling and tends to listen to sirens of neo-fascist populism. They vote for Trump, and the far right elsewhere. Labour must offer them hope, a path back to economic security.

A second group, which I call Nostalgics, consists of migrants and minorities who feel deprived of a present, a home. They are losing rights and are demonised. Many are detached from society. Many are enraged, and justifiably so. Labour must offer them a real sense of home.

The third group is the Progressives, mostly young, who go to university or college and are promised a 'career', only to emerge feeling deprived of a future. They are dangerous in a positive way. They do not want to return to a drab past, but so far do not see their aspirations articulated by mainstream politicians. They want to break the mould, revive the commons and restore security to the heart of social policy. Labour must offer them that future.

At this point, there is bad and good news. The bad is that many Nostalgics and Progressives remain withdrawn from politics through disillusionment, leaving a vacuum for neo-fascist populists to be stronger than they should be. They tend to see social democrats as 'dead men walking', but are waiting for something exciting.

The good news is that re-engagement is occurring, and that the number of Atavists has peaked. They are ageing, a legacy of deindustrialisation. They must not be ignored or denigrated, in the way Hilary Clinton and Gordon Brown did. We must identify a dignifying future that will lessen their fears. Nostalgics are finding their voice, and Progressives are growing and mobilising

in new movements. It takes time for progressive politics to take shape, with some false dawns. But a new politics of paradise is coming.

A Commons Fund and Commons Dividends

The challenge for Labour and any progressive movement, including unions, is to offer an economic strategy that appeals not only to Progressives in the precariat but also to enough of the Nostalgists and Atavists to mobilise more of them.

The challenge is twofold – to offer a *narrative* about the economic crisis that explains why the precariat has been hit so hard, and to formulate a coherent *transformative* strategy. Showing empathy with the precariat is key to the narrative. Showing a realistic strategy for building a new income distribution system suited to a social market economy is key to the transformative vision. In both respects, we need to be bold, including renewing a progressive *vocabulary*, not retreating into old clichés and the tired rhetoric of the last century.

Schematically – and that is all that space allows for here – a new distribution system must come from dismantling rentier capitalism and from capturing and redistributing rentier income. A way to do this is to emphasise the value of the commons: that which belongs to all of us as commoners. Here is one way of doing so. A set of levies should be introduced on sources of rent and deposited in a *Commons Fund*, a democratic sovereign wealth fund. The proposed name reflects the fact that most rentier income is derived from the plunder of the commons.[6]

Start with land. It belongs to all of us, yet over the centuries it has been enclosed and privatised, mostly without moral or economic justification. A land value tax (LVT) could be levied on all holdings of half an acre or more, so as to avoid cheap accusations that it would be a 'garden tax'.[7] At, perhaps, 3 per cent, with a higher rate for unoccupied properties, an LVT would raise considerable revenue, which should go into the fund, on the reasoning that land as an asset has value for future generations as

well as current citizens. It should not be used for tax cuts for a favoured group or for selective spending that would not go to all commoners. An LVT should be complemented by a levy on the market value of all private developments on formerly publicly owned land, since their private owners are gaining from public investment; and there should be a levy on profits gained from using common land, as is done in the Lake District, at devastating ecological cost.

A commons levy should be applied to wealth, starting with a reform of inheritance tax. That somebody can inherit a property worth £1 million tax-free is obscene. But a modest financial wealth tax would also be fair and raise significant revenue.

Next, a carbon tax and other eco-taxes should be introduced. Pollution affects all commoners, but it would be better to fine and penalise polluters rather than legitimise them by selling them permits to pollute, as is done now. The revenue from a carbon tax should go into the fund. By itself it would be regressive, since lower-income consumers would pay proportionately more. That justifies equal dividends, to which I will return.

A levy should be introduced on all those using natural resources for profit, on top of what they may pay a local authority or local landowners. This should apply to woodlands, energy and minerals, and commercial use of waterways, including our coastline. All deprive us of commons resources, often depleting them. The most egregious case is the ongoing construction of the biggest mine in Britain, for making potash. This is being tunnelled partly under a national park, which epitomises the commons, and will enrich not only the entrepreneur and his shareholders but a few local landowners, including the Royal Estate and Duchy of Lancaster, none of whom have done any work to deserve their forthcoming millions.

A special commons levy should be applied to all commercial activity being allowed by the Forestry Commission on the 1 million hectares of commons that it is supposed to protect.[8]

A commons levy should be imposed on the monopolistic income derived from patents, copyrights, industrial designs and

registered brands, to reflect the fact that the intellectual property rights regime is an artificial capture of the intellectual commons. Even at a modest rate, this would raise a great deal.

A levy should be made on income derived by Big Tech's use of our data and metadata, which gives them vast advertising revenue and the means to construct new commodities. The data, for which they do not pay, belongs to us commoners. The fairest way is not to introduce 'nano-payments' for each time we use the internet, but to apply a levy to their revenue, putting that into the Commons Fund. This would be consistent with the 3 per cent 'digital tax' proposed by the European Commission on all revenue obtained by the big technology companies.

A levy should also be made on all online transactions involving apps and 'requesters'. At present, platform operators take 25 per cent or even 50 per cent of every transaction. They are brokers and rentiers, and should be subject to a rental levy.

There are other potential sources based on the same principle. However, the fund should be augmented initially by redirecting some of the billions of pounds currently paid in selective and regressive subsidies, and the edifice of regressive tax reliefs.[9] Some of the biggest recipients are the country's richest landowners.

The Commons Fund should be administered by independent democratic management, guided by two principles, the Public Trust doctrine and Hartwick's rule. These require that the state should preserve the value of commons assets and ensure that future generations gain as much as today's. Revenue should not be dissipated in windfall spending, as was done with Britain's income from North Sea oil.

In the case of revenue raised from levies on depletable resources, only the return to the fund should be distributed, whereas revenue attributable to levies on non-depletable resources could be distributed annually. Based on experience with the well-designed Norwegian Fund, which pursues an ecological and ethical investment strategy, the net annual return could be above 4 per cent. But the Norwegian Fund relies entirely on a depleting resource, oil. The proposed Commons Fund would be able to

distribute more than 4 per cent without jeopardising its 'permanent' character.

As it would be a Commons Fund, just one principle should determine how the return should be distributed. Every commoner should receive an equal amount. Suppose a dividend were paid to every adult resident citizen, with half the amount going to every child under age sixteen, and with legally documented migrants having to wait for two years before becoming entitled.

The Commons Dividends would initially be small, but would be significant for those on low incomes. They would rise as the Commons Fund grew. We would be on a journey, and to make it progressive and equitable the dividend could be clawed back from those with higher incomes, perhaps through raising the upper rate of income tax and corporation tax.

No cut is envisaged in spending on social services, the NHS or education, which need to be strengthened by de-privatisation and de-commodification. But we need to build a new income distribution system, in which a Commons Fund and Commons Dividends would be ecologically desirable and enhance security. For the precariat, this could make a significant difference.

Towards a Basic Income

The Commons Dividends relate to basic incomes, on which there have been some intemperate remarks recently that are wilfully misleading. A basic income would be a modest regular payment to every legal resident in the community, paid unconditionally as a right, regardless of income, employment or relationship status.

The case for it does not rest on the assumption that robots and artificial intelligence will cause mass unemployment or that it would be a more efficient way of relieving poverty than current social assistance (although it would). The main arguments are ethical.[10]

First, it is a matter of social justice. Our wealth and income have far more to do with the efforts and achievements of our

collective forebears than with anything we do ourselves. If we allow private inheritance, we should accept social inheritance, regarding basic income as a 'social dividend' on our collective wealth. In an era of rentier capitalism, in which more income is channelled to owners of assets – physical, financial and intellectual – and in which wages are stagnating, a basic income would provide an anchor for a fairer distribution system. It would also compensate the precariat, which has been hit by labour flexibility, technological disruption and economic uncertainty.

Second, basic income would enhance freedom. The political right preaches freedom but fails to recognise that financial insecurity constrains the ability to make rational choices. People must be able to say 'no' to oppressive or exploitative relationships, as women know only too well. But the left has ignored freedom in supporting paternalistic policies. Welfare recipients are treated as subjects of charity or pity, subject to arbitrary and intrusive controls to prove themselves 'deserving'.

Basic income would also enhance 'republican freedom', that is, freedom from potential as well as actual domination by figures of unaccountable power. As argued elsewhere, a basic income is the only welfare policy for which the 'emancipatory value' is greater than the monetary value. It would also reduce feelings that define the precariat, of being supplicants.

Third, basic income would give people basic (not total) security in an era of chronic insecurity. Basic security is a natural public good. You having it does not deprive me of it; indeed, we gain from others having it. Psychologists have shown that insecurity lowers IQ and 'mental bandwidth', diminishing the ability to make rational decisions, causing stress and mental illness. People with basic security tend to be more altruistic, empathetic, solidaristic and engaged in the community.

I will finish by responding to the two most frequent objections to basic income. The first is that it is unaffordable. Many of the sums bandied about are just back-of-the-envelope calculations that assume a certain level of basic income multiplied by the population. Such gross figures ignore clawback through taxes,

savings in other areas of public spending and dynamic effects. Studies have shown that basic income is affordable even with existing tax/benefit systems.

My preference would be the Commons Fund route. The fund could pay small basic incomes initially, rising as it grows. As pilots have shown, even a small basic income can have a big impact on nutrition, health, schooling, economic activity and social solidarity.

The second standard objection is that a basic income would induce laziness, undermining the 'work ethic'. This is contradicted by the evidence, especially if all forms of work and not just paid labour are considered. Besides giving people more energy, confidence and ability to take risks, a basic income would remove poverty and precarity traps embedded in means-tested systems that are major disincentives to taking low-paid jobs.

Since the status quo is untenable and inequitable, opponents of basic income should tell us what alternative would provide everybody with basic security while enhancing freedom and serving social justice. I have not seen any such proposal.

List of Contributors

Grace Blakeley is a research Fellow on the Commission on Economic Justice at the progressive policy think tank IPPR. She specialises in macroeconomic policy, with a particular focus on finance.

Francesca Bria is the chief technology and digital innovation officer for the City of Barcelona. She is the founder of the Decode Project.

Matthew Brown is the leader of Preston City Council. He has been widely credited as the driving force behind the 'Preston model', a pioneering grassroots economic initiative promoting local cooperatives and networks.

Rob Calvert Jump is a lecturer in economics at the University of West England, teaching quantitative methods and macroeconomics. His research focuses on macroeconomic policy, corporate governance and ownership reform, using New Keynesian frameworks, and he has undertaken work for the British Labour Party in this area.

Barry Gardiner has been Labour MP for Brent North since 1997. In addition, he is currently the shadow secretary of state for international trade and shadow minister for international climate change.

Joe Guinan is a senior fellow at the Democracy Collaborative and executive director of the Next System Project. With a decade of experience in international economics, trade policy, global agriculture, and food security, he is a frequently cited expert on economic development in major news media including the *New York Times*, *Financial Times*, *Wall Street Journal* and BBC News.

Thomas M. Hanna is director of research at the Democracy Collaborative. He is the author of *Our Common Wealth: The Return of Public Ownership in the United States* and has published in popular and academic periodicals, including the *New York Times*, *OpenDemocracy* and the *Independent*.

Ted Howard is an author as well as founder and executive director of the Democracy Collaborative. He is known for his work on the 'Cleveland model', which redirects local spending for community wealth through the use of worker cooperatives.

Matthew Jackson is the William D. Eberle Professor of Economics at Stanford University, an external faculty member of the Santa Fe Institute, and a senior fellow of CIFAR.

Antonia Jennings is policy and public affairs manager at the UK Health Alliance on Climate Change. She was previously head of engagement at Economy (ecnmy.org), a charity that works to empower citizens to engage with economic narratives, thus driving the democratization of economic decisions.

Costas Lapavitsas is professor of economics at the School of Oriental and African Studies, University of London. He is a columnist for the *Guardian* and founder of Research on Money and Finance (RMF), an international network of political economists focusing on money, finance and the evolution of contemporary capitalism.

Neil McInroy is the chief executive of the Centre for Local Economic Strategies (CLES), a not-for-profit 'think–do tank' that works with a diverse range of regeneration and economic development practitioners and community members, with a focus on developing policy grounded in real-life problems.

Johnna Montgomerie is a senior lecturer in economics at Goldsmiths, University of London and the deputy director of the Political Economy Research Centre.

Özlem Onaran is professor of economics at the University of Greenwich and the director of the Greenwich Political Economy Research Centre.

Ann Pettifor is the director of Prime (Policy Research in Macroeconomics), an honorary research fellow at City University, and a fellow of the New Economics Foundation. She has an honorary doctorate from Newcastle University. In 2015 she was invited by Jeremy Corbyn onto the economic advisory board of the British Labour Party.

J. Christopher Proctor is the pluralist economics associate at Oikos International, an international student-driven organisation for sustainability in economics and management. He is an active organiser with Rethinking Economics and co-editor of the forthcoming book *Rethinking Economics: An Introduction to Pluralist Economics*.

Luke Raikes is a senior research fellow at the progressive policy think-tank IPPR, where he leads the work on the UK's regional economies and develops industrial strategy for the North. He has been a councillor on Manchester City Council since 2012.

Prem Sikka is professor of accounting at the University of Sheffield and emeritus professor of accounting at the University of Essex. His research largely focuses on the 'dark side of

capitalism', including issues to do with corporate abuse, predatory capitalism, fraud, and wealth inequality.

Nick Srnicek is a lecturer in digital economy at King's College London. He is the author of *Platform Capitalism* and co-author of *Inventing the Future: Postcapitalism and a World without Work*.

Guy Standing is professor of development studies at the School of Oriental and African Studies, University of London, and co-founder of the Basic Income Earth Network (BIEN), an NGO promoting basic income as a right. He was previously director of the Socio-Economic Security Programme of the International Labour Organisation.

Simon Wren-Lewis is currently professor of economic policy at the Blavatnik School of Government at the University of Oxford and emeritus fellow of Merton College. He has advised HM Treasury, the Bank of England, and the Office for Budget Responsibility, and has written extensively on macroeconomic policy on his blog mainlymacro.blogspot.com.

Notes

Introduction

1 Committee on the Rights of Persons with Disabilities, *Inquiry Concerning the United Kingdom of Great Britain and Northern Ireland Carried Out by the Committee under Article 6 of the Optional Protocol to the Convention* (2016), 20.

2 J. Stiglitz, *Rewriting the Rules of the American Economy: An Agenda for Shared Growth and Prosperity*, W. W. Norton and Co., 2015.

3 Estimates reported in WWF, 'Tens of Billions of Pounds to Be Lost by UK Economy Due to Extreme Weather – WWF Report Warns', 26 September 2017.

4 T. Hazeldine, 'Revolt of the Rustbelt', *New Left Review*, 105, 2017.

5 M. Mazzucato, *The Entrepreneurial State: Debunking Public vs. Private Sector Myths*, PublicAffairs, 2013.

6 OECD Economic Surveys: United Kingdom, October 2013, figure 23.

7 See argument in GFC Economics/Clearpoint, *Financing Investment: Final Words*, 20 June 2018.

8 Carillion plc, *Annual Report and Accounts*, 2016, p. 43.

9 C. Berry, 'The Making of a Movement: Who's Shaping Corbynism?', Sheffield Political Economy Research Institute, 18 December 2017.

1. Democratising Economics in a Post-truth World

1 J. Earle, C. Moran and Z. Ward-Perkins, *The Econocracy*, Manchester University Press, 2017.

2 H. Chang, *Economics: A User's Guide*, Penguin, 2014, 163.

3 *Economy, The Case for Understandable Economics*, 2016, 11.

4 YouGov, 'Britain's Financial Literacy', yougov.co.uk.

5 C. Santry, 'The UK Is "Below Average" at Teaching Financial Literacy, Study Finds', tes.com, 11 October 2016.

6 YouGov/Ecnmy Survey Results, May 2017.

7 Edelman UK, 'Edelman Trust Barometer 2017 – UK Results', slideshare.net, 13 January 2017.

8 European University Institute, 'World Values Survey', eui.eu.

9 YouGov/Ecnmy Survey Results, May 2017.

10 YouGov/Ecnmy Survey Results, September 2016.

11 D. Vockins and C. Afoko, 'Framing the Economy', 11 September 2013, neweconomics.org.

12 Full Fact, 'The UK's EU Membership Fee', fullfact.org, 9 November 2017.

13 Earle, Moran and Ward-Perkins, *The Econocracy*.

14 E. Said, *Representations of the Intellectual: The 1993 Reith Lectures*, Vintage, 1994, 11.

2. Labour's Fiscal Credibility Rule in Context

1 T. Kirsanova, C. Leith and S. Wren-Lewis, 'Monetary and Fiscal Policy Interaction: The Current Consensus Assignment in the Light of Recent Developments', *Economic Journal*, 119(514): F482–F496, 2009.

2 S. Wren-Lewis, 'A General Theory of Austerity', Blavatnik Working Paper No. 2016/014, 2016.

3 Wren-Lewis, S., 'What Brexit and Austerity Tell Us about Economics, Policy and the Media', SPERI Paper No. 36, 2016.

4 MMT also, quite rightly, questions why the 'theory of the money multiplier' is still to be found in undergraduate textbooks, when this mechanism has no relevance today (if it ever did have relevance). They also dispute the idea that government debt can crowd out private investment.

5 This leads to other problems I have with MMT. They make a fetish out of distinguishing themselves from the mainstream, when in fact their basic economic model is mainstream with just some different beliefs about the stability of reactions to monetary and fiscal policy. They also have two other related characteristics which I find annoying: an obsession with what could be called the 'accountancy' of government funding operations, and an aversion to equations.

3. Rising to the Challenge of Tax Avoidance

1 See the International Consortium of Investigative Journalists: panamapapers. icij.org; icij.org/project/luxembourg-leaks; and projects.icij.org/swiss-leaks/.

2 As per HMRC's 2016/17 annual report and accounts.

3 R. Syal, 'Amazon and eBay Turning Blind Eye to VAT Evasion, Say MPs', *Guardian*, 13 September 2017.

4 Her Majesty's Revenue and Customs, 'Research Report 433: Understanding Evasion by Small and Mid-sized Businesses', HMRC, September 2017.

5 K. Raczkowski, 'Measuring the Tax Gap in the European Economy', *Journal of Economics and Management*, 21(3), 2015: 58–72. Also see FISCALIS Tax

Gap Project Group, 'The Concept of Tax Gaps: Report on VAT Gap Estimations', European Commission, 2016.

6 Reuters, 'EU Lost up to 5.4 Billion Euros in Tax Revenues from Google, Facebook: Report', 13 September 2017.

7 P. Sikka, 'No Accounting for Tax Avoidance', *Political Quarterly*, 86(3), 2015: 427–33.

8 HMRC, Transfer Pricing and Diverted Profits Tax statistics, to 2016–17.

9 House of Commons Committee of Public Accounts, Corporate Tax Settlements, the Stationery Office, February 2016, 9.

10 House of Commons Committee of Public Accounts, Tackling Tax Fraud, March 2016.

11 House of Commons Committee of Public Accounts, 'HM Revenue and Customs Performance in 2014–15', the Stationery Office, 2015.

12 P. Sikka, M. Christensen, J. Christensen, C. Cooper, T. Hadden, D. Hargreaves, C. Haslam, P. Ireland, G. Morgan, M. Parker, G. Pearson, S. Picciotto, J. Veldman and H. Willmott, 'Reforming HMRC: Making It Fit for the Twenty-First Century', Policy Paper published by the UK Labour Party, 8 September 2016.

13 S. Picciotto, *International Business Taxation: A Study in the Internationalization of Business Regulation*, Cambridge University Press, 1992.

14 European Commission, Proposal for a Council Directive on a Common Corporate Tax Base, COM(2016) 685 final 2016/0337 (CNS), 25 October 2016; European Commission, Proposal for a Council Directive on a Common Consolidated Corporate Tax Base (CCCTB), COM (2011) 121 final – 2011/0058, 2011 (CNS).

15 P. Sikka and H. Willmott, 'The Dark Side of Transfer Pricing: Its Role in Tax Avoidance and Wealth Retentiveness', *Critical Perspectives on Accounting*, 21(4), 2010: 342–56.

16 European Commission, Proposal for a Council Directive on a Common Corporate Tax Base.

17 UK House of Commons Committee of Public Accounts, 'Tax Avoidance: The Role of Large Accountancy Firms', the Stationery Office, 2013.

18 See Jesse Drucker, 'Man Making Ireland Tax Avoidance Hub Proves Local Hero', Bloomberg, 28 October 2013; and T. Hadden, P. Ireland, G. Morgan, M. Parker, G. Pearson, S. Picciotto, P. Sikka and H. Willmott, *Fighting Corporate Abuse: Beyond Predatory Capitalism*, Pluto, 2014.

19 A. Mitchell and P. Sikka, *The Pin-Stripe Mafia: How Accountancy Firms Destroy Societies*, Association for Accountancy & Business Affairs, 2011.

20 F. Modigliani and M. H. Miller, 'Corporate Income Taxes and the Cost of Capital: A Correction', *American Economic Review*, 53(3): 433–43, 1963.

21 G. Gros and S. Micossi, *The Beginning of the End Game*, Centre for European Policy Studies, 2008.

22 Dominic Crossley-Holland, 'Lehman Brothers, the Bank That Bust the Boom', *Telegraph*, 6 September 2009.

23 Cyrus Sanati, 'Cayne and Schwartz at Odds over Bear's Leverage', *New York Times*, 5 October 2010.

24 Kevin Dowd, *No Stress III: The Flaws in the Bank of England's 2016 Stress Tests*, Adam Smith Institute, 2017.

25 From April 2017 there will be a phased restriction of the tax relief to the basic rate of income tax. It is not being abolished.

26 Change to Win, Unite the Union and War on Want, 'Alliance Boots and the Tax Gap', 2013.

27 G. Plimmer and J. Espinoza, 'Thames Water: The Murky Structure of a Utility Company', *Financial Times*, 4 May 2017.

28 M. Robinson, 'How Macquarie Bank Left Thames Water with Extra £2bn Debt,' BBC News, 5 September 2017.

29 J. Burton, 'Vultures Who Left Thames Water with £10bn of Debt: Controversial Aussie Bank Macquarie Sells Stake in UK Giant', *Daily Mail*, 14 March 2017.

30 H. Mance and K. Stacey, 'Please Restore Strikeout Online: Midnight Embargo Anger as No-Tax Company Wins Mobile Deal', *Financial Times*, 13 May 2013.

31 'BEPS Action 4: Interest Deductions and Other Financial Payments', Organisation for Economic Cooperation and Development, 2014.

32 HMRC, 'Tax Deductibility of Corporate Interest Expense: Consultation', October 2015, updated 5 December 2016.

33 J. Mirrlees, S. Adam, T. Besley, R. Blundell, S. Bond, R. Chote, M. Gammie, P. Johnson, G. Myles and J. M. Poterba, *Tax by Design*, Institute for Fiscal Studies, 2011.

34 House of Commons Work and Pensions and Business, Innovation and Skills Committees, 'BHS', House of Commons, July 2016.

35 Office of Tax Simplification, 'Tax Reliefs: Final Report', March 2011.

36 'Tax Reliefs', National Audit Office, April 2014.

37 V. Houlder, 'Cost of UK Tax Breaks Rises to £117bn', *Financial Times*, 10 January 2016.

38 National Audit Office, Tax Reliefs, 7 April 2014.

39 House of Commons Public Accounts Committee, 'The Effective Management of Tax Reliefs', House of Commons, March 2015.

40 House of Commons Public Accounts Committee, 'HM Revenue and Customs Performance in 2015–16', House of Commons, December 2016, 5.

41 'The Effective Management of Tax Reliefs', National Audit Office, November 2014, 11.

42 'Consultation Document – VAT: Retail Export Scheme', HMRC, July 2013.

43 Hansard, House of Commons Debates, 9 October 2017.

44 Table showing 'Costs of Tax Relief', gov.uk/government/uploads/system/uploads/attachment_data/file/622401/Table_10_2.pdf. HM Treasury, 'Tax Reliefs in Force in 2015–16 or 2016–17: Estimates of Cost Unavailable'.

4. To Secure a Future, Britain Needs a Green New Deal

1 D. Wallace-Wells, 'The Uninhabitable Earth Famine, Economic Collapse, a Sun that Cooks Us: What Climate Change Could Wreak – Sooner Than You Think', *New York Magazine*, 9 July 2017.

2 Ibid.

3 D. McCrum, 'Saudi Aramco IPO Will Leave Fund Industry with No Place to Hide: Listing Offers a Unique Experiment to Prove the Value of Paying Stock Pickers' Fees', *Financial Times*, 20 July 2017.

4 Ibid.

5 G. Tily, 'The National Accounts, GDP and the "Growthmen"', primeeconomics.org, January 2015.

6 S. Brittan, *The Treasury under the Tories, 1951–1964*, London, 1964, 141

7 M. Liebreich, 'Bloomberg New Energy Finance Summit', agora-energiewende.de, 25 April 2017.

8 Ibid.

9 Ibid.

10 ComRes, 'Survey of British Adults on Behalf of ECIU on Climate Change', February 2017.

11 Ibid.

12 Verco, 'Warm Homes, Not Warm Words, Report for WWF-UK on How the UK Can Move to a Low Carbon Heat System', October 2014.

13 DECC, 'The Future of Heating: Meeting the Challenge', March 2013.

14 J. Corbyn, 'Protecting Our Planet', Labour Party.

15 TUC Economic Report Series, 'Green Collar Nation: A Just Transtion to a Low-Carbon Economy', 2015.

16 Verco and Cambridge Econometrics, 'Building the Future: The Economic and Fiscal Impacts of Making Homes Energy Efficient', 2015.

5. Fair, Open and Progressive: The Roots and Reasons behind Labour's Global Trade Policy

1 Cited in F. Trentmann, *Free Trade Nation: Commerce, Consumption and Civil Society in Modern Britain*, Oxford University Press, 2008, 134.

2 F. Trentmann, 'Wealth versus Welfare: The British Left between Free Trade and National Political Economy before the First World War', *Historical Research*, 70(171), 1997: 70–98.

3 R. Toye, 'The Labour Party's External Economic Policy in the 1940s', *Historical Journal*, 43(1), 2000: 189–215.

4 D. Irwin, P. Mavroidis and A. Sykes, *The Genesis of the GATT*, Cambridge University Press, 2008; also R. Toye, 'The Attlee Government, the Imperial Preference System and the Creation of the GATT', *English Historical Review*, 118(478), 2003: 912–39.

5 'Exporters and Importers in Great Britain, 2014', Office for National Statistics, November 2015.

6 *For the Many, Not the Few: The Labour Party Manifesto 2017*, Labour Party, 2017, 30.

7 'Estimate of the Proportion of UK SMEs in the Supply Chain of Exporters: Methodology Note', Department for Business, Innovation and Skills, May 2016.

8 *Global Value Chains and Development: Investment and Value Added Trade in the Global Economy*, United Nations Conference on Trade and Development, 2013.

9 *UK Balance of Payments: The Pink Book*, Office for National Statistics, July 2016.

10 'International Trade in Services, UK: 2015', Office for National Statistics, January 2017.

11 'UK Environmental Goods and Services Sector (EGSS): 2010 to 2014', Office for National Statistics, January 2017.

12 R. Baldwin (ed.), *The Great Trade Collapse: Causes, Consequences and Prospects*, Centre for Economic Policy Research, November 2009.

13 *Making Trade an Engine of Growth for All: The Case for Trade and for Policies to Facilitate Adjustment*, International Monetary Fund, World Bank and World Trade Organization, March 2017.

14 *NAFTA at 20*, AFL-CIO, March 2014.

15 'Impact Assessment Report on the Future of EU–US Trade Relations', Commission staff working document SWD (2013) 68, European Commission, March 2013.

16 *Trade and Employment: From Myths to Facts*, International Labour Organisation, 2011.

17 P. Minford, *Should Britain Leave the EU? An Economic Analysis of a Troubled Relationship*, Edward Elgar, 2nd edition, 2015.

18 S. Van Berkum et al., *Implications of a UK Exit from the EU for British Agriculture: Study for the National Farmers' Union*, LEI Wageningen UR, April 2016.

19 *Agriculture in the United Kingdom 201*, Department for Environment, Food and Rural Affairs, July 2017.

20 B. Milanovic, *Global Inequality: A New Approach for the Age of Globalization*, Harvard University Press, 2016.

21 *Global Wage Report 2016/17: Wage Inequality in the Workplace*, International Labour Organisation, December 2016.

22 S. O'Connor, 'UK Workers Squeezed as Inflation Outstrips Wage Growth', *Financial Times*, 12 July 2017.

23 'Reflections Paper on Services of General Interest in Bilateral FTAs (Applicable to Both Positive and Negative Lists)', European Commission, February 2011; 'Commission Proposal for the Modernisation of the Treatment of Public Services in EU Trade Agreements', European Commission, October 2011.

24 *Doing Business 2017: Equal Opportunity for All*, World Bank, 2017.

25 I. Arto et al., 'EU Exports to the World: Effects on Employment and Income', Publications Office of the European Union, June 2015.

26 N. Kabeer, S. Mahmud and S. Tasneem, 'Does Paid Work Provide a Pathway to Women's Empowerment? Empirical Findings from Bangladesh', Institute of Development Studies, September 2011.

27 *Assessment of Labour Provisions in Trade and Investment Arrangements*, International Labour Organisation, July 2016.

28 Ibid.

29 J. Ruggie, 'Business and Human Rights: Mapping International Standards of Responsibility and Accountability for Corporate Acts', UN document A/HRC/4/035, 9 February 2007.

30 'Good Business: Implementing the UN Guiding Principles on Business and Human Rights', HM Government, May 2016.

31 'Government Pledges to Help Improve Access to UK Markets for World's Poorest Countries Post-Brexit', UK government press release, 24 June 2017.

32 *IMF Involvement in International Trade Policy Issues*, Independent Evaluation Office evaluation report, International Monetary Fund, 2009.

33 P. Collier, *The Bottom Billion: Why the Poorest Countries Are Failing and What Can Be Done about It*, Oxford University Press, 2007, 87.

34 *Bittersweet Harvest: A Human Rights Impact Assessment of the European Union's Everything but Arms Initiative in Cambodia*, Equitable Cambodia and Inclusive Development International, 2013.

35 M. Grady, 'Post-Brexit Trade: Options for Continued and Improved Market Access Arrangements for Developing Countries', Traidcraft, February 2017.

36 C. Stevens and J. Kennan, 'Trade Implications of Brexit for Commonwealth Developing Countries', Commonwealth Secretariat, August 2016.

37 A. Cobham and P. Jansky, 'Global Distribution of Revenue Loss from Tax Avoidance: Re-estimation and Country Results', United Nations University World Institute for Development Economics Research, March 2017

38 L. Poulsen, 'British Foreign Investment Policy Post-Brexit: Treaty Obligations vs Bottom-Up Reforms', UCL European Institute, July 2017.

6. 'De-financialising' the UK Economy: The Importance of Public Banks

1 Thanks are due to Giorgos Diagourtas for excellent research assistantship.

2 The crisis of 2007–9 has given rise to a large literature on its causes and outcomes. The account given here draws heavily on my book *Profiting without Producing: How Finance Exploits Us All*, Verso, 2013.

3 For an influential account of this process see G. Gorton and A. Metrick, 'Securitized Banking and the Run on Repo', *Journal of Financial Economics*, 104(3), 2012: 425–51.

4 Financialisation is a term that is increasingly deployed in the social sciences to indicate the rise of finance in recent decades. For a useful survey of the literature, see N. A. J. Van der Zwan, 'Making Sense of Financialization', *Socio-economic Review* 12(1), 2014: 99–129.

5 For a useful description of the functioning and the magnitude of the UK financial system, see O. Bush, S. Knott and C. Peacock, 'Why Is the UK Banking System So Big and Is That a Problem?', *Bank of England Quarterly Bulletin*, Q4, 2014: 385–94; and O. Burrows, K. Low and H. Cummings, 'Mapping the UK Financial System', *Bank of England Quarterly Bulletin*, Q2, 2015, 114–29.

6 Separate data for banks and building societies have been discontinued from January 2010 onwards.

7 Note that (a) following Bank of England money market reform on 18 May 2006 the Bank of England 'Bank Return' was changed. This series forms part of the new Bank Return, with data starting on 24 May 2006. (b) The large increases in Reserves and other accounts and Advances and other accounts from January 1999 arise from the Bank of England's role in TARGET, as a result of which other European central banks may hold substantial credit balances or overdrafts with the Bank.

8 The complexity is substantial and developments will depend on political choices; for a provisional assessment, see DGECON (Directorate-General for Internal Policies, European Parliament, Committee on Economic and Monetary Affairs), 'Implications of Brexit on EU Financial Services', European Parliament, June 2017.

7. Better Models of Business Ownership

1 All data are taken from the ONS UKBAE data set, 'UK Business: Activity, Size, and Location', and associated statistical bulletins. I would like to thank Les Huckfield for a number of useful suggestions.

2 See the House of Commons Library Research Paper 14/61 for details on privatisations in the UK.

3 See, for example, the collection of essays in J. Williamson, C. Driver and P. Kenway (eds), *Beyond Shareholder Value: The Reasons and Choices for Corporate Governance Reform*, TUC, 2014.

4 This section, and the two following sections, draw on the 2017 report to the Shadow Cabinet entitled 'Alternative Models of Ownership', with contributions by Cheryl Barrott, Cllr Matthew Brown, Andrew Cumbers, Christopher Hope, Les Huckfield, Rob Calvert Jump, Neil McInroy, Linda Shaw and others.

5 See S. Arando, et al., 'Assessing Mondragon: Stability and Managed Change in the Face of Globalization', William Davidson Institute Working Paper 1003, 2010.

6 See B. Craig et al., 'Participation and Productivity: A Comparison of Worker Cooperatives and Conventional Firms in the Plywood Industry', *Brookings Papers on Economic Activity: Microeconomics*, 1995: 121–74. See G. Dow, *Governing the Firm: Workers' Control in Theory and Practice*, Cambridge University Press, 2003, for a useful overview of the literature.

7 See ibid. See the International Cooperative Alliance's 'Blueprint for a

Cooperative Decade', 2013, for a useful discussion of 'cooperative capital'.

8 See, e.g., M. Hayes, 'The Capital Finance of Cooperative and Community Benefit Societies', Cooperatives UK thinkpiece 11, 2013, for a discussion of methods of financing consistent with cooperative principles. Interestingly, limited return on capital is applicable as a general principle to any instrument involving limited liability – not just the financing instruments of cooperatives and other non-capitalistic forms of production.

9 See H. Lawton-Smith, 'Deregulation and Privatization in the UK Freight, and Bus and Coach Industries', Regulatory Policy Research Centre Working Paper, 1995; and A. Pendleton, *Employee Ownership, Participation, and Governance: A Study of ESOPs in the UK*, Routledge, 1995.

10 See Social Enterprise UK's 'State of Social Enterprise Survey 2015' for information on the size, behaviour, and reach of social enterprises, some of which is summarised on their website.

11 See H.-J. Chang, 'State-Owned Enterprise Reform', UNDESA Policy Note, 2007, for a useful policy-focused discussion of nationalisation. See L. Hannah, 'The Economic Consequences of the State Ownership of Industry, 1945–1990', in R. Floud and D. McCloskey (eds), *The Economic History of Britain since 1700, Vol. 3*, Cambridge University Press, 1994, for a discussion of the UK experience of nationalised industry.

12 See N. Calamita, 'The British Bank Nationalizations: An International Law Perspective', *International and Comparative Law Quarterly*, 58(1), 2009: 119–49, for a recent discussion of compensation in the context of bank nationalisation. See the Office of National Statistics, 'Ownership of UK Quoted Shares' Statistical Bulletins for information about UK share ownership. There is a great deal of media coverage concerning Royal Mail share price movements post-privatisation in and around October 2013, and the House of Commons Library Briefing Paper 06668, 'Privatisation of Royal Mail', provides further information.

13 See the 'Report of the Committee of Inquiry on Industrial Democracy', 1977, also known as the 'Bullock Report', and the 1976 Industrial Common Ownership Act.

8. Beyond the Divide

1 M. Jacobs, I. Hatfield, L. King, L. Raikes and A. Stirling, 'Industrial Strategy: Steering Structural Change in the UK Economy', IPPR, 2017.

2 G. Blakeley, 'Paying for Our Progress: How Will the Northern Powerhouse Be Financed and Funded?', IPPR, 2017. P. McCann, *The UK Regional– National Economic Problem: Geography, Globalisation and Governance*, Routledge, 2016.

3 C. Roberts, M. Lawrence and L. King, 'Managing Automation: Employment, Inequality and Ethics in the Digital Age', IPPR, 2017.

4 R. Martin and P. Sunley, 'On the Notion of Regional Economic Resilience:

Conceptualization and Explanation', *Journal of Economic Geography*, 15(1), 2015: 1–42.

5 Blakeley, 'Paying for Our Progress: How Will the Northern Powerhouse Be Financed and Funded?'

6 T. Hazeldine, 'Revolt of the Rust Belt', *New Left Review*, 105 (May–June), 2017. J. Green, 'Anglo-American Development, the Euromarkets, and the Deeper Origins of Neoliberal Deregulation', *Review of International Studies*, 42(3), 2016: 425–49. J. Christensen, N. Shaxson and D. Wigan, 'The Finance Curse: Britain and the World Economy', *British Journal of Politics and International Relations*, 18(1), 2016: 255–69.

7 G. Blakeley, 'On Borrowed Time: Finance and the UK's Current Account Deficit', IPPR, 2018.

8 ONS (Office for National Statistics), 'UK Economic Accounts: Balance of Payments – Current Account', 2018.

9 G. Standing, *The Corruption of Capitalism: Why Rentiers Thrive and Work Does Not Pay*, Biteback Publishing, 2016. I. Kaminska, 'Brexit and Britain's Dutch Disease', *FT Alphaville*, 12 October 2016.

10 C. Rhodes, 'Historic Data on Industries in the UK', House of Commons Library, 2016.

11 J. Springford and S. Tilford, 'Sterling Slump Won't Rescue the British Economy', Centre for European Reform, 2016.

12 M. Kitson and J. Michie, *The Deindustrial Revolution: The Rise and Fall of UK Manufacturing, 1970–2010*, Centre for Business Research, Cambridge University, 2014.

13 ONS (Office for National Statistics), 'Monthly Average, Effective Exchange Rate Index, Sterling', 2018.

14 ONS, 'UK Economic Accounts: Balance of Payments – Current Account'.

15 M. Baddeley, 'Structural Shifts in UK Unemployment 1980–2002: The Twin Impacts of Financial Deregulation and Computerisation', University of Cambridge Centre for Economic and Public Policy, 2005.

16 J. Jenkins, 'The Labour Market in the 1980s, 1990s, and 2008/09 Recessions', *Economic and Labour Market Review*, 4(8), 2010: 29–36.

17 ONS (Office for National Statistics), 'Regional Labour Market Statistics in the UK: June 2018', 2018. IPPR Commission on Economic Justice, 'Time for Change: A New Vision for the British Economy – the Interim Report of the IPPR Commission on Economic Justice', IPPR, 2017.

18 See, for example, NOMIS, 'Qualifications – Area Composition', nomisweb. co.uk, 2018.

19 E. Cox, 'Taking Back Control in the North: A Council of the North and Other Ideas', IPPR, 2017.

20 S. Lavery, L. Quaglia and C. Dannreuther, 'The Political Economy of Brexit and the UK's National Business Model', SPERI, 2017.

21 A. Davies, *The City of London and Social Democracy: The Political Economy of Finance in Britain, 1959–1979*, Oxford University Press, 2017.

22 OECD (Organisation for Economic Cooperation and Development), 'Table 1.4. Tax Revenues of Subsectors of General Government as Per Cent of Total Tax Revenue, Revenue Statistics – Taxes by Level of Government', 2016.

23 H. Blöchliger, B. Égert and K. Fredriksen, 'Fiscal Federalism and Its Impact on Economic Activity, Public Investment and the Performance of Educational Systems', OECD Working Paper, 2013. D. Bartolini, S. Stossberg and H. Blöchliger, 'Fiscal Decentralisation and Regional Disparities Economics Department', OECD Working Paper, 2016. C. Jeffery, 'Wales, the Referendum and the Multi-level State', speech at Cardiff University, 8 March 2011; CURDS (Centre for Urban and Regional Development Studies), 'Decentralisation Outcomes: A Review of Evidence and Analysis of International Data', Department for Communities and Local Government, 2011. E. Cox, G. Henderson and L. Raikes, 'Decentralisation Decade: A Plan for Economic Prosperity, Public Service Transformation and Democratic Renewal in England', IPPR North, 2014.

24 Cox, 'Taking Back Control in the North'.

9. Democratic Ownership in the New Economy

1 G. D. H. Cole, *Guild Socialism Re-stated*, Leonard Parsons, 1920, 12.

2 S. Kasmir, 'The Mondragon Cooperatives and Global Capitalism: A Critical Analysis', *New Labor Forum*, 25(1), 2016: 52–9.

3 J. Restakis, *Humanizing the Economy: Co-operatives in the Age of Capital*, New Society Publishers, 2010.

4 J. Duda and V. Zamagni, 'Learning from Emilia Romagna's Cooperative Economy', thenextsystem.org, 18 February 2016.

5 J. Walljasper, 'A More Equitable Economy Exists Right Next Door', *Alternet*, 22 March 2017.

6 From N. Klein's preface to Lavaca Collective, *Sin Patrón: Stories from Argentina's Worker-Run Factories*, Haymarket, 2007, 8.

7 J. McDonnell, Speech at Co-op Ways Forward Conference, Co-operative Party, 21 January 2016.

10. A New Urban Economic System: The UK and the US

1 More information on these pieces of work can be found at New Start, 'Good City Economies', newstartmag.co.uk; CLES, 'Bringing Community Wealth to Birmingham', cles.org.uk, 28 September 2016; and URBACT, 'URBACT Network: Procure', urbact.eu/procure.

11. Debt Dependence and the Financialisation of Everyday Life

1 H. Y. Feng, J. Froud, S. Johal, C. Haslam and K. Williams, 'A New Business Model? The Capital Market and the New Economy', *Economy and Society*, 30(4), 2001: 467–503.

2 W. Lazonick and M. O'Sullivan, 'Maximizing Shareholder Value: A New Ideology for Corporate Governance', *Economy and Society*, 29(1), 2000: 13–35.

3 G. Krippner, 'Financialization and the American Economy', *Socio-economic Review*, 3(2), 2005: 173–208.

4 A. Gamble, *The Spectre at the Feast : Capitalist Crisis and the Politics of Recession*, Palgrave Macmillan, 2009.

5 C. Hay, 'Pathology without Crisis? The Strange Demise of the Anglo-liberal Growth Model', *Government and Opposition*, 46(1), 2011: 1–31.

6 J. Froud, S. Johal, J. Montgomerie and K. Williams, 'Escaping the Tyranny of Earned Income? The Failure of Finance as Social Innovation', *New Political Economy*, 15(1), 2010: 147–64.

7 P. Langley, *The Everyday Life of Global Finance: Saving and Borrowing in Anglo-America*, Oxford University Press, 2008; J. Montgomerie and D. Tepe-Belfrage, 'Caring for Debts: How the Household Economy Exposes the Limits of Financialisation', *Critical Sociology*, 43(4–5), 2016: 653–68.

8 Office for National Statistics, 'Households and NPISH: Saving Ratio: Per Cent: SA', 2017.

9 The Money Charity, 'Credit Statistics', 2017.

10 A. Finlayson, 'Financialisation, Financial Literacy and Asset-Based Welfare', *British Journal of Politics and International Relations*, 11(3) 2009: 400–21,; R. Prabhakar, 'Asset-Based Welfare: Financialization or Financial Inclusion?', *Critical Social Policy*, 33(4), 2013: 658–78.

11 S. G. Lowe, B. A. Searle and S. J. Smith, 'From Housing Wealth to Mortgage Debt: The Emergence of Britain's Asset-Shaped Welfare State', *Social Policy and Society*, 11(1, 2012): 105–16; M. Watson, 'House Price Keynesianism and the Contradictions of the Modern Investor Subject', *Housing Studies*, 25(3), 2010: 413–26.

12 M. McLeay, A. Radia and R. Thomas, 'Money in the Modern Economy', *Quarterly Bulletin*, Q1, Bank of England, 2014.

13 A. Mian and A. Sufi, *House of Debt: How They (and You) Caused the Great Recession, and How We Can Prevent It from Happening Again*, University of Chicago Press, 2014.

14 J. Montgomerie and M. Büdenbender, 'Round the Houses: Homeownership and Failures of Asset-Based Welfare in the United Kingdom', *New Political Economy*, 20(3), 2014: 386–405.

15 Bank of England and P. Manaton, 'Housing Equity Withdrawal (HEW) – Notes', Statistical Notes, Bank of England, 2016.

16 The Money Charity, 'Credit Statistics'.

17 J. Montgomerie, 'The Pursuit of (Past) Happiness? Middle-Class Indebtedness and Anglo-American Financialisation', *New Political Economy*, 14(1), 2009: 1–24.

18 D. Gibbons, *Solving Britain's Personal Debt Crisis*, Searching Finance, 2014.

19 Department for Business, Innovation and Skills, 'Student Loan Company Statistical Release 2013–14', 2014.

20 Step Change, 'Statistics Yearbook, Personal Debt 2013', stechange.org, 2013.

21 Office for Budget Responsibility, 'Economic and Fiscal Outlook', 2017, Chart 3.23.

12. Platform Monopolies and the Political Economy of AI

1 This is measured by market capitalisation. These companies are Apple, Alphabet, Microsoft, Amazon, Tencent, Alibaba and Facebook.

2 In the economics literature, platforms are often referred to as two-sided (or multi-sided) *markets*. I prefer the term 'platform' because it does not assume the market-centric nature of the interactions. See J. C. Rochet and J. Tirole, 'Platform Competition in Two-Sided Markets', *IDEI Working Papers*, 152, Institut d'économie industrielle, 2003; J. C. Rochet and J. Tirole, 'Two-Sided Markets: A Progress Report', *RAND Journal of Economics*, 37(3), 2006: 645–67; A. Gawer's introduction to the collection she edited, *Platforms, Markets and Innovation*, Edward Elgar Publishing Inc., 2009.

3 This is something of a simplification, as for some platform businesses, placing a limit on the number of users can be a useful strategy. For an accessible elaboration of some of these nuances, see D. Evans and R. Schmalensee, *Matchmakers: The New Economics of Multisided Platforms*, Harvard Business Review Press, 2016.

4 K. Marx, *Capital: Critique of Political Economy, Vol. 1*, Penguin Classics, 1990, 776–81; D. Autor, D. Dorn, L. Katz, C. Patterson and J. Van Reenen, 'Concentrating on the Fall of the Labor Share', NBER Working Paper, 2017; S. Barkai, 'Declining Labor and Capital Shares', Job Market Paper, 2017; B. Blonigen and J. Pierce, 'Evidence for the Effects of Mergers on Market Power and Efficiency', NBER Working Paper, 2016; Council of Economic Advisors, *Benefits of Competition and Indicators of Market Power*, Issue Brief, 2006; J. De Loecker and J. Eeckhout, 'The Rise of Market Power and the Macroeconomic Implications', NBER Working Paper, 2017.

5 The gambling industry is perhaps the pioneer in making effective use of these techniques: I. Leslie, 'The Scientists Who Make Apps Addictive', *1843 Magazine*, 2016; N. S. Schüll, *Addiction by Design: Machine Gambling in Las Vegas*, Princeton University Press, 2014.

6 B. Morris and D. Seetharaman, 'The New Copycats: How Facebook Squashes Competition from Startups', *Wall Street Journal*, 9 August 2017.

7 For a more in-depth analysis of the different types of platforms and where they may be headed, see N. Srnicek, *Platform Capitalism*, Polity Press, 2016, chapters 2–3.

8 B. Fu, R. Wang, M. Wang, *Deep and Cross Network for Ad Click Predictions*, Cornell University Library, 2017.

9 For examples, see Amazon's AWS AI Blog: aws.amazon.com/blogs/ai.

10 N. F. Ayan, J. M. Pino and A. Sidorov, *Transitioning Entirely to Neural Machine Translation*, Facebook Code, 2017.

11 It is important to add that this emphasis on data often means that the gendered and racialised biases of society are simply transferred over to systems based on mirroring social data. R. Calo and K. Crawford, 'There Is a Blind Spot in AI Research', *Nature International Journal of Science*, 13 October 2016; K. Crawford, 'The Hidden Biases in Big Data', *Harvard Business Review*, 1 April 2013.

12 A. Gupta, A. Shrivastava, S. Singh and C. Sun, *Revisiting Unreasonable Effectiveness of Data in Deep Learning Era*, Cornell University Library, 2017.

13 M. Andreessen, 'Why Software Is Eating the World', *Wall Street Journal*, 20 August 2011.

14 N. Laptev, S. Shanmugam and S. Smyl, 'Engineering Extreme Event Forecasting at Uber with Recurrent Neural Networks', uber.com, 9 June 2017.

15 H. Godwin, 'The Software Routing 260,000 Grocery Deliveries a Week', ocadotechnology.com, 15 August 2017.

16 J. Ryan, 'How the GDPR Will Disrupt Google and Facebook', pagefair.com, 30 August 2017.

17 P. Brietzke, 'Robert Bork: The Antitrust Paradox: A Policy at War with Itself', *Valparaiso University Law Review* 13 (2), Winter 1979: 403–21.

18 A. Grunes and M. Stucke, *Big Data and Competition Policy*, Oxford University Press, 2016; L. Khan, 'Amazon's Antitrust Paradox', *Yale Law Journal* 126, 3 January 2017: 710.

19 The following analysis is based upon the more detailed reflection on the case in Grunes and Stucke, *Big Data and Competition Policy*, 74–84.

20 J. Taplin, *Move Fast and Break Things: How Facebook, Google, and Amazon Cornered Culture and Undermined Democracy*, Little Brown and Company, 2017.

21 A. Desai, 'Wiretapping before the Wires: The Post Office and the Birth of Communications Privacy', *Stanford Law Review* 60 (2), April 2010: 553–94.

22 B. Laurie and M. Suleyman, 'Trust, Confidence and Verifiable Data Audit', deepmind.com, 9 March 2017.

23 For more on platforms and how they baffle our Westphalian assumptions of sovereignty and territory, see B. H. Bratton, *The Stack: On Software and Sovereignty*, MIT Press, 2016.

24 N. Schneider and T. Scholz, *Ours to Hack and to Own*, O/R Books, 2017; T. Scholz, *Platform Cooperativism: Challenging the Corporate Sharing Economy*, Rosa Luxemburg Stiftung, 2016.

13. A New Deal for Data

1 This chapter draws on a 2018 study co-written by Francesca Bria and Evgeny Morozov called 'Rethinking the Smart City, Democratizing Urban Technology', Rosa Luxemburg Stiftung.
2 decodeproject.eu.

14. Rethinking Economics for a New Economy

1 J. M. Keynes, *The General Theory of Employment, Interest and Money*, Macmillan, 1936, Chapter 24
2 J. Earle, C. Moran and Z. Ward-Perkins, *The Econocracy: The Perils of Leaving Economics to the Experts*, Manchester University Press, 2016. Chapter 2, 'Economics as Indoctrination', is particularly helpful.
3 Labour Party, *Manifesto 2017: Creating an Economy that Works for All*, Labour. org.uk, 2017.
4 A useful introduction to the recent reforms in British higher education can be found in A. McGettigan, *The Great University Gamble: Money, Markets and the Future of Higher Education*, Pluto Press, 2013. The topic is also discussed at length in Earle, Moran and Ward-Perkins, *The Econocracy*, Chapter 5, 'Rediscovering the Liberal Education'.
5 The cap is now indexed to inflation, so the fee cap for 2017 is £9,250.
6 D. Jobbins, 'Almost All English Universities to Charge Maximum £9,000 Tuition Fee', thecompleteuniversityguide.co.uk, 13 August 2015.
7 Competition and Markets Authority, 'An Effective Regulatory Framework for Higher Education', assets.publishing.service.gov.uk, 23 March 2015.
8 K. Soffen and K. Uhrmacher, 'Every County's Obamacare Marketplace Will Have an Insurer in 2018', Washingtonpost.com, originally published 14 June 2017, updated 11 September 2017.
9 For an introduction to some of these schools of thought, L. Fischer, J. Hasell, J. C. Proctor, D. Uwakwe, Z. Ward Perkins and C. Watson, *Rethinking Economics: An Introduction to Pluralist Economics*, Routledge, 2018, is quite helpful.

15. Public Investment in Social Infrastructure for a Caring, Sustainable and Productive Economy

1 UK Women's Budget Group and Scottish Women's Budget Group (WBG), 'Plan F: A Feminist Economic Strategy for a Caring and Sustainable Economy', 2015.
2 See ibid.
3 J. Stiglitz, A. Sen and J.-P. Fitoussi, 'Report by the Commission on the Measurement of Economic Performance and Social Progress', ec.europa.eu, 2009.

4 D. Elson, 'Gender Budgeting and Macroeconomic Policy', in J. Campbell and M. Gillespie (eds), *Feminist Economics and Public Policy: Reflections on the Work and Impact of Ailsa Mckay*, Routledge, 2016, 25–35.

5 See I. Ilkkaracan, 'The Purple Economy: A Call for a New Economic Order Beyond the Green', in U. Röhr and C. van Heemstra (eds), *Sustainable Economy and Green Growth: Who Cares?*, LIFE e.V./German Federal Ministry for the Environment, 2013, 32–7. Purple is historically associated with women's liberation movements struggling to achieve gender equality, and it was used alongside green and white as the colours of the Women's Social and Political Union, which led Britain's women's suffrage movement in the early twentieth century.

6 Ö. Onaran, 'The Role of Gender Equality in an Equality-Led Sustainable Development Strategy', in H. Bargawi, G. Cozzi and S. Himmelweit (eds), *Economics and Austerity in Europe: Gendered Impacts and Sustainable Alternatives*, Routledge, 2017, 40–56.

7 D. Elson, 'A Gender-Equitable Macroeconomic Framework for Europe', in Bargawi, Cozzi and Himmelweit, *Economics and Austerity in Europe*, 15–26.

8 Ö. Onaran, M. Nikolaidi and T. Obst, 'The Role of Public Spending and Incomes Policies for Investment and Equality-Led Development in the UK', GPERC Policy Briefs, University of Greenwich, #PB17-2017, 2017; T. Obst, Ö. Onaran and M. Nikolaidi, 'The Effect of Income Distribution and Fiscal Policy on Growth, Investment, and Budget Balance: The Case of Europe', Greenwich Papers in Political Economy, University of Greenwich, #GPERC43, 2017; Ö. Onaran and T. Obst, 'Wage-Led Growth in the EU15 Member States: The Effects of Income Distribution on Growth, Investment, Trade Balance, and Inflation', *Cambridge Journal of Economics*, 40(6), 2016: 1517–51.

9 Ö. Onaran and A. Guschanski, 'Reverting Inequality: A Win–Win for People and Economic Performance', in A. Harrop (ed.), *Raising the Bar*, Fabian Society, 2018, 45–54; Ö. Onaran and A. Guschanski, 'Capital Lessons: Labour, Inequality and How to Respond', *Institute for Public Policy Research Progressive Review*, 24(2), 2017: 152–62.

10 Ö. Onaran and D. Tori, 'Productivity Puzzle? Financialization, Inequality, Investment in the UK', GPERC Policy Briefs, University of Greenwich, #PB16-2017, 2017; Ö. Onaran and D. Tori, 'The Effects of Financialization on Investment: Evidence from Firm-Level Data for the UK', *Cambridge Journal of Economics*, forthcoming.

11 Onaran, Nikolaidi and Obst, 'The Role of Public Spending'; Obst, Onaran and Nikolaidi, 'The Effect of Income Distribution'.

12 A £1 billion increase in public spending without increasing any tax rates would generate about £150 million extra tax revenues, because it leads to higher national income via the multiplier effects. See Obst, Onaran and Nikolaidi, 'The Effect of Income Distribution'.

13 Ö. Onaran, C. Oyvat and E. Fotopoulou, 'The Effects of Income, Gender and Wealth Inequality and Economic Policies on Macroeconomic Performance', Rebuilding Macroeconomics, ESRC NW+Project Report, forthcoming.

14 Ibid.

15 J. De Henau, S. Himmelweit, Z. Łapniewska and D. Perrons, 'Investing in the Care Economy: A Gender Analysis of Employment Stimulus in Seven OECD Countries', report by the UK Women's Budget Group for the International Trade Union Confederation, Brussels, 2016; R. Antonopoulos, K. Kim, T. Masterson and A. Zacharias, 'Investing in Care: A Strategy for Effective and Equitable Job Creation', Working Paper No. 610, Levy Economics Institute, 2010; I. İlkkaracan, K. Kim and T. Kaya, 'The Impact of Public Investment in Social Care Services on Employment, Gender Equality, and Poverty: The Turkish Case', Research Project Report, Istanbul Technical University Women's Studies Center in Science, Engineering and Technology and the Levy Economics Institute, in partnership with ILO and UNDP Turkey, and the UNDP and UN Women Regional Offices for Europe and Central Asia, 2015; Onaran, Oyvat and Fotopoulou, 'The Effects of Income, Gender and Wealth Inequality'.

16. Rentier Capitalism and the Precariat: The Case for a Commons Fund

1 G. Standing, *The Corruption of Capitalism: Why Rentiers Thrive and Work Does Not Pay*, Biteback, 2016.

2 For example, the five US-based Big Tech giants bought 519 firms between 2007 and 2017.

3 K. Farnworth, 'The British Corporate Welfare State: Public Provision for Private Businesses', SPERI Paper No. 24, University of Sheffield, 2015.

4 Over-financialisation is a form of Dutch disease, accelerating deindustrialisation. In 1975 finance equalled 100 per cent of GDP; in 2015 it was 300 per cent.

5 G. Standing, *The Precariat: The New Dangerous Class*, Bloomsbury, 3rd edition, 2016.

6 See Standing, *Corruption of Capitalism*, Chapter 5. This theme is developed in my book *Plunder of the Commons: A Charter for Revival*, Allen Lane, forthcoming.

7 An alternative to a threshold would be an overhaul of local taxation, involving an updating of property values that for council tax are still based on 1991 values.

8 Of course, the Forestry Commission should be reformed, and banned from privatising any more than it has quietly been doing.

9 As of 2018, according to Treasury data there were 1,156 forms of tax relief, depriving the Exchequer of well over £400 billion a year. It is presumed in what follows that these could be phased out, and that part of this could be redirected to the Commons Fund.

10 The points made in this section are developed in more detail elsewhere. G. Standing, *Basic Income: And How We Can Make It Happen*, Pelican, 2017.